W9-AEO-744

THE ELECTRIC STATE

Simon Stålenhag

SKYBOUND
BOOKS

ATRIA

New York · London · Toronto · Sydney · New Delhi

They'd put us on a railroad

They'd dearly make us pay

For laughing in their faces

And making it our way

There's emptiness behind their eyes

There's dust in all their hearts

They just want to steal us all

And take us all apart

But not in

Love my way, it's a new road

I follow where my mind goes . . .

So swallow all your tears, my love

And put on your new face

You can never win or lose

If you don't run the race . . .

The Psychedelic Furs,
"Love My Way," *Forever Now*, 1982

The war had been fought and won by drone pilots—men and women in control rooms far from the battlefields, where unmanned machines fought each other in a strategy game played over seven years. The pilots of the federal army had lived a good life in brand-new suburbs where they could choose from thirty kinds of cereal on their way home from work. The drone technology was praised because it spared us meaningless loss of life.

The collateral damage was of two kinds: the civilians unfortunate enough to be caught in the crossfire, and the children of the federal pilots, who, as a concession to the godheads of defense technology, were all stillborn.

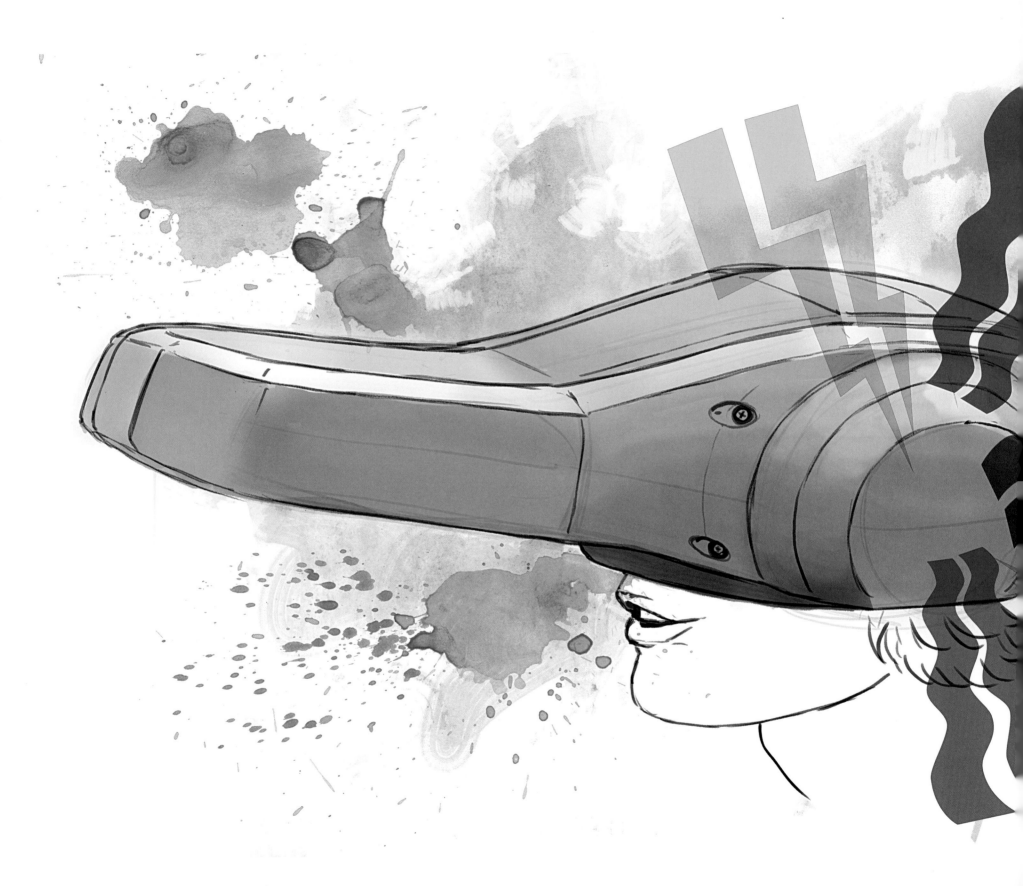

mode 6

A new experience arrives.
01.11.1996

SENTRE
Stay connected.

*Mode 6 is compatible with all Sentre Stimulus devices.

MOJAVE DESERT, PACIFICA, USA
SPRING 1997

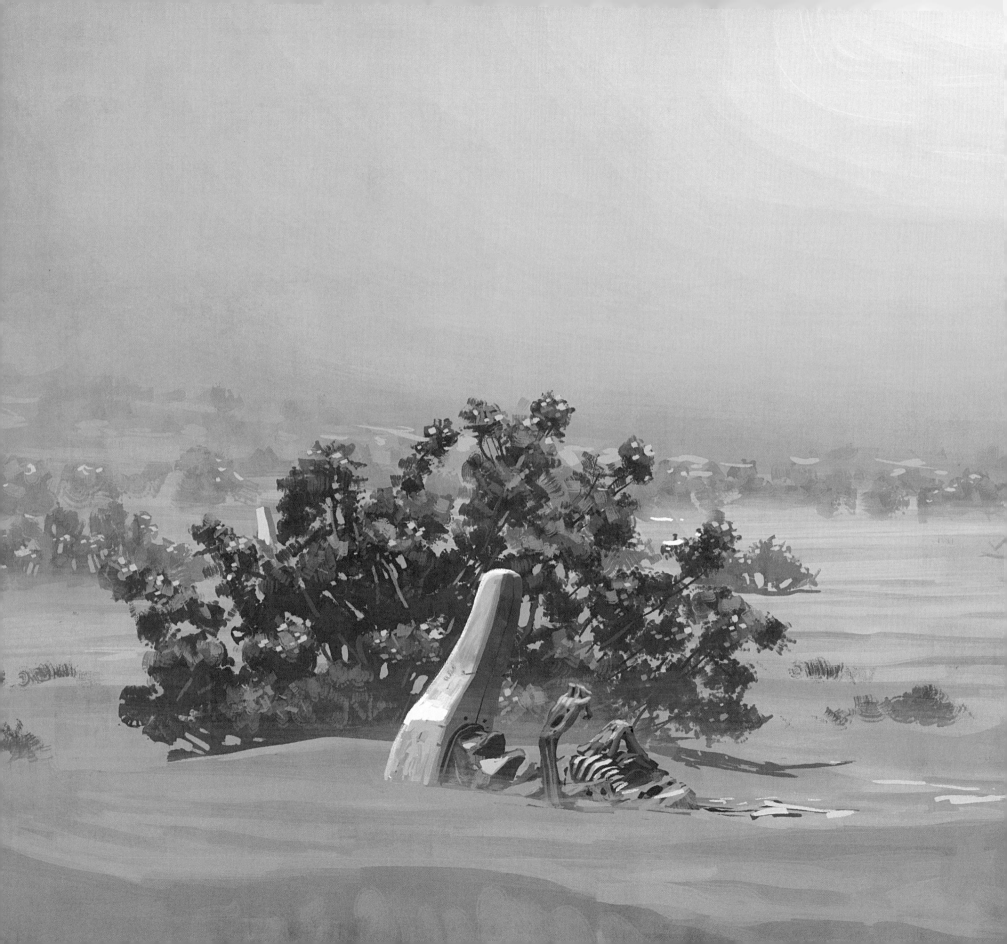

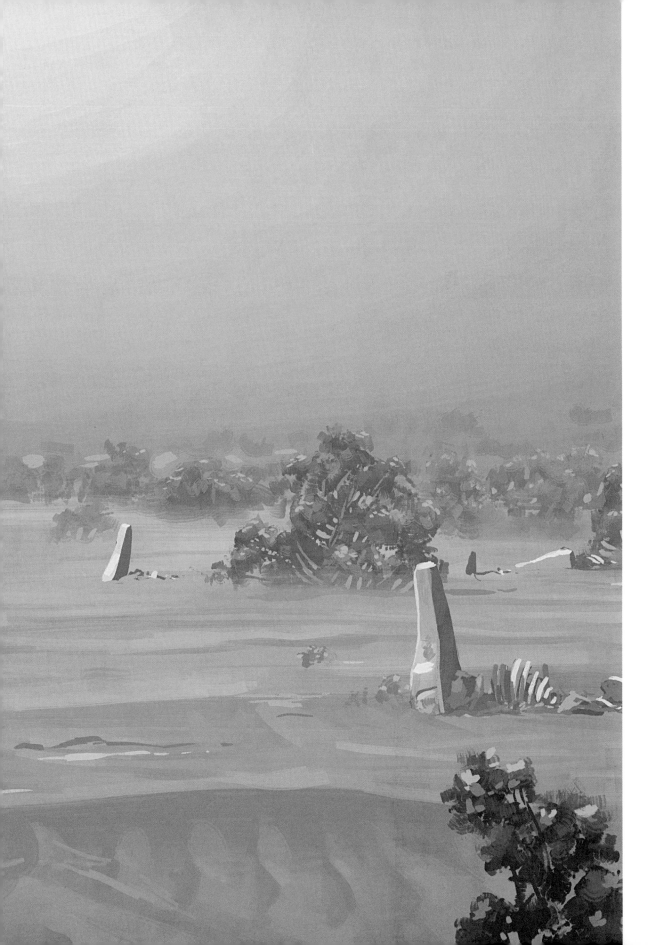

May is the time of dust. Gusts of wind rise and ebb through the haze, carrying huge sheets of dun-colored dust that seethe and rustle across the landscape. They slither across the ground, hissing among the creosote bushes and on until piling up in billowing dunes and waves that wander unseen and grow in the constant static.

Lighthouse keepers were once warned they shouldn't listen to the sea for too long: likewise, you could hear voices in the static and lose your mind.

It was as if there were a code in there—a code that could, as soon as your mind detected it, irrevocably conjure demons from the depths.

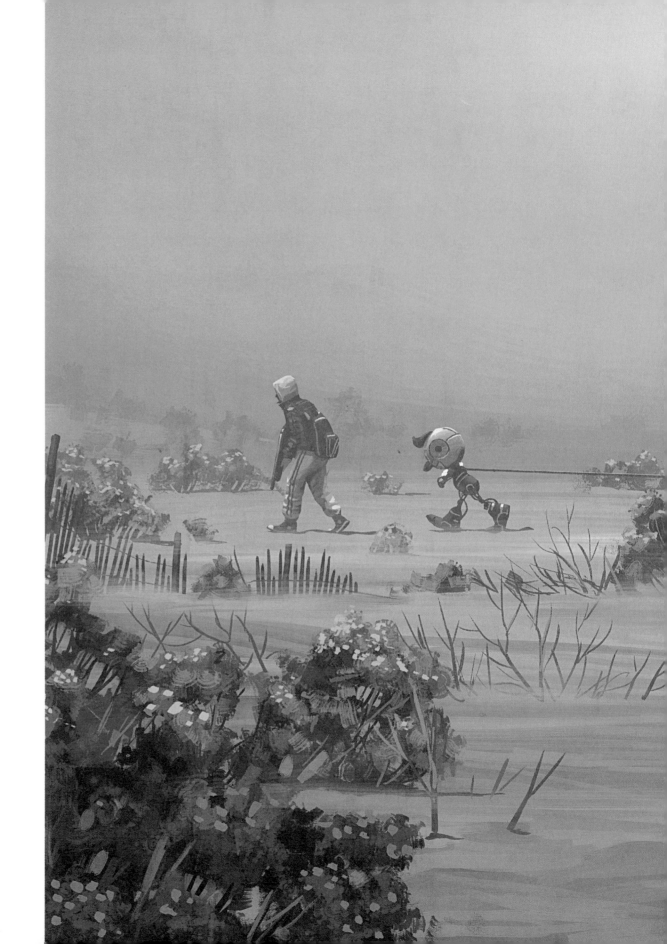

I DIDN'T HEAR the wind anymore. My shoulders ached from carrying the heavy shotgun, and my feet worked mechanically, as if they didn't belong to me. My thoughts were meandering away into a daydream: I thought about Ted under the beach umbrella in Soest as he lay there with large colorful birds in his arms and dreamed of something. His mouth was moving.

I noticed something soft inside my mouth. I stopped and spat out a gray lump of rubbery saliva. Skip came up to me and looked at the lump on the ground. It looked like a furry caterpillar. I stomped on it and tried to smear it into the sand, but only managed to roll it out into a long string of spaghetti. Skip looked at me.

"It's the dust," I said.

I took my water bottle out of my backpack, rinsed my mouth, and spat a few times. When I put my pack back on, I saw something in the distance: a pink piece of cloth protruded from a sand dune, billowing in the wind like a small parachute. I walked over and poked it with my foot. It was a pair of panties.

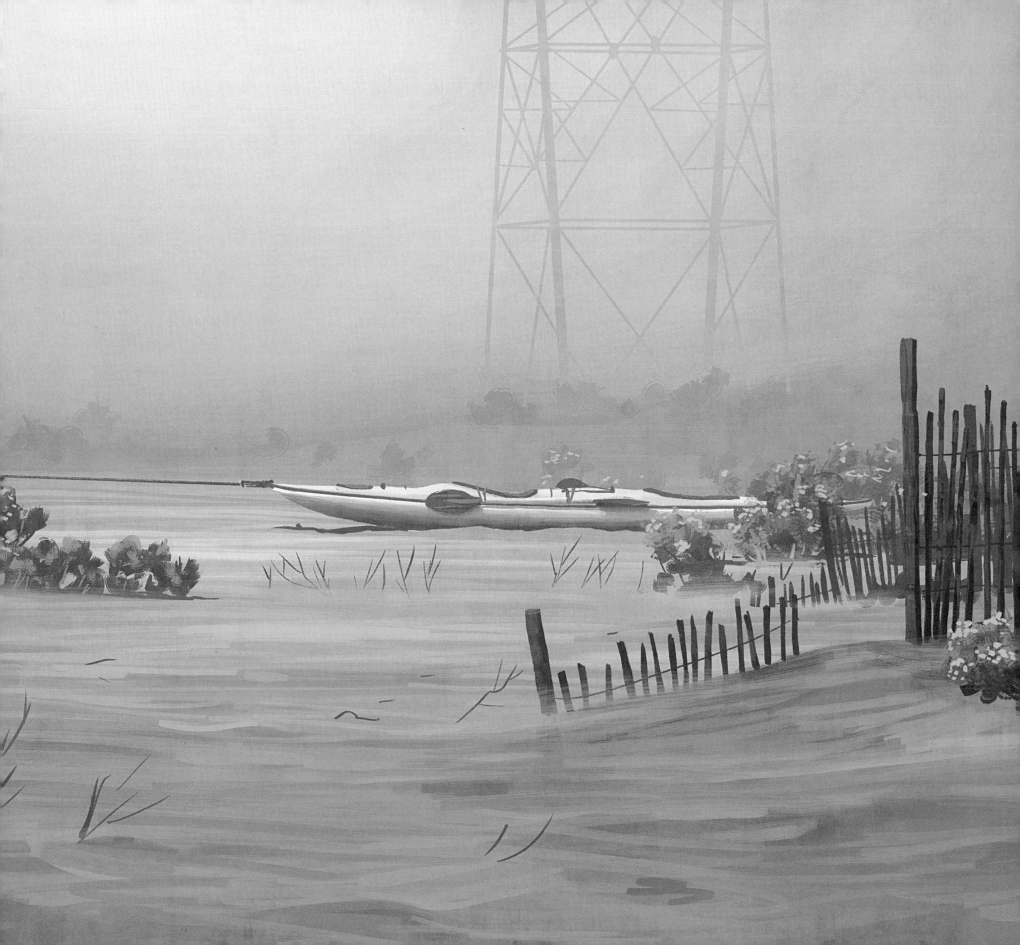

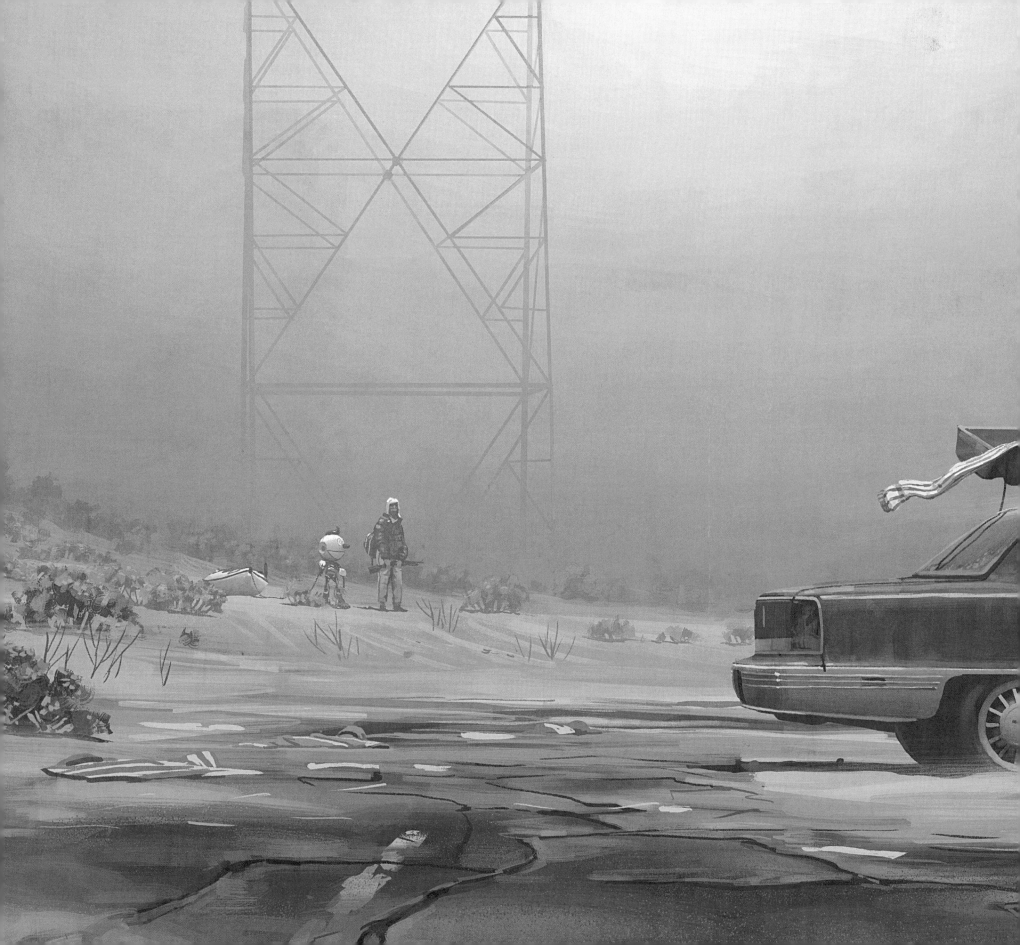

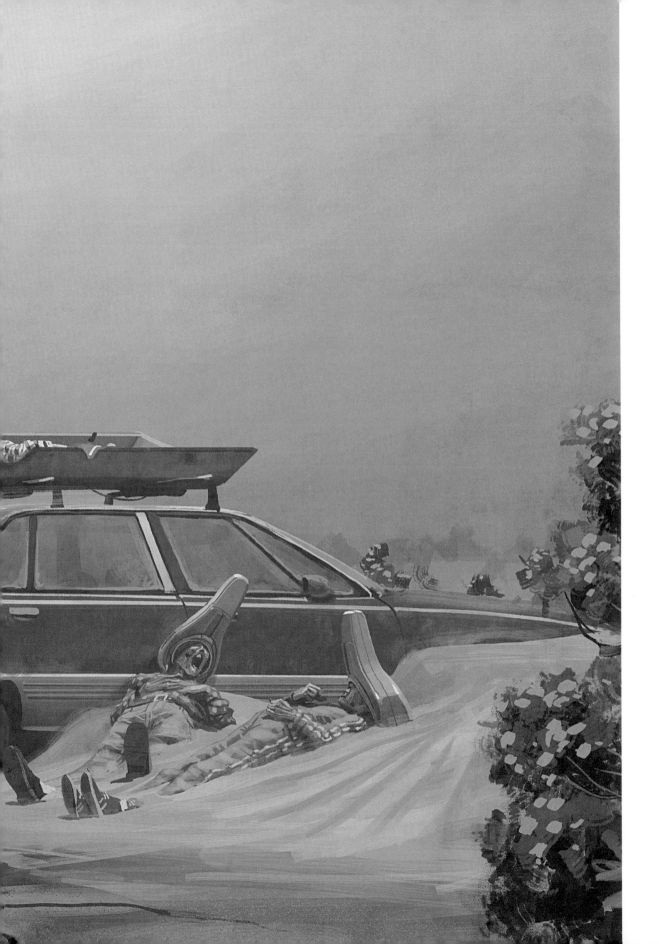

THE PINK PANTIES had been blown from the roof box of a black Oldsmobile in a parking lot nearby. The box was open to the wind, and the parking lot was littered with clothes. Apart from being covered in dust, the car seemed fine—no flat tires or broken lights, and the windows were intact.

It looked like an expensive model, and the owners sprawled in the sand next to it must have been an elderly couple. There were two oblong cardboard boxes on the backseat, and the seat cushions were covered in Styrofoam peanuts. Other than that, the inside of the car was spotless and lovingly cared for. I rummaged through the couple's pockets, hoping to find some cash. The woman's pockets were empty, but in the man's left pocket I found the keys to the car and a folded envelope. The envelope contained a city map with notes, a ten-dollar bill, receipts for two Sentre Stimulus TLEs, and what looked like two entry permits to Canada. I got behind the wheel, inserted the keys, and turned them. The car emitted an electronic whir, coughed, and started. The dashboard lit up with digital symbols, a synthetic clock chimed, and green text scrolled across a display underneath the speedometer: GOOD AFTERNOON. I leaned forward and kissed the steering wheel, and I realized that, with any luck, this might be the last car I drove until we reached the Pacific.

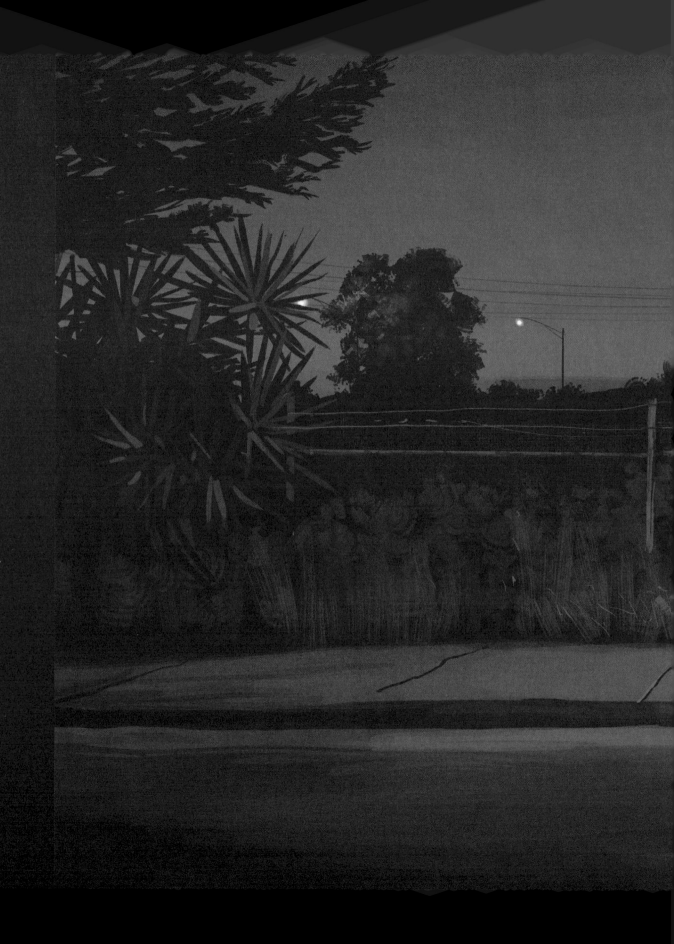

Walter, you once asked me what they need him for. The boy, that is. If I should say it out loud, I fear it will sound like madness. How can I explain this?

Do you know how the brain works? Do you have any idea of what we know about how the brain and consciousness work? Us humans, I mean. And I'm not talking about some new-age hocus-pocus, I'm talking about the sum of the knowledge compiled by disciplined scientists over three hundred years through arduous experiments and skeptic vetting of theories. I'm talking about the insights you gain by actually looking around inside people's heads, studying human behavior, and conducting experiments to figure out the truth, and separating that from all the bullshit about the brain and consciousness that has no basis in reality whatsoever. I'm talking about the understanding of the brain that has resulted in things like neuronic warfare, the neurographic network, and Sentre Stimulus TLEs. How much do you really know about that?

I suppose you still have the typical twentieth-century view of the whole thing. The self is situated in the brain somehow, like a small pilot in a cockpit behind your eyes. You believe that it is a mix of memories and emotions and things that make you cry, and all that is probably also inside your brain, because it would be strange if that were inside your heart, which you've been taught is a muscle. But at the same time you're having trouble reconciling with the fact that all that is you, all your thoughts and experiences and knowledge and taste and opinions, should exist inside your cranium. So you tend not to dwell on such questions, thinking "There's probably more to it" and being satisfied with a fuzzy image of a gaseous, transparent Something floating around in an undefined void.

Maybe you don't even put it into words, but we both know that you're thinking about an archetypical soul. You believe in an invisible ghost,

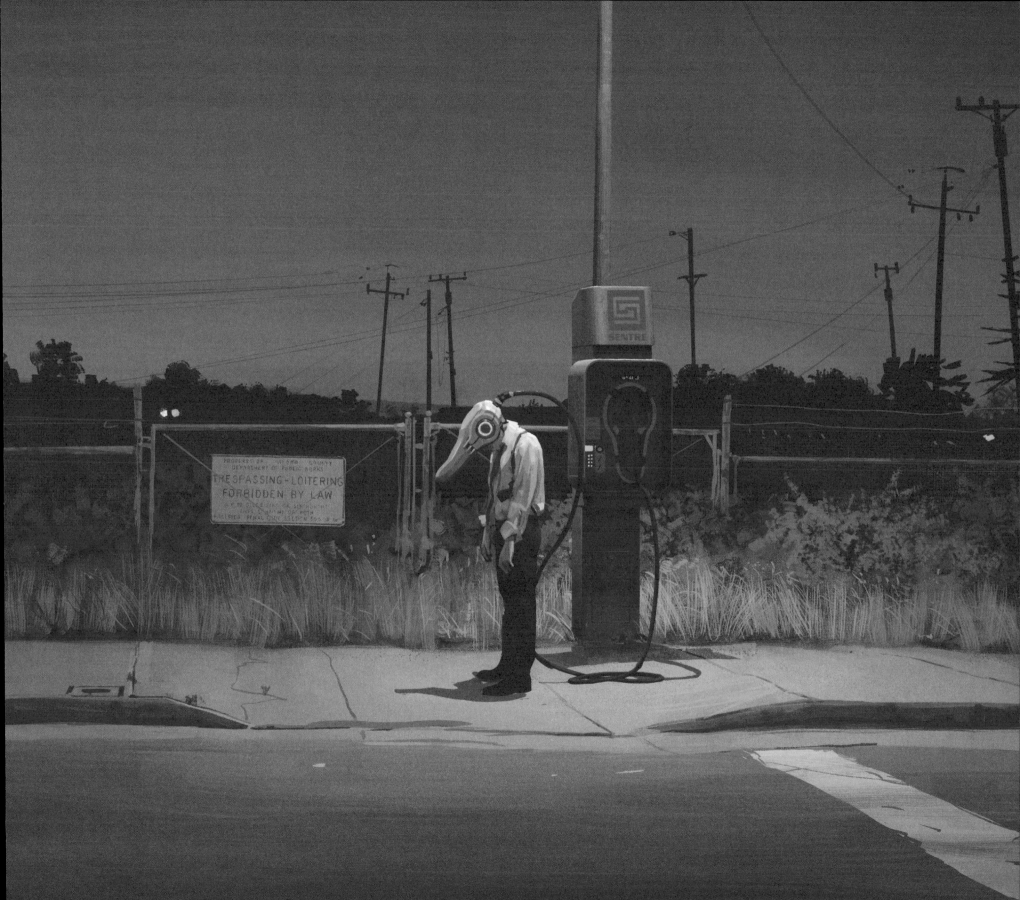

I SAT AND STUDIED Skip's map, the car's engine idling. He had drawn a red circle in the sea a bit north of San Francisco Memorial City, right outside a cape that reached into the sea like a long finger. There was a small community at the end of the cape, Point Linden, and Skip had marked it with a messy red spot. Clipped to the edge of the map was a Realtor's brochure for a house on 2139 Mill Road.

It wasn't easy to figure out where we were, but I suspected it was somewhere west of Pacifica's state line, probably around Interstate 15. Most of the roads in southeastern Pacifica were probably unserviceable nowadays because of the dust, but I really wanted to avoid the major cities and the densely populated areas to the west for as long as possible. One thing at a time. First, we simply had to go west until there were better roads. With any luck, the 395 up north would be open, and we could move through the rural areas east of the Sierra Nevadas. That's what we would do.

Interstate 15 was barely discernible under a soft cover of dust, and visibility was really low. Now and then abandoned cars would appear in the road, so I didn't dare go faster than twenty-five miles per hour. I was leaning forward, concentrating on distinguishing the edges of the road below the dust, but I was soon exhausted. Later in the afternoon the wind picked up, and visibility was so low that we had no other choice than to wait out the storm. I took the first available exit and stopped in what I assumed was a rest stop. Outside, the wind whipped ferociously through the shrubs, and a tide of dust and sand swallowed them until I couldn't see anything.

When we fell asleep, the car was engulfed by howling darkness. It rocked in the wind, and I dreamed I slept inside the belly of a giant.

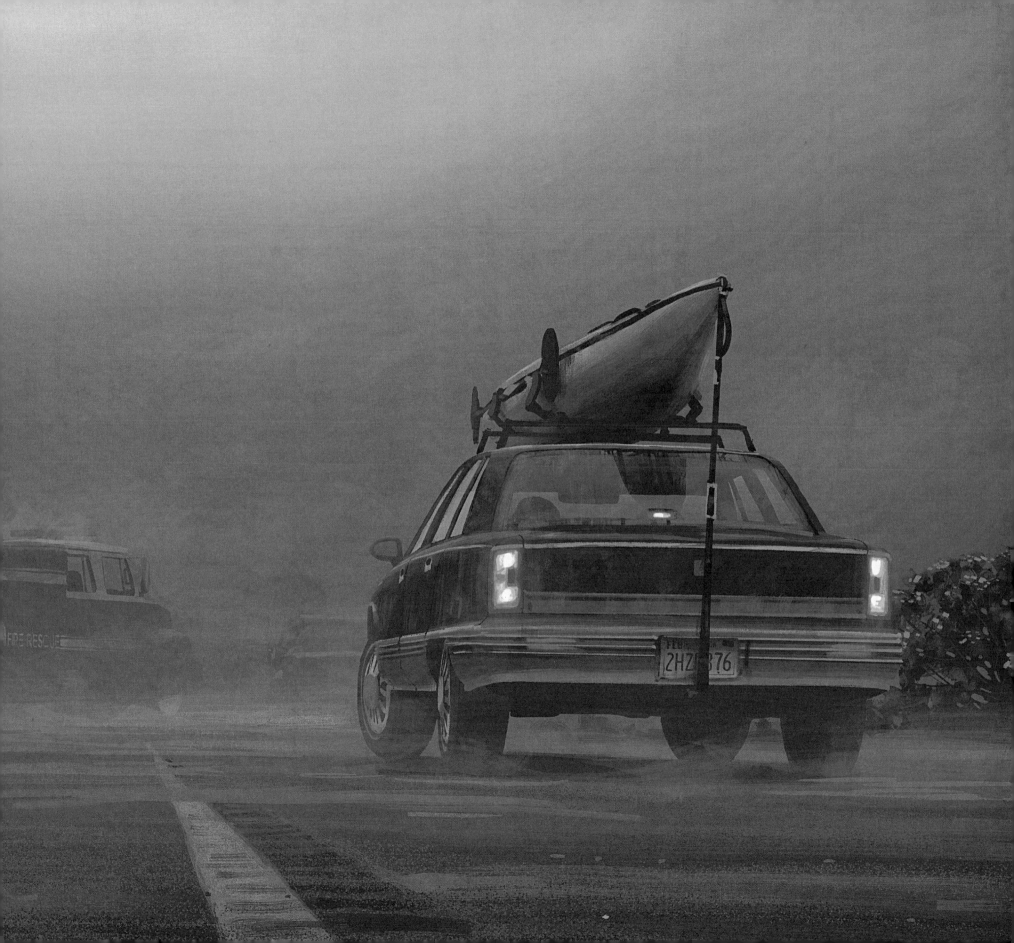

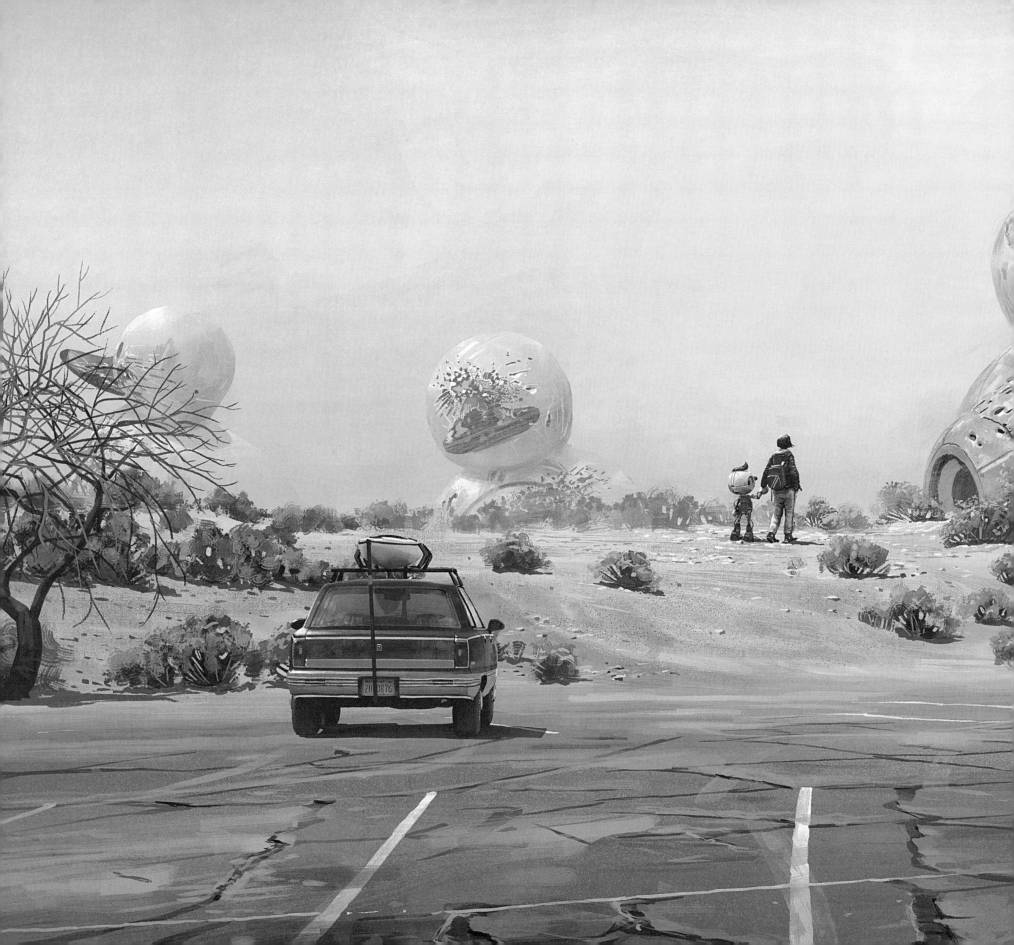

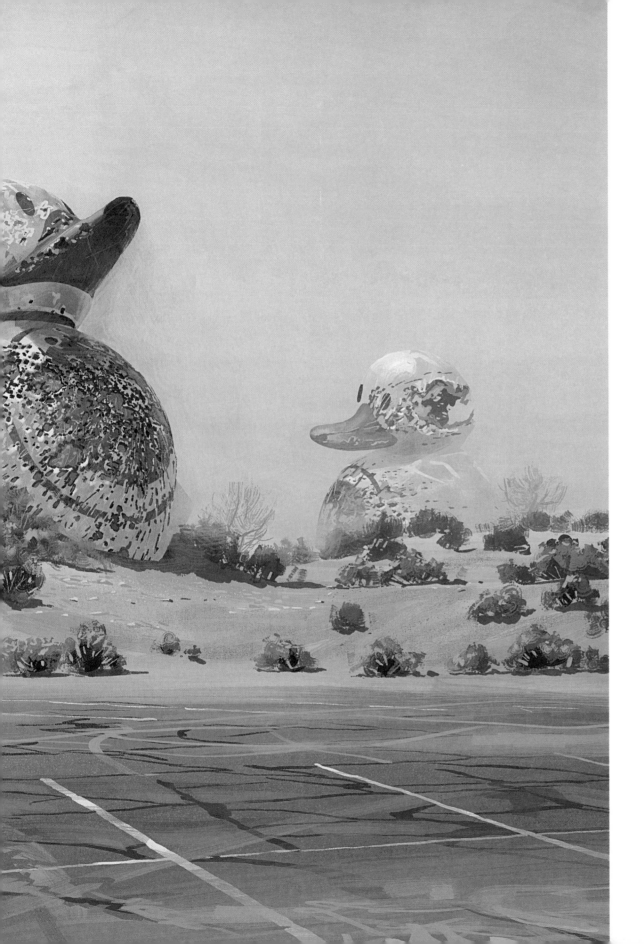

IN THE MORNING, the wind had abated, and outside the car stood a number of huge yellow ducks. For a moment I thought they had arrived with the storm during the night, but the place we had slept in turned out to be some kind of shooting range, and all the ducks were riddled with impacts from various kinds of large-caliber rounds.

We spent a few hours exploring the abandoned range. We found a complete set of tools in a toolbox and a half-full box of shotgun cartridges, and on a mattress in a toolshed we found something lying on its back, vacantly staring at the ceiling. It looked like a homebrew. The red-painted mouth on the large face gaped emptily into the gloom. The thought of what had been shoved into that hole made me cringe. I grabbed its torso carefully, my hands protected by my shirt sleeves, and turned it onto its side. I opened the back hatch using the screwdriver from the toolbox and pulled out three large Vanadium redox batteries. They were warm.

Back in the car, I was about to turn the key when something made me stop. That something was gnawing at the back of my mind. I released the seat belt, grabbed the shotgun, and got out. I told Skip to stay in the car and lock the doors, then I carefully shut the door and walked back to the shooting range.

I found the owner of the sex robot in a derelict trailer on the other side of the compound. He was toothless and bearded, and gasped for breath beneath his neurocaster. His body was emaciated and shriveled, and the place reeked. A tube in his arm snaked around an IV stand to a huge tank in the ceiling that had once been full of something yellow and gooey. The old man was completely incapacitated, and it was impossible to say how long he had been there. I found two hundred dollars rolled up in a glass jar underneath his bed. I took the money and left.

WE SPENT TWO NIGHTS driving out of the restricted zone. I wanted to avoid being seen when we passed the roadblocks, so I waited until the middle of the night before driving the last distance to Barstow. I had hoped to stop for gas and food there before we turned onto 395 North, but the drought had edged west the last few years and swallowed Barstow completely. The dust and the sand had wandered far into town. Apart from a few vagrants dragging their carts through the dunes, the city was completely deserted. If we wanted to refuel, we would have to get to Mojave, which was tens of miles farther west than I was comfortable with.

The car moved through the pitch-black desert night like a submarine in a deep-sea trench. The dashboard clock said it was three thirty in the morning when we first saw the lights of Mojave on the horizon. When we got closer, I killed the headlights and drove as slowly as I could until I saw the flashing yellow lights of the roadblock. I stopped on the shoulder of the road and turned the engine off. Skip was asleep, and I had to wake him up. He sat up and stared out the window for a long while. I explained that I needed help with the roadblock, and then we got out of the car and walked the last few hundred yards. Together we managed to move the barriers enough to get the car through, and once we had driven past the roadblock we got out, walked back, and replaced the barriers. I didn't dare turn the headlights on before we were in the town.

We found a parking lot at the edge of Mojave and stopped there. When I lay down on the backseat and closed my eyes, I saw the storm recede behind us like a giant wall of brown cotton.

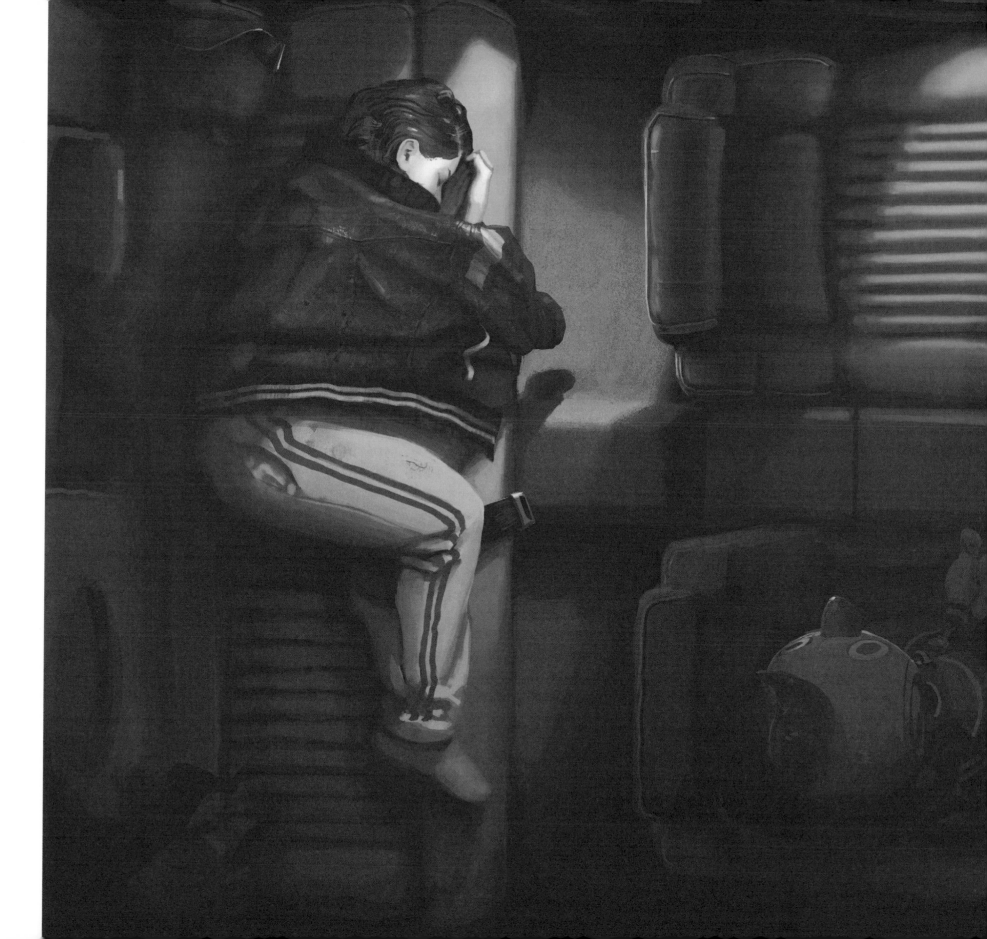

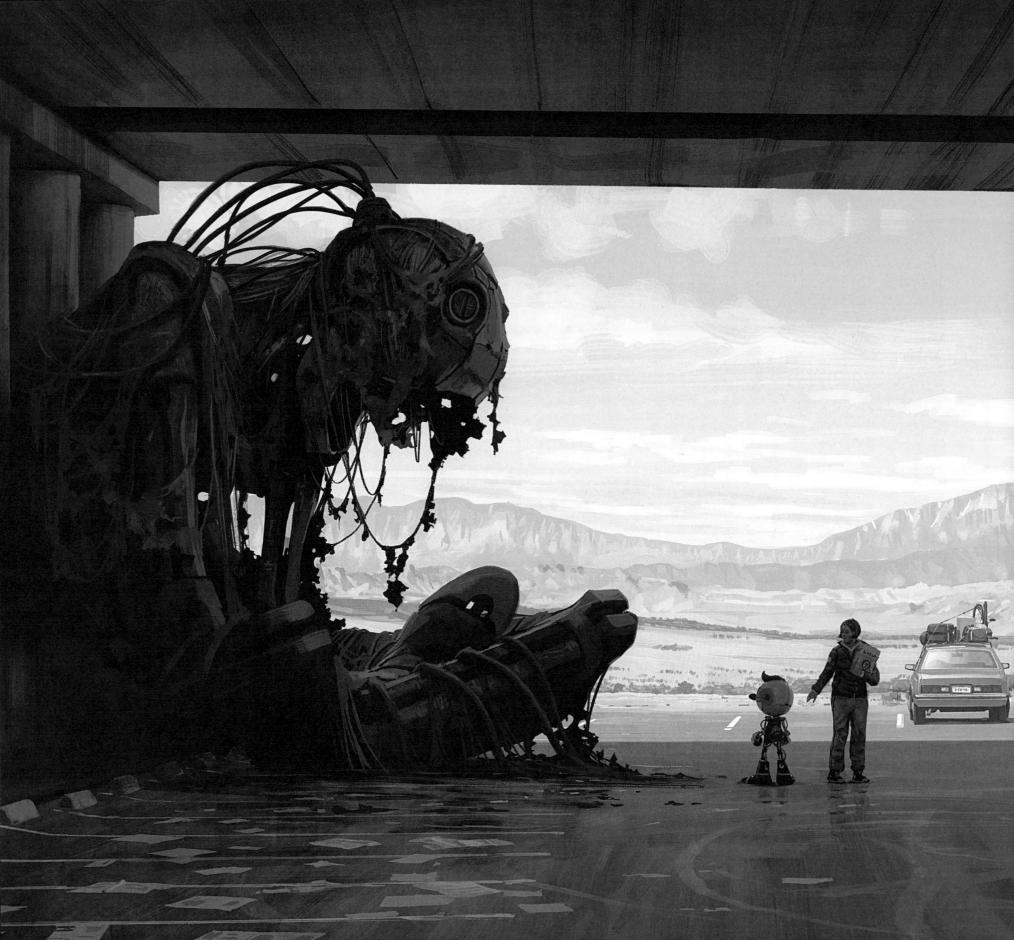

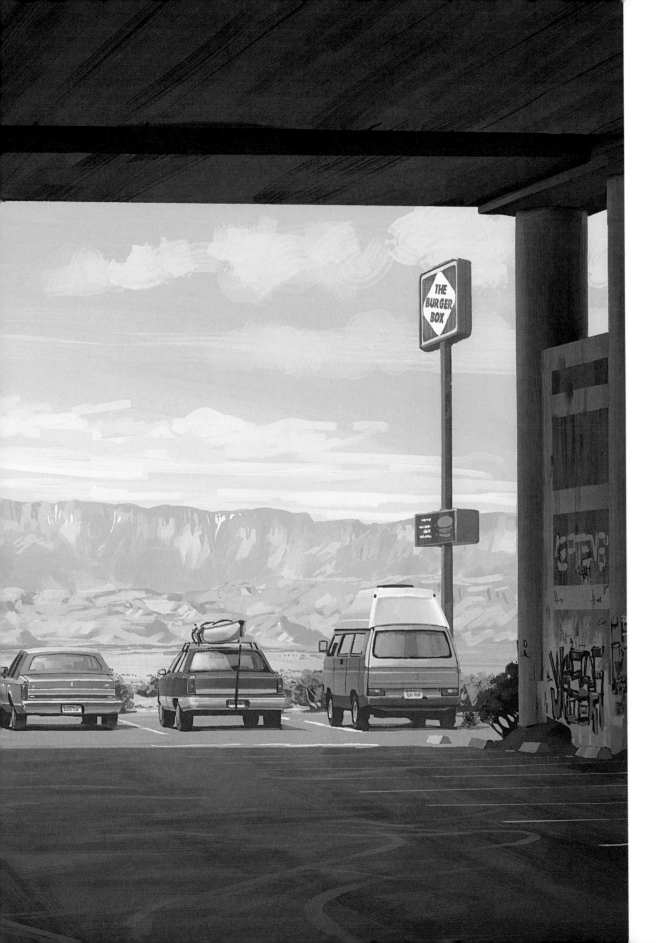

I MANAGED TO get a lot of things done in Mojave. I washed my clothes, bought food, put gas in the car and washed it, and even managed to find some comic books and Kid Kosmo action figures for Skip.

The town was emptying out. There were heavily loaded cars everywhere. Beds, couches, and large TVs were carried out and lashed to trailers and car roofs. The supermarkets were chaotic and crowded, and the shelves were mostly empty. The long lines of shoppers shivered with anxiety and apprehension, people glancing at one another like they were waiting for looting to break out.

I saw bloated, nervous men everywhere, barging through, trailing their wives and kids. Outside an electronics store, a group of boys wearing body armor stood guard, holding automatic weapons and walkie-talkies. They tried to look serious and stern, but their practiced expressions fooled no one; they were loving this.

I sat by myself for a while outside a Burger Box and ate a piece of apple pie. The patio was empty and quiet, apart from a boy bouncing dejectedly up and down in a yellow inflatable castle outside the entrance. I noticed he had peed himself: a dark stain stretched down one leg of his pants all the way to his shoe. He saw me, and our eyes met. He grinned, with more teeth missing than was normal.

"Jump with me," he yelled.

I looked around. We were all alone.

"Where are your mom and dad?"

"Everywhere," the boy replied.

I saw a guy get shot during the war. He was named Max, and we were smoking on the terrace behind the B pavilion at Fort Hull, talking about lasagna. Max loved lasagna, and when the bullet hit he was in the middle of a recipe for béchamel sauce. One of ALA's black assault ships had slipped up above the horizon, and no one had noticed. It was a short burst—three rounds, two of which hit the concrete wall behind us. The third hit Max just next to the cheekbone, close to his nose. I don't want to go into unnecessary detail, but details about the physical realities of this world are exactly what this is all about, so you're just going to have to deal with it. The bullets fired from the assault ship were very special: magnetic neodymium, traveling at over twelve thousand feet per second. The kinetic energy was beyond belief. The bullet took off everything above Max's mouth.

Afterward, I was curled up on the ground and saw the pink chunks spread across the flagstones around me, and before Fort Hull's alarm system started blaring I had the time to think: That's it, right there! The recipe for béchamel sauce. But even if I did my utmost to scoop up the pieces and put them back in the pit that used to be Max's skull, his recipe would still be lost. Max's lasagna existed in the intricate way those pink chunks had been assembled, just like love and hate and anxiety and creativity and art and law and order. Everything that makes us humans something more than elongated chimpanzees. There it was, spilled across the flagstones, and no technology known to man could ever put it back together. It was incredible.

That was my materialistic revelation. What I'm trying to say is that what we call lasagna is simply a phenomenon that arises somewhere between the physical parts of the brain and in the way they're put together, and anyone claiming lasagna is something more has underestimated how complicated the brain is and in how many ways its parts can be assembled. Or they have overestimated the phenomenon of lasagna.

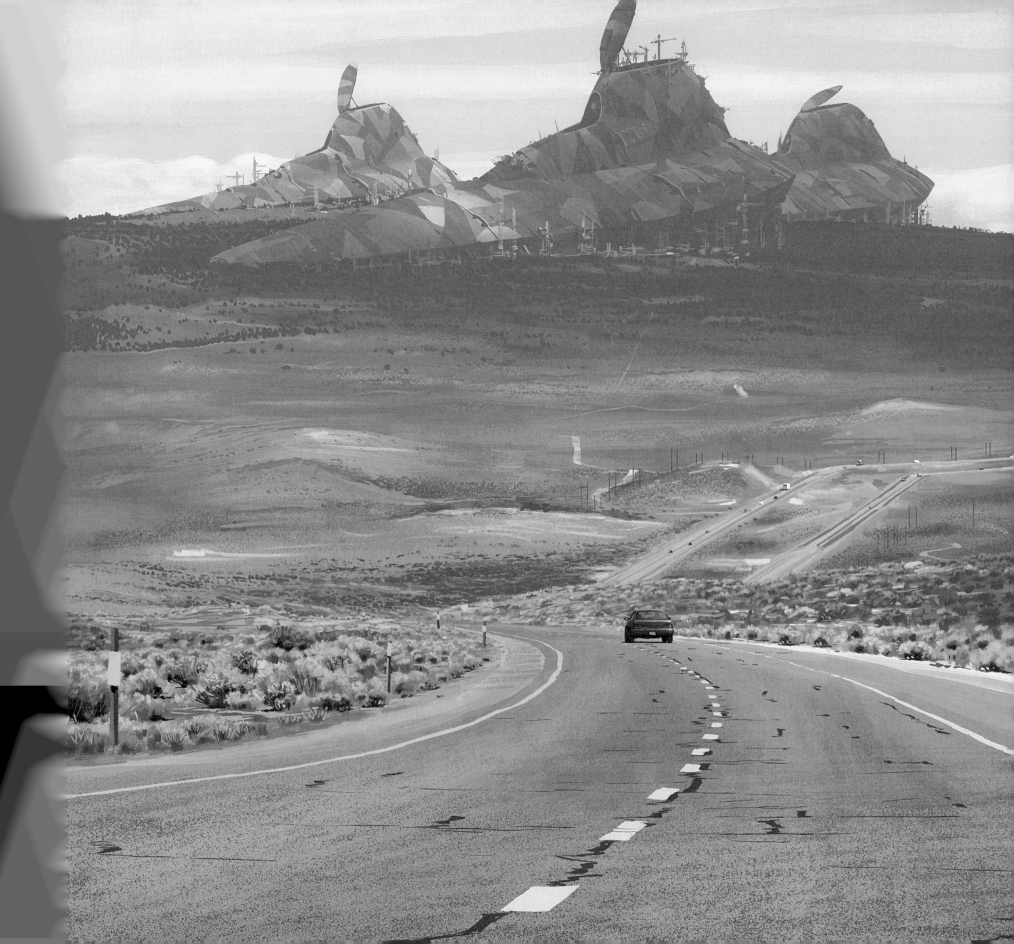

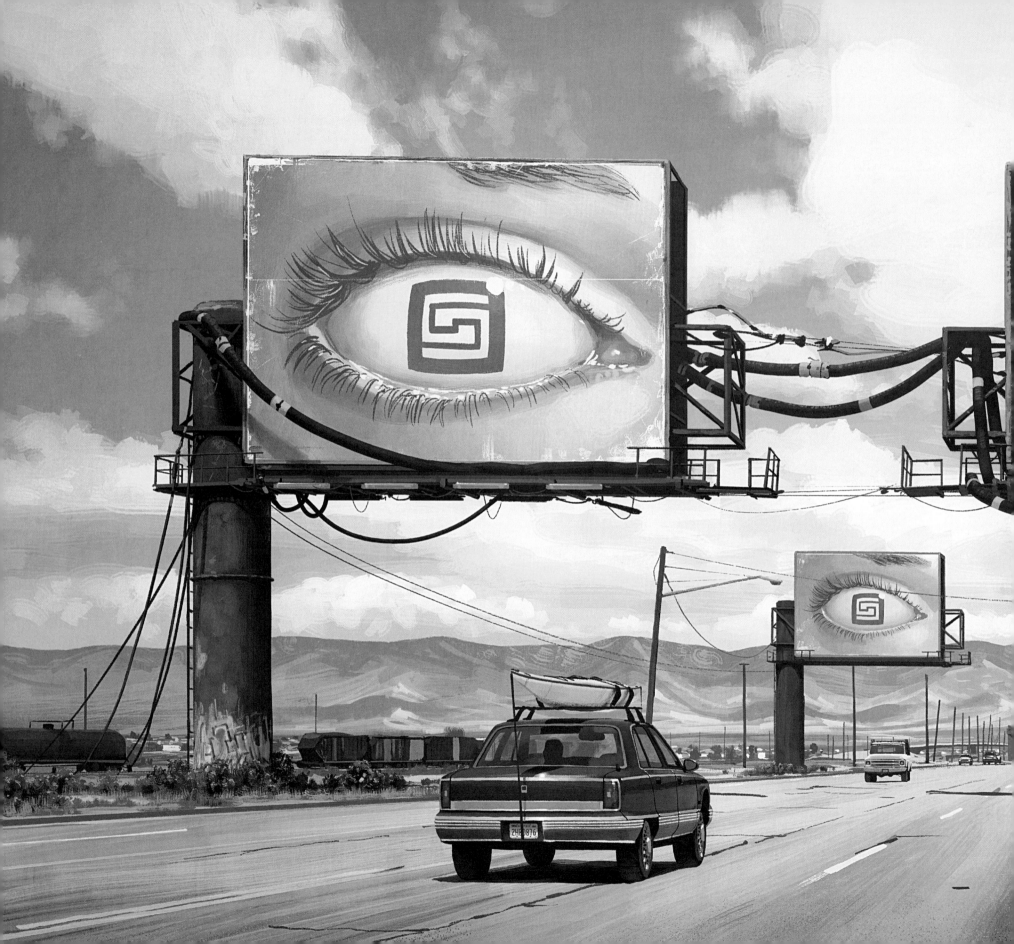

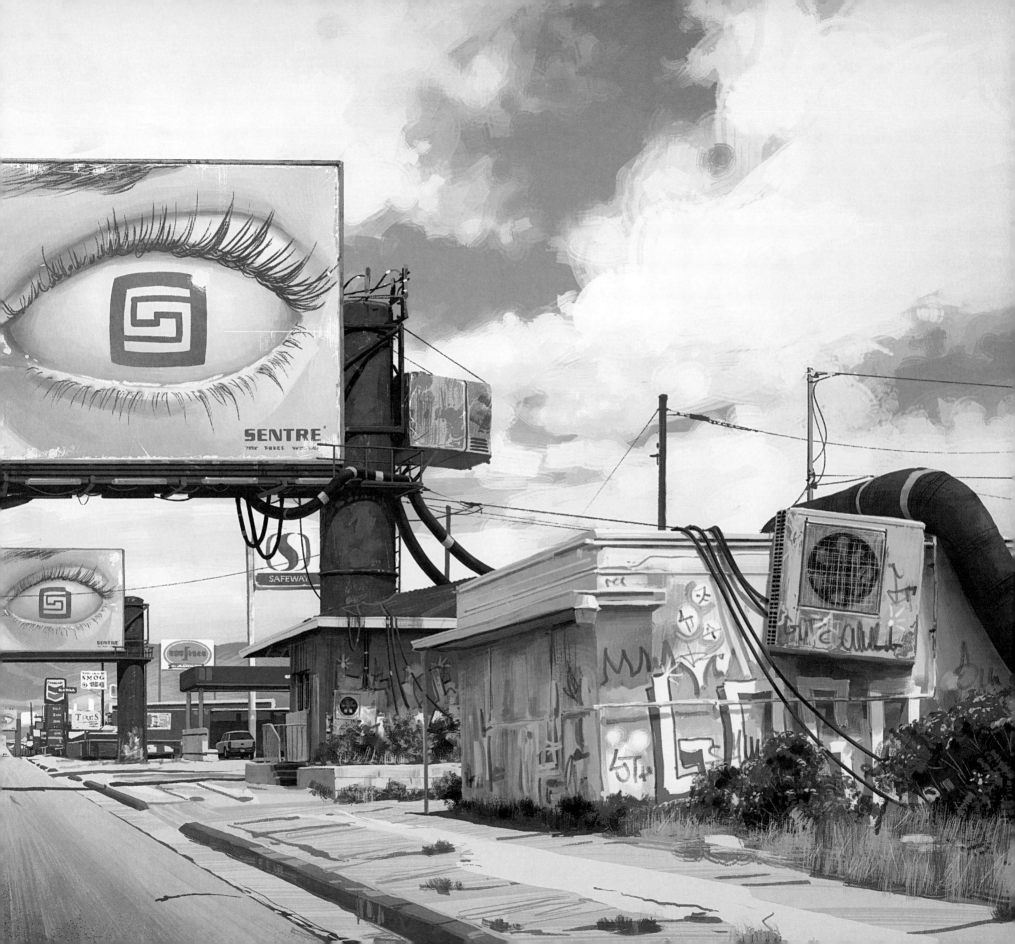

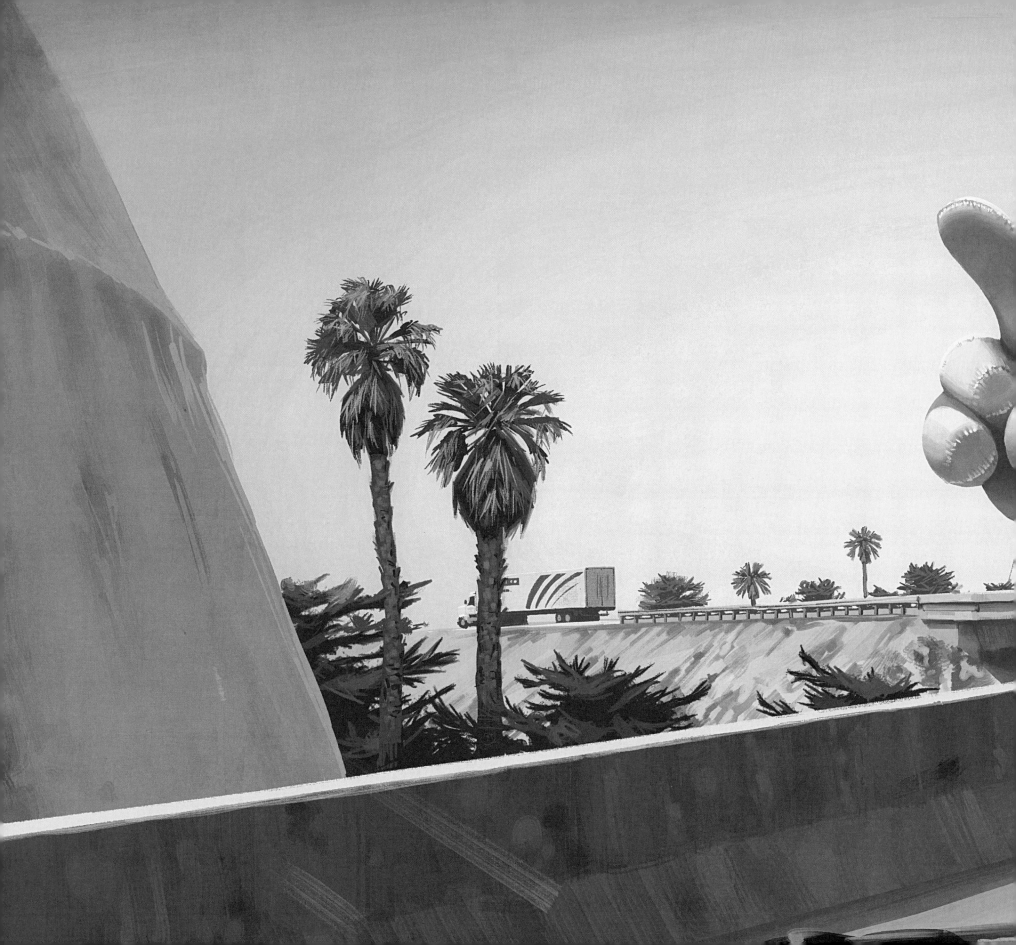

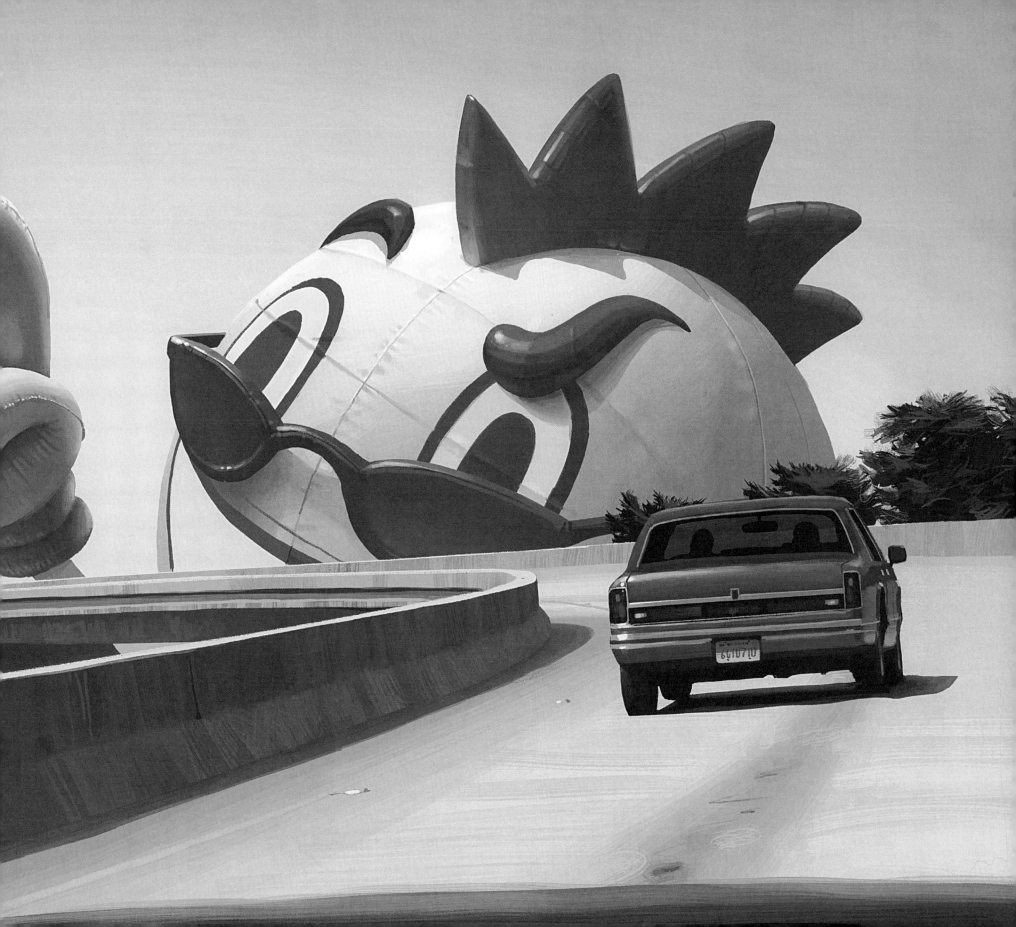

WE HAD LEFT the town behind and traveled out into the desert. North of Mojave, the 395 was almost entirely empty of traffic and cut through the barren landscape in a ruler-straight line. The view outside the windows made me uneasy. After three weeks in the Blackwelt badlands, where visibility never went beyond a few hundred yards, we were suddenly distinct in the great void, the car crawling like a black bug across a vast sheet of white paper.

I had been here before. When I was fourteen, Ted and Birgitte drove us through this very desert. They had bought me a camera. Their working hypothesis was that some artistic creativity would do Michelle good. My first idea was to take a series of photos of roadkill, but Birgitte refused to let me ruin the trip with my morbid obsession with destruction, as she called it when I wanted to stop by a coyote that had been run over.

They said that the whole point of the trip was to spend time together and get to know one another and have a merry ol' time, so I was not allowed to wear my headphones. Birgitte kept turning down the radio and talking about how Pacifica had fallen apart since they started coddling the neurine addicts. She talked a lot about self-respect and taking responsibility, and how addicts usually lacked the capacity for that. Like my mother, for example.

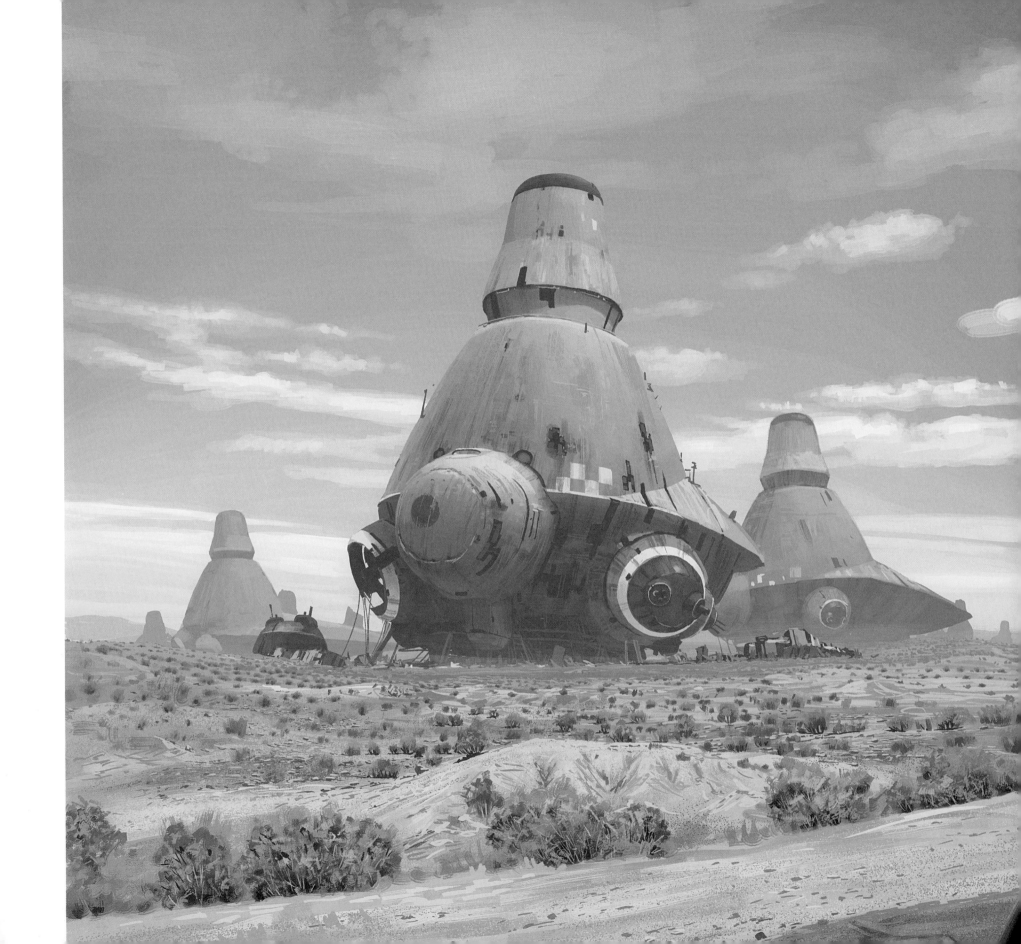

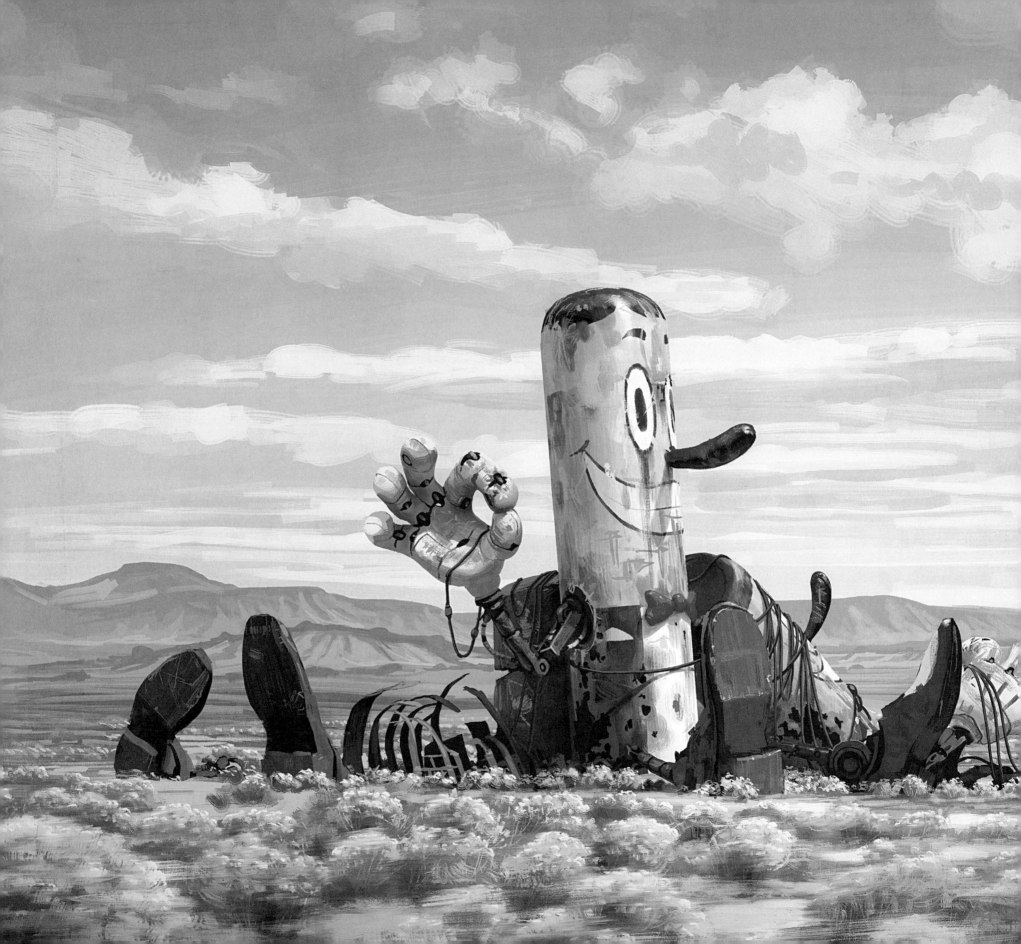

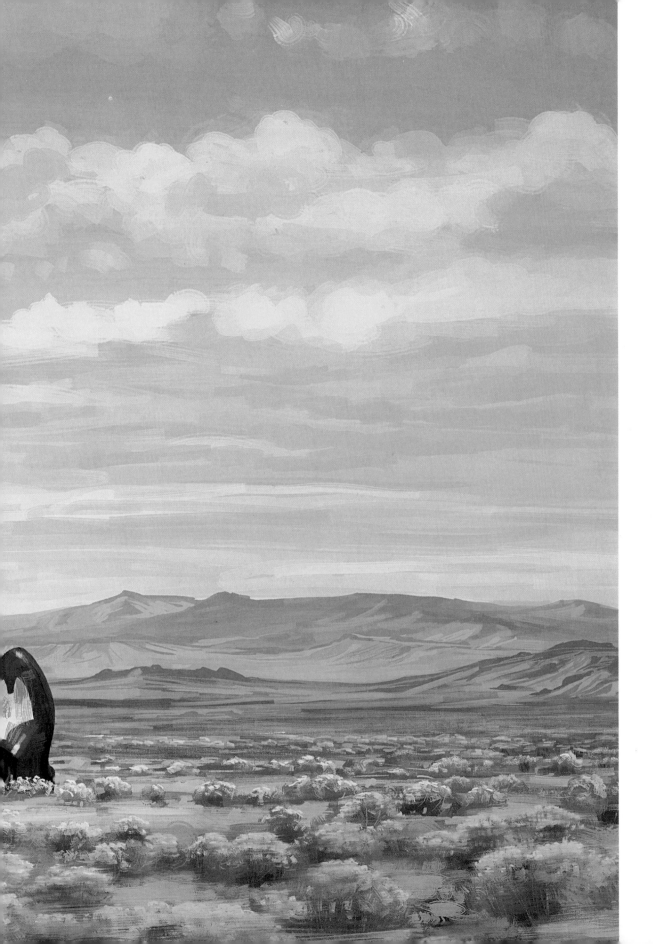

LATER WE VISITED a national park. The patio outside the gift shop was full of blond teenage girls who looked just like me and a lot of moms and dads who looked just like Ted and Birgitte, and they were all annoyed with one another and argued about jackets and baby carriages and sunscreen lotion and when and what to eat and how expensive it was, and when Birgitte went to order food I told Ted I wanted to dye my hair black, and Ted told me he had had long hair in the sixties and we talked about how the Beatles had influenced Kurt Cobain; and when Birgitte came back with our food Ted said do you think Michelle would look good with black hair and Birgitte chuckled:

Oh no, sweetheart, you really must take better care of your appearance.

I said nothing and escaped to the bathroom, and after a while I thought my rage had subsided, but when I walked up to our table again I grabbed a food tray someone had left on the table next to ours and smacked it into the back of Birgitte's head, sending saucers and plastic containers and half-eaten sandwiches flying around the customers. I don't know where I found the strength, but I grabbed her hair bun and slammed her face into the table hard enough to break her nose.

Back then I felt bad about what I had done. Now as I drove past these places and thought about what had happened, I didn't feel even a trace of shame. Birgitte had deserved it, and everything that came later. You don't know what you got 'til it's gone. True. Birgitte was a fucking asshole and she was gone, and I felt nothing.

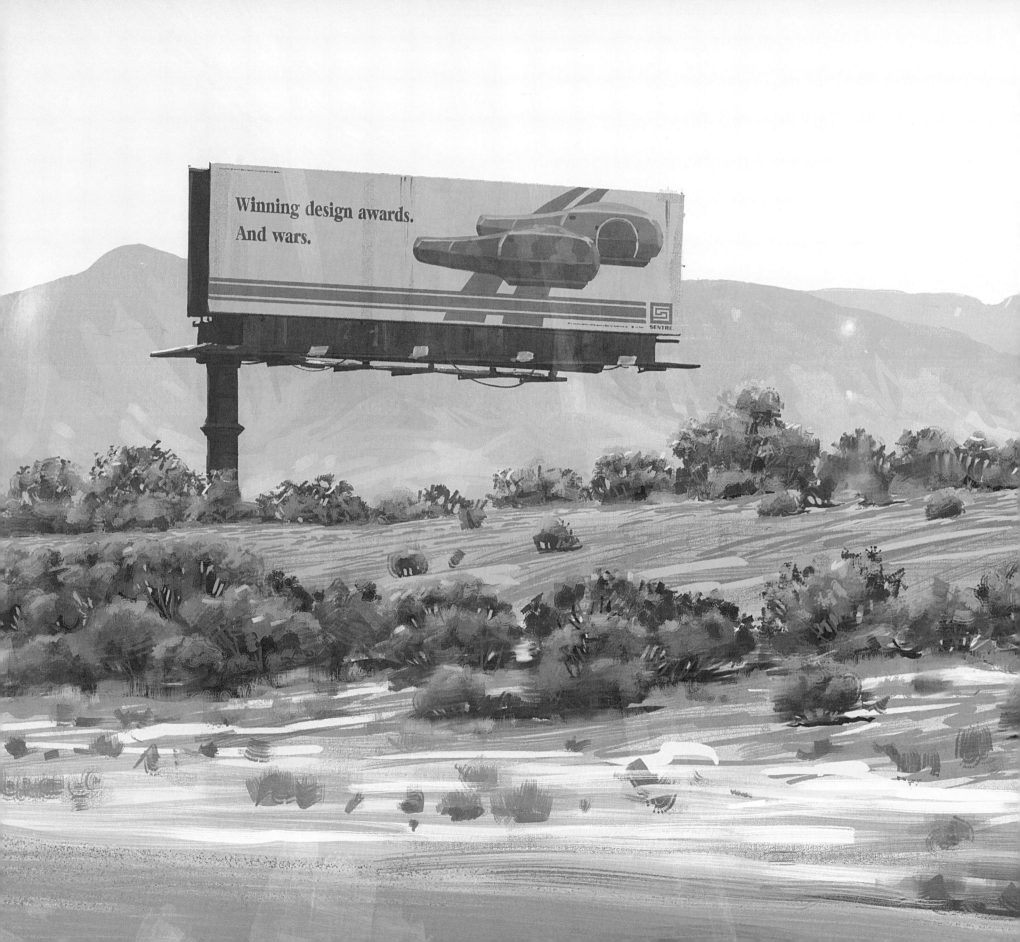

SKIP WAS ABSORBED in a comic book. I tried to find a station on the radio but it was mostly static; the only thing coming through was a voice singing *I will always love you* in Spanish, so I gave up. I sat back in the seat.

Oddly enough, breaking the nose of my foster mother made things better for me. I ended up at Summerglade, where I met Amanda. She was in my class at Riverside and had earned her place at Summerglade by attacking her chemistry teacher with a stun gun.

Vicky Sorensen was in charge at Summerglade, and she led us on long hikes around a small lake called Esquagamah. We carried heavy backpacks and pitched tents and learned about wilderness hygiene and getting up early and starting a fire and cooking breakfast in small aluminum pots, and then we packed up our camp and hiked around the lake again. Now and then we would stop to solve some fictional problem together so we could learn how to trust each other and break the downward spiral of destruction that stopped us from being happy and feeling hopeful for the future.

Amanda and I rubbed a pair of panties in fish goo and hid them in Vicky Sorensen's pack.

A FEW YEARS AFTER Summerglade we were sitting in Tommy's yard. Sean's sister Connie was tearing aluminum foil from cigarette packs to make small wedding rings to put on Chris's fingers, and I tried to hear what Tommy was saying to Amanda, and then Chris wanted to go to the limestone quarry in Neptune for a swim; when we squeezed into the car I ended up in Amanda's lap, and next to her was Tommy, who immediately put his arm around her and started rubbing her shoulder. I couldn't decide whether she liked his groping because she didn't resist him, and when we went up onto the highway he started playing with her hair and I turned away to look out the window, but Amanda must have noticed because she immediately put her hand on my thigh in between my thigh and the car door where no one could see and ran her thumb up and down the fabric of my jeans, and everything was warm and I held my breath and didn't hear what anyone was saying until we got out of the car down in the quarry.

There was a diving tower in the emerald-green water at the bottom of the quarry, and Tommy and Sean dove perfectly from the top and Connie screamed when Chris stood balanc-ing on the rail at the very top. Then they swam over to the other side and it was only Amanda and me left on the diving tower, and we climbed to the very top and dusk was falling when a breeze rippled across the water and beyond through the birch trees, the traffic on Lafayette a million points of light coalescing on the horizon, and Amanda said Michelle, you have the palest thighs in Soest City.

She kissed me in the darkness below the diving tower, where no one saw, and I couldn't stop shaking but I said it was because the water was so cold.

In the fall, I taught her how to get into the Boneyard at Itasca, where I showed her how to extract dream glint from the neuronics of the Erginus wrecks. We crushed the dream glint and melted it and made pills that we sold to a guy on Vandeventer for five dollars apiece, and we recorded the sound from a porno on a tape that we left cranked up high on a boom box outside the church where Amanda's father preached. We rolled our eyes through classes and skipped school and trespassed on private property and stole clothes and records together, and all of a sudden I didn't want to run away from Soest anymore.

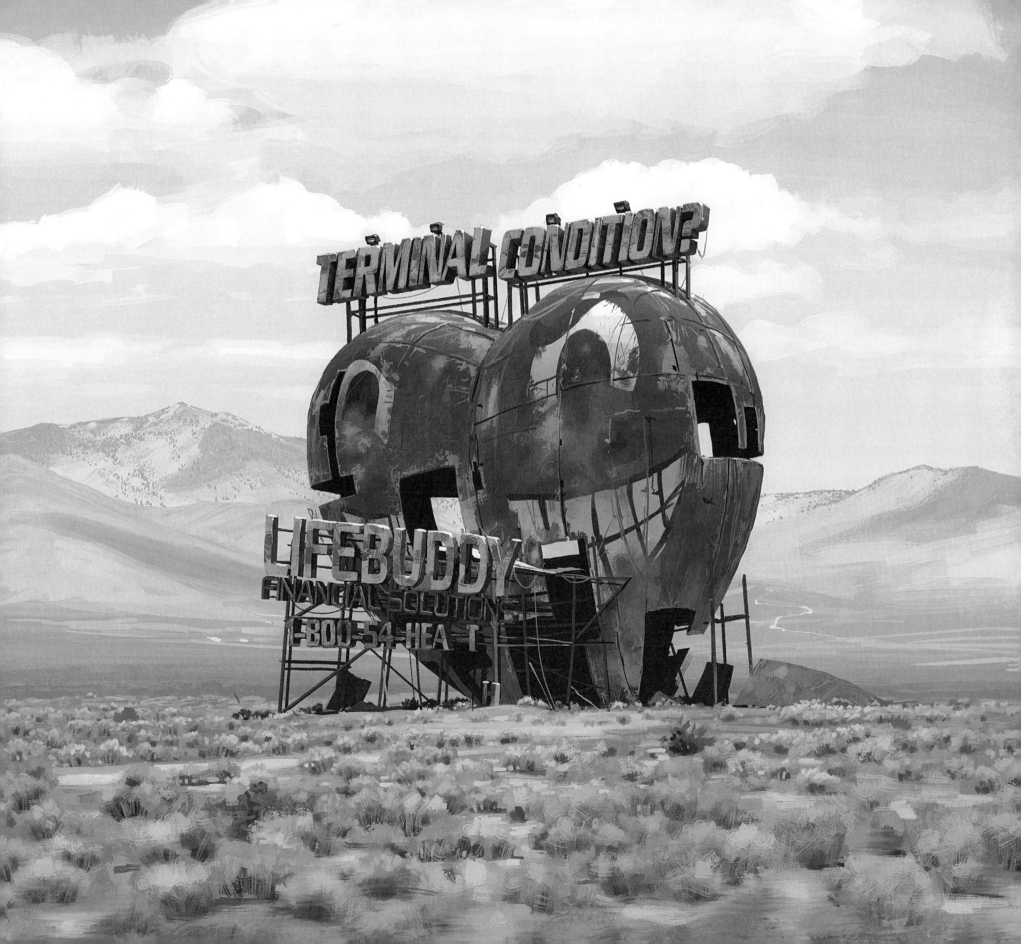

WASHOE INSULAR ZONE

CHIEF

THE BLACKWELT EXCL

119°

Gardnerville

THE WASSUK EXCELSIOR WASTELANDS

S. LAKE
FALLEN LEAF LAKE
FREE PEAK
88
MR SIEGEL
null
null

GEORGETOWN SADDLE MTN ROBBS PEAK
TAHOE
Woodfords
Markleeville

Placerville Kit Carson Silver Lake
EL DORADO
Mechanized Weapons Site

PLACERVILLE CAMINO LEEK SPRING SILVER LAKE MARKLEEVILLE TOPAZ LAKE DESERT CREEK PEAK null null
88 Lake Coleville
Alpine 395
AMADOR Buckhorn ALPINE

Sutter
Creek West Point
CALAVERAS Dardanelle
Martell MOKELUMNE DARDANELLES SONORA PASS FALFS BRIDGEPORT AURORA null
SUTTER CREEK HILL BLUE MTN BIG MEADOW CONE HOT SPRINGS
Jackson Bridgeport

lace San Andreas Strawberry
Valley
Springs Murphys TUOLUMNE MATTERHORN TRENCH HUNTOON
VALLEY ANGELES CAMP COLUMBIA LONG BARN PINECREST TOWER PEAK PEAK BODIE CANYON VALLEY null
SPRINGS

Columbia Twain Harte
Sonora Soulsbyville Lee Vinig
Copperopolis Tuolumne
Jamestown
Mather
Groveland HETCH HETCHY TUOLUMNE MONO COWTRACK MTN GLASS MTN Bento
ESCALON COPPEROPOLIS CHINESE GROVELAND LAKE ELEANOR RESERVOIR MEADOWS CRATERS Benton
scalon CAMP MONO
Oakdale Moccasin Big June Lake
Oak
Flat NAVAL AIR FORCE BASE MAMMOTH LAKES

Riverbank Coulterville Mammoth
MODESTO El Portal Lakes

WATERFORD MERCED COULTERVILLE EL PORTAL YOSEMITE MERCED PEAK DEVILS MT MORRISON CASA DIABLO WHITE
TURLOCK LAKE FALLS POSTPILE MTN PEA
Montpelier Midpines Toms Place
Denair Snelling Chalfant

Mariposa

rock Delhi Bootjack Rovana
Winton Ahwahnee MT ABBOT MT TOM Bish
TURLOCK ATWATER MERCED INDIAN GULCH MARIPOSA BASS LAKE SHUTEYE PEAK KAISER PEAK Mono Hot BISH
Merced MARIPOSA Oakhurst Lakeshore Springs
ewman Planada
Le Grand Coarsegold 395
stine MERCED Raymond North FRESNO Big Pine
Fork

THE MOUNTAINS

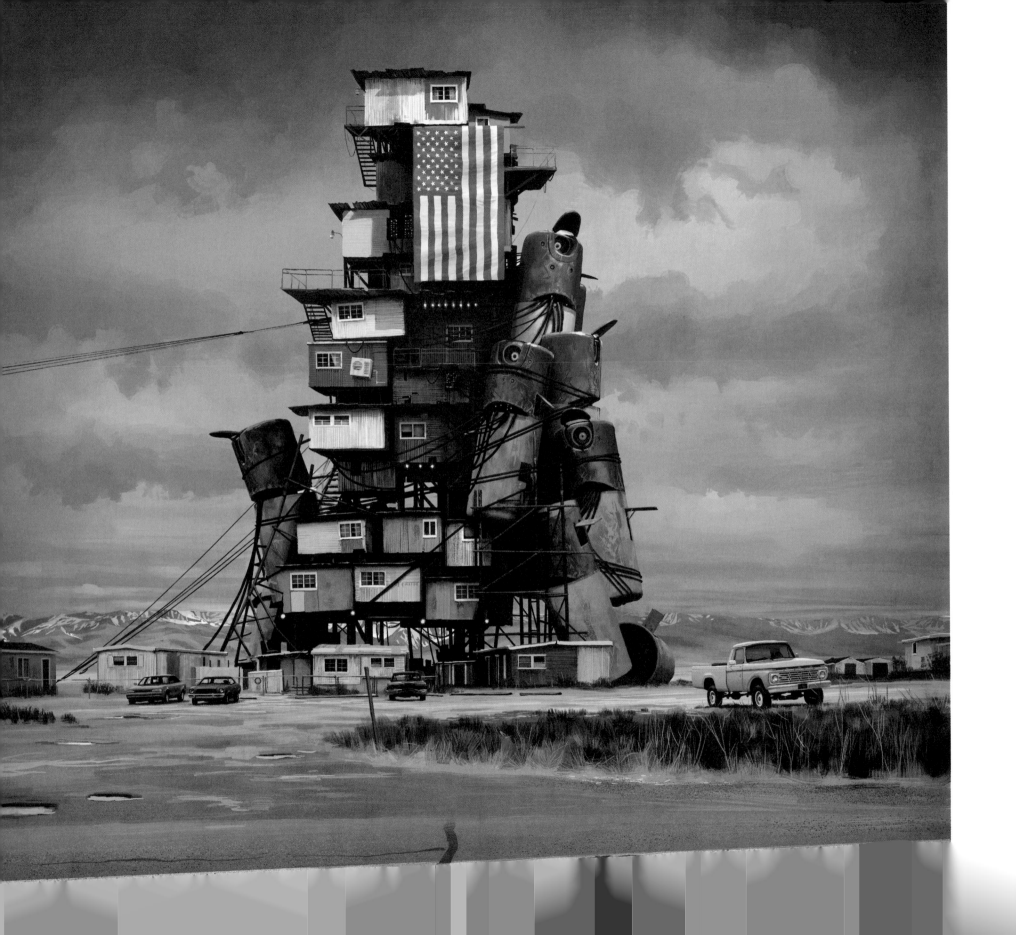

MOST OF THE MOUNTAIN PASSES were covered in snow, so we had to drive almost all the way up to Carson City before we found an open path west over the mountains. I didn't like going that far north, since the whole valley around the Carson River was a notoriously lawless area. We were finally able to turn southwest onto Route 88 at Gardnerville, taking us up into Alpine County and past the shantytowns of Fredericksburg, Paynesville, and Mesa Vista. Whole apartment complexes that looked like they were getting their energy from salvaged suspension engines had sprung up there. I was sure there were laws against that kind of thing, but any presence of law and order was barely perceptible on the windswept highlands east of the mountains. We needed to get gas and I had to pee, but when we arrived at the gas station in Woodfords there were several huge pickup trucks parked by the pumps, surrounded by armed men in camouflage pants and sunglasses, a couple of gaming drones secured to the beds of the trucks, so I just kept on driving.

Finally I stopped the car at a turnaround for big rigs, ran down into the ditch, and peed. While sitting there, I noticed an emaciated mare in the undergrowth a few meters out on the plain. When I was done peeing I tried calling to it.

Hey, girl, I said, and the horse pricked up its ears and turned its head toward me, and where her eyes should have been there were only two dark pits.

WHILE WE LISTENED to one of Skip's tapes on the car stereo, the terrain outside the car was becoming rockier, and elevation signs appeared more frequently. The road straightened out and stretched through a rocky valley where the shadows of clouds walked across the jagged ground. Down in the valley it felt like our car was a microscopic probe inside a snow globe. The wreck of an old assault ship reached up from a ridge between the boulders. Someone had drawn a cartoon face on the gun tower. Skip sat up in his seat and stared at the ship. Yes, I see it—Sir Astor, I said. Skip kept staring at the grinning face of the intergalactic space cat until it disappeared behind us.

I thought about what might have happened to the blind horse. Maybe a disease. Now and then my grandfather had taken care of a dog in Kingston with only one eye. Cody. A small furry thing; I can't remember what breed it was. It would walk into lampposts sometimes. He took care of it on the weekends. We used to go on walks with Cody around the artificial lake where all the mobile homes stood and where I once found a dead fish right on the trail. We would rent a pedal boat and eat at the Waffle Kitchen on the small island in the middle of the lake. There were big carp in the lake, tame and fat from all the campers feeding them leftover waffles. The fat carp would come up to the boat, and Cody would bark at them.

There was a neurograph game in the restaurant, a coin-operated thing that no one ever used. The machine had a screen with a live feed of what was happening, and when no one played it just showed a video feed from the arena the machine was connected to. I would stand there with the small one-eyed dog in my arms and watch the video, wishing I could play.

I saw Cody for the last time at my grandfather's funeral.

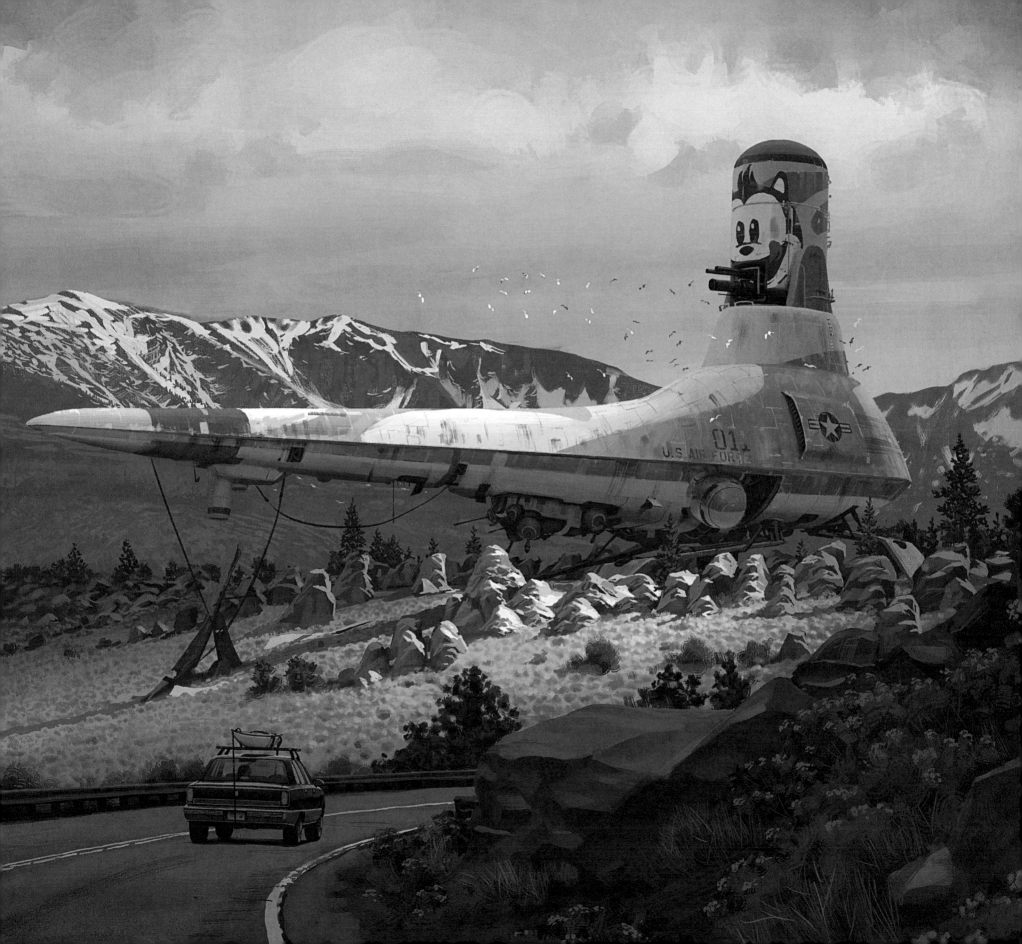

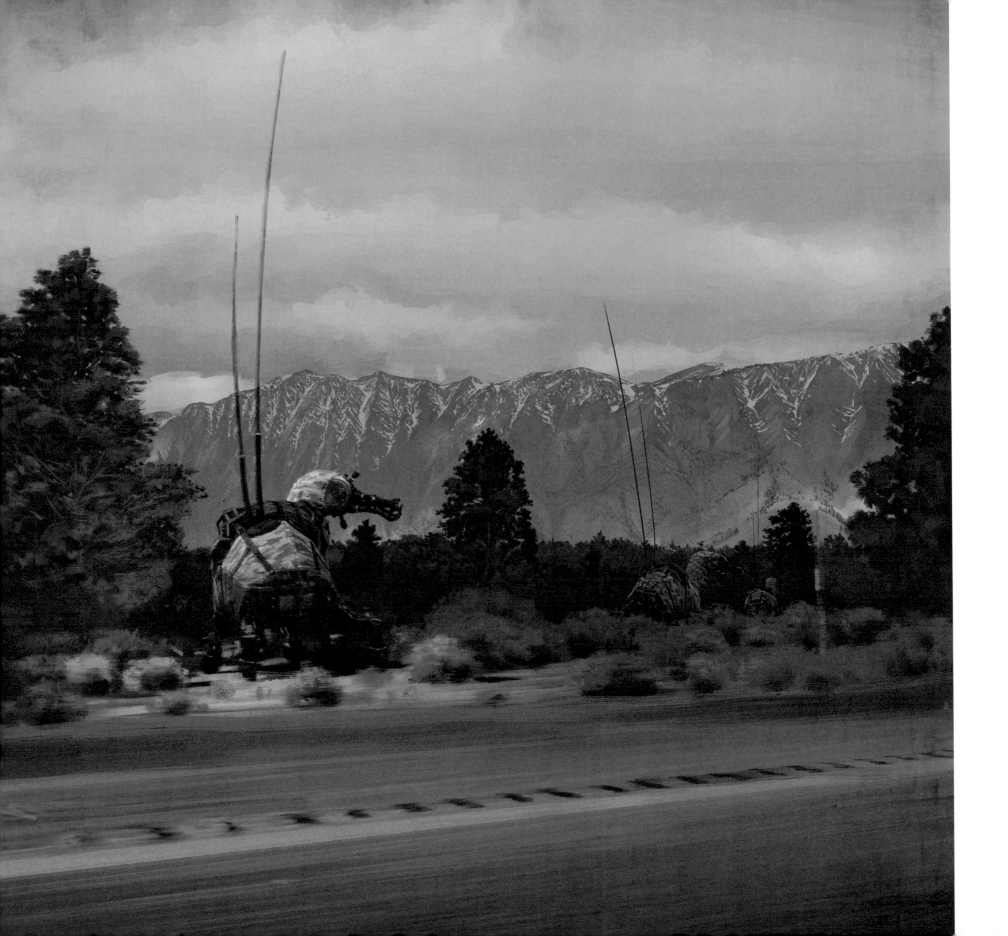

THE ROAD FOUGHT its way over the ridge into the next empty valley, where a sign informed us we were passing into a military restricted zone. Skip had fallen asleep, and remote-operated machines moved around out there in the valley, their long radio masts waving like antennae above the underbrush as they worked their way across the rocky terrain.

My grandfather always made my bed in a special way. He sort of tucked in a pillow under the sheets, then a regular pillow on top of it. Then he had a top sheet with a lace edge that he folded over the duvet. He was very particular about how things looked in his home.

I lived with my grandfather in Kingston for three years. That city reeked of some substance that spewed from the smokestacks at the shipyards, all day and all night. They built suspension ships in Kingston. Just like all the other older men in town, my grandfather had worked in the yards, and just like so many of the yard workers, he walked around coughing all the time. At night I lay in bed listening to his wheezing breath in the bathroom and couldn't go back to sleep until I heard him snoring in his bedroom again. His coughing got worse in the last year I lived there, and one night we were playing chess in the kitchen when he coughed until he couldn't breathe and fell down across the chessboard, scattering the chess pieces everywhere. Two months later I was living with Ted and Birgitte in Soest.

ROUTE 88 TOOK US higher and higher along the Carson Pass, and my ears popped. The mountainsides were patterned with large slabs of snow, and the road was bordered by heaps of snow so dirty they were hard to distinguish from the gravel. Somewhere far away I glimpsed a huge smiling face—an advertisement that winked into and out of view and disappeared behind the trees. Power lines cut across the sky above us, and when we rounded a bend we saw that the lines shot out of a massive spherical building rising from the woods on the side of the mountain. Steam and water poured out between the ragged tree trunks, forming streams that ran down the wooded slope and across the road. On the side of the building there was a Sentre ad, and I assumed the whole installation must have been theirs. I guess there must have been millions of minds bouncing around inside that thing, and the power required to please them melted the snow.

Someone should really heave those installations from their foundations and let them roll down the mountains into the suburbs, where they could crush whatever was left of all the gardens, houses, and responsible mothers and fathers and their SUVs and finally lay themselves calmly to rest in the abandoned city centers as memorials to humankind.

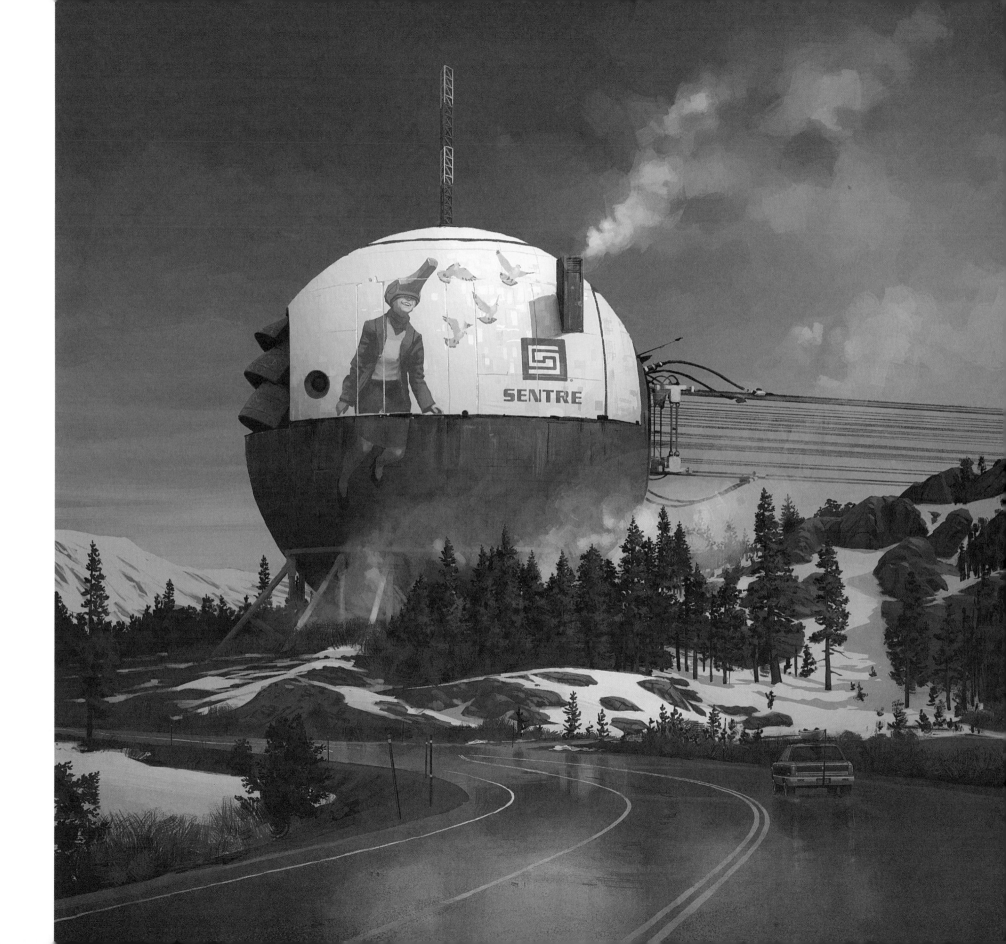

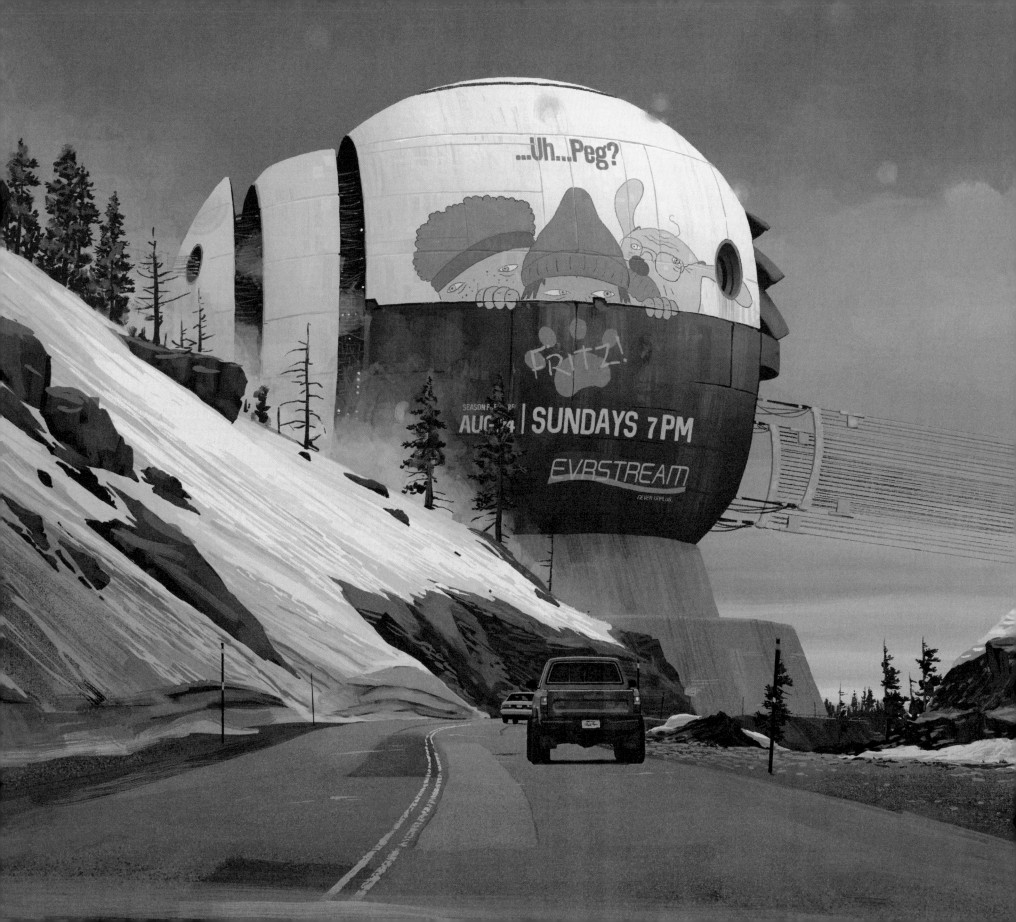

WHEN DID IT ALL START? I can't really remember. It started like any recreational activity, I guess. Like TV. Sometimes they watched TV, and sometimes they sat there wearing their neurocasters. I didn't care. It was after the big update of 1996 that things got weird. Mode Six.

After that they rarely watched TV anymore. The house was quieter. I remember that sometimes when Amanda and I came home from school, Ted and Birgitte were still on the couch in the living room with their neurocasters on. They were completely out of it, and one night we amused ourselves by dressing them up. Amanda painted a mustache on Birgitte.

On the weekends they slept in late, and I tried to bring it up when we were all in the kitchen together for once. I asked what the deal was with the casters. They didn't seem particularly worried and answered that there had been an awful lot of caster time lately. Ted patted my cheek and said:

Good thinking, Michelle. We have to watch out for you!

Then he pinched my nose and made a honking sound.

ANOTHER TIME, Ted tried to explain why so many of his T-shirts and shirts were stained across the chest:

> *It's not dangerous at all; it can happen to some people, and it's completely normal and harmless. Lactation is more common among men than you would think. It's called galactorrhea, and it's perfectly harmless. All the washing is a pain, though!*

Ted was in the corner of his home office later. He leaned back in his chair with the neurocaster on, wearing nothing but underwear. His mouth moved beneath the horn of the caster, and the corners of his lips twitched. I had to restart the modem because it had frozen, and when I leaned across the desk I noticed a small drop materializing on the desktop, right in the middle of the light cast by the lamp. And another. Then one landed on my arm. I thought it was saliva at first, that Ted had accidentally blown a few drops of saliva from his mouth, but then I saw something running down his stomach and chest—a white, milky fluid that flowed in little silent squirts from his trembling nipples.

Outside the car, yellow service robots moved, hauling massive cable rollers. They waddled like slow turtles across the road, following the conduits of the neurograph network through the ragged alpine trees.

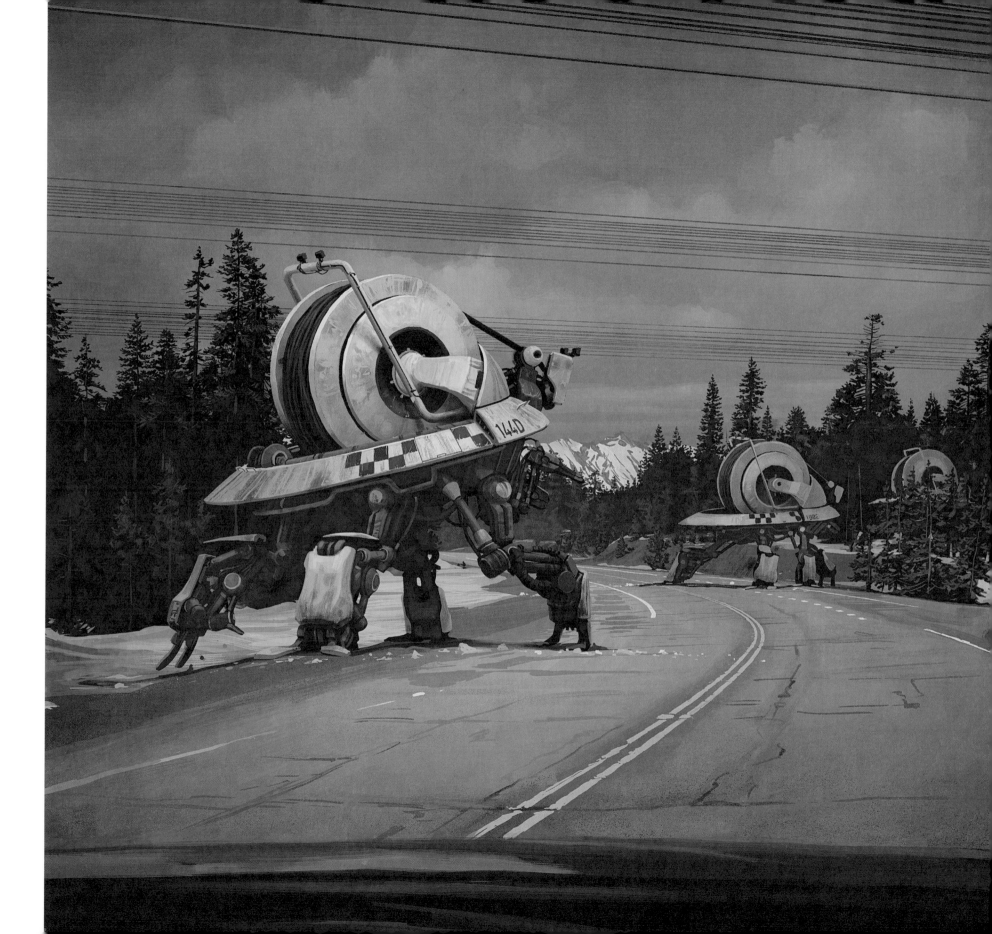

WE FINALLY MANAGED to get gas at Cook Station, and I took the opportunity to buy extra cans of gas to put in the trunk of the car. The restaurant was closed, but I bought a sandwich, beef jerky, and a few cans of soda in the store. The sun came out and we sat out back, and I ate my sandwich and gave Skip pieces of bread, and he ran around trying to feed the local chipmunks. You have contracted Chipmunkiosis, I said. After a while he sat down and put his head on my shoulder. Are you tired, I asked. Skip nodded.

Me too. We can rest for a while.

I woke up when it started raining again. Skip was standing farther away on the gravel lot, looking at something out in the woods. When I walked up to him I saw what had caught his attention. A dog stood between two tree trunks, a lonely little white chihuahua. It was wearing a tiny coat and was trembling and looking at us with its ears pointing straight up. Come on, Skip, I said. Come on, let's go. I grabbed his hand and we walked back to the car.

In the beginning, God created the neuron, and when electricity flowed through the three-dimensional nerve cell matrix in the brain, there was consciousness. The more nerve cells the better, and our brains contain hundreds of billions of neurons; that's why we make better lasagna than chimpanzees. Like I said, no one really understands how all this works. The progress made in neuronics in the 1960s all had to do with our ability to read, copy, and send information into the brain, and the biggest discovery was how to send all that data between pilot and drone without latency. Neuronics was never really about our understanding of the mind. It's basically a cut-and-paste technology, developed to create a suitable user interface for the advanced robots that were built by the federal army in the early '70s. An advanced joystick, basically.

So, if the human intellect forms in the interaction among one hundred billion brain cells, what would happen if you connected them to a few hundred billion more? Would it be possible on a neuronic level to link two or more brains? If so, what type of consciousness could emerge from such a vastly bigger neural matrix?

There are those who believe that such a hive mind took shape inside the military neurograph network during the war, as a side effect of an unbelievable number of nerve cells linked to one another. An Intercerebral Intelligence, they call it. The same people also believe that this higher consciousness is trying to take physical form by influencing the reproductive cycles of the drone pilots. In that case, it was responsible for all the stillbirths during the war.

They call themselves the Convergence. I would probably have dismissed them as yet another new-age techno cult if I hadn't seen what I saw moving across the snow on Charlton Island seventeen years ago.

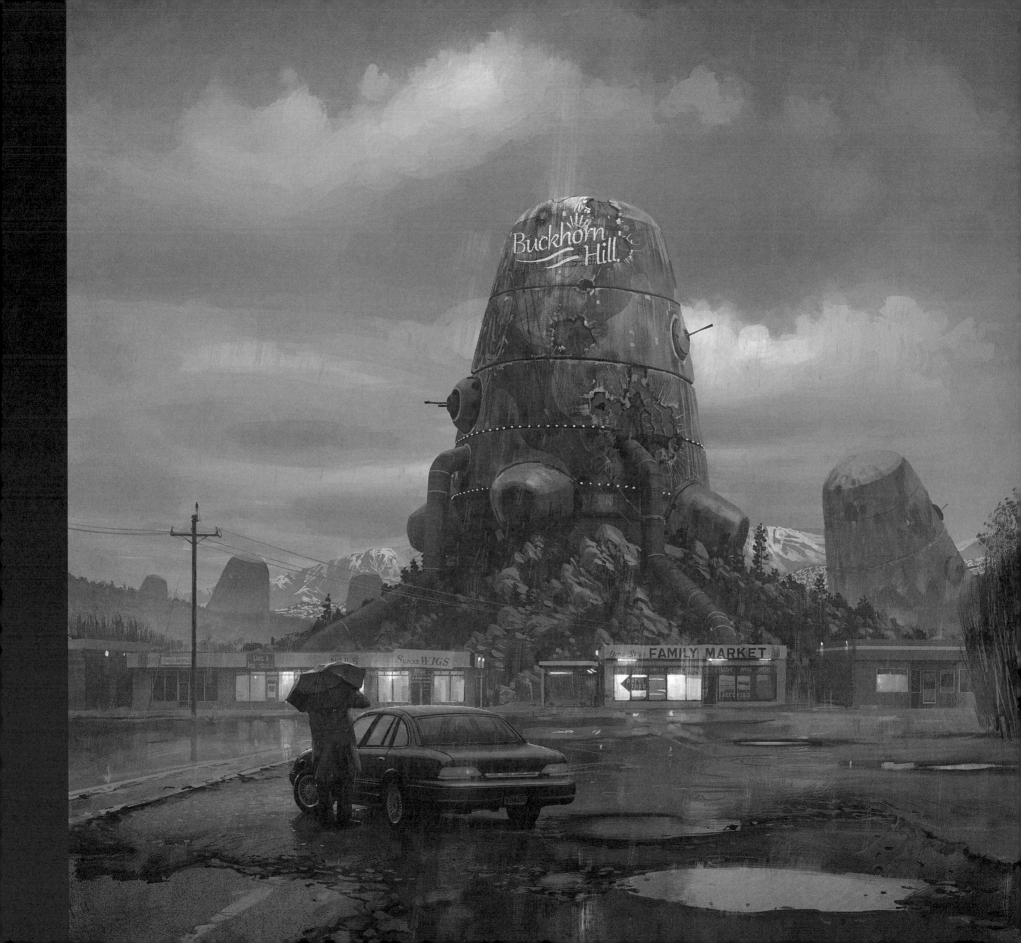

THE CENTRAL VALLEY

ROUTE 88 FINALLY took us down from the mountains, and we approached the fine mesh of the civilized and structured road system. On the surface it appeared as if the world on this side of the mountains hadn't stopped yet. Cars and people moved in a slow stream below the red signal lights of the neurograph towers, seemingly in the middle of their daily routines, as yet untouched by the chain reaction that had started far inland. It didn't make me feel any better at all. I preferred it when the police and curious people were distracted by other things. Technically, I had stolen the car as well as the shotgun; if we were stopped, it was over. I avoided the highways and tried to stay away from the larger communities for as long as possible, but it was hard down here. The cars crowded in and bunched up, and panic grew inside me: Someone is going to see us, someone is definitely going to see us, and the police will stop us. We can't do this—we have to get off the road.

My first thought was that we should park somewhere private and just wait in the car, but it occurred to me that the police love disturbing people sitting in parked cars. Our second option was to check into a motel, but that was expensive and we didn't have that much money left, and, worst case, they would want to see some ID. Down here where there was a semblance of law and order, I didn't want to attract any attention. It didn't feel good at all; we were so close now.

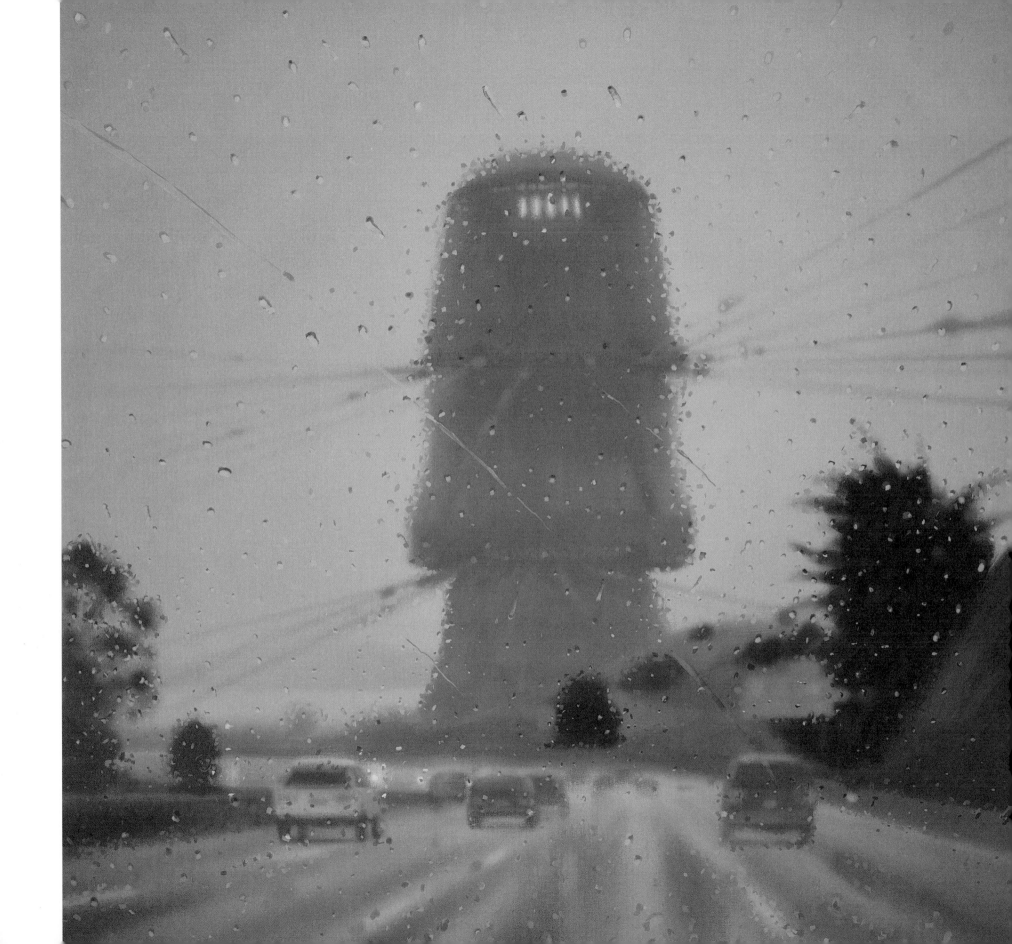

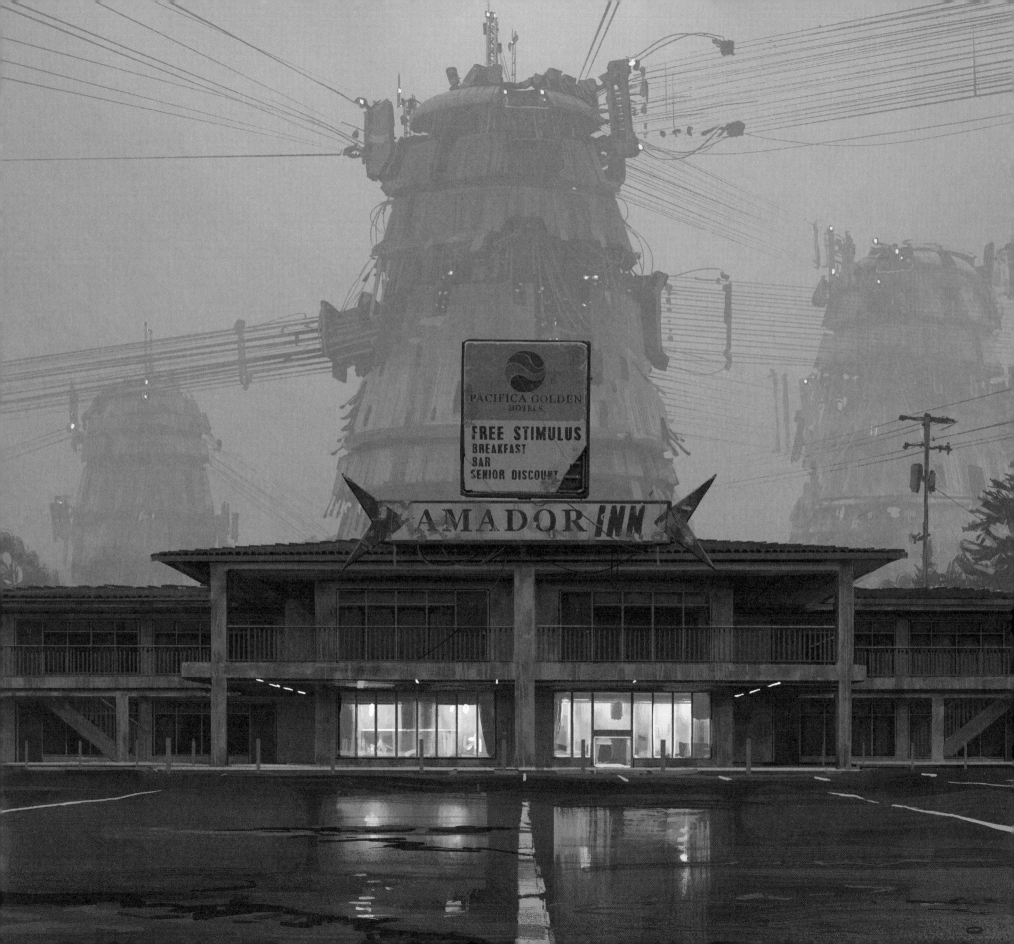

FINALLY, WE STOPPED at a little motel in a small town called Martell. They didn't ask for ID. They didn't ask about anything at all; the man behind the counter didn't seem happy to interrupt whatever it was he was doing in his neurocaster, and as soon as I took the key from him he pulled the caster back down over his face and faded away.

Nothing worked in the room; the TV showed nothing but static, and the AC was broken. Night had already fallen, and we didn't have many hours before we had to keep going. Skip sat motionless on the floor with his toys lined up in front of him, his head hanging down. Skip, you sleepyhead, I said.

Pick up your toys and sit in the armchair. I don't want to trip over you in the dark.

I set the alarm on the clock radio to three in the morning, and then I threw myself onto the covers and fell asleep.

The wooden floor of the patio had been stained with water. Birgitte's cardigan was lying in the grass like a lemon-yellow lump. I turned the lights on and stood by the edge of the pool, looking down into the water. The surface was completely still; fuzzy pieces of potato chips swirled down there, and Birgitte was on the bottom, her waterlogged body heavy like a marble statue against the tiles, the LEDs on her neurocaster still burning like glowing embers. There was something going on with her mouth. It moved like the mouth of someone dreaming, and it didn't stop moving until later, when Ted took the neurocaster off and she finally died.

I CARRIED SKIP to the car. I had been forced to open the little hatch in the back of his head to read the display in there just to make sure he was still online. I don't know—he had been cold to the touch.

When we hit the road again, it was pitch-black, and the images in my head felt more real than the world outside the car. Birgitte's eyes had been grayish, looking for something that had just been pulled away. How long had she been there at the bottom of the pool? Hours? She had vomited all the water from her body onto the couch, and then she had curled up, lifeless. Ted sat on the floor, dazed and heartbroken, with her wet body in his lap, holding her arms like he was playing with a doll. When the paramedics had taken her away, he sat down on the couch for a while. Red, empty eyes. Then he had put his neurocaster on and leaned back into the cushions.

The sky was vaguely bluish, and out there in the morning light we passed a never-ending stream of small towns and suburbs. Finally we reached a city bisected by a large, six-lane highway; we turned west on a small country road called Bodega Avenue, and soon we had left civilization behind. Out in the fields, glimmering neurocasters appeared out of the darkness. Exhausted, they wandered in long lines, and I slowed down. Some of them stopped and sniffed after us when the car drove by. During the last weeks in Soest I had been awakened early in the mornings by similar crowds, shuffling along the streets in confusion—uneasy nocturnal animals on their way back to their dens and burrows in the suburbs.

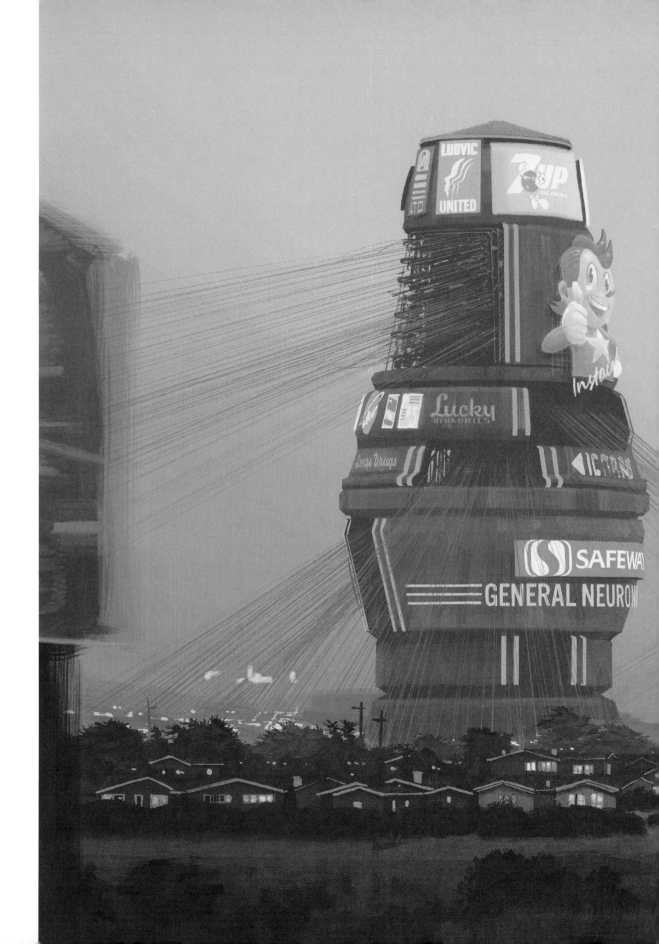

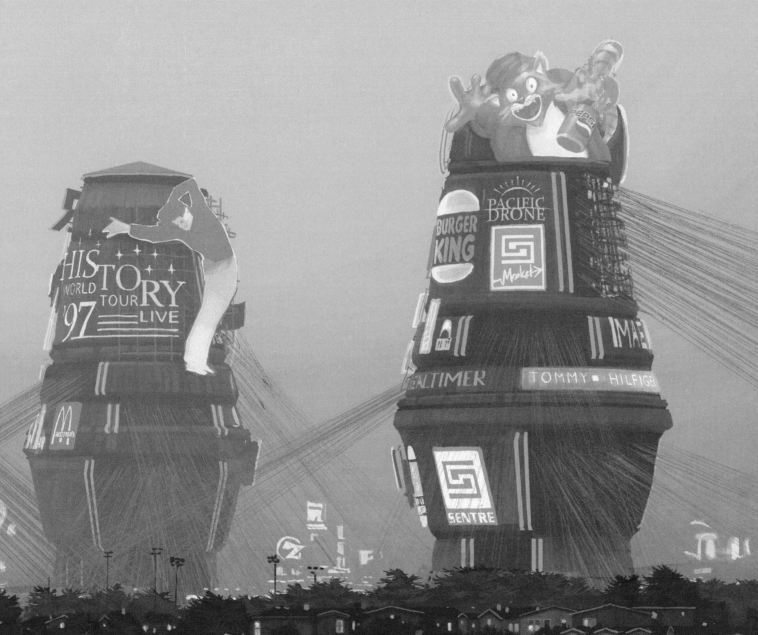

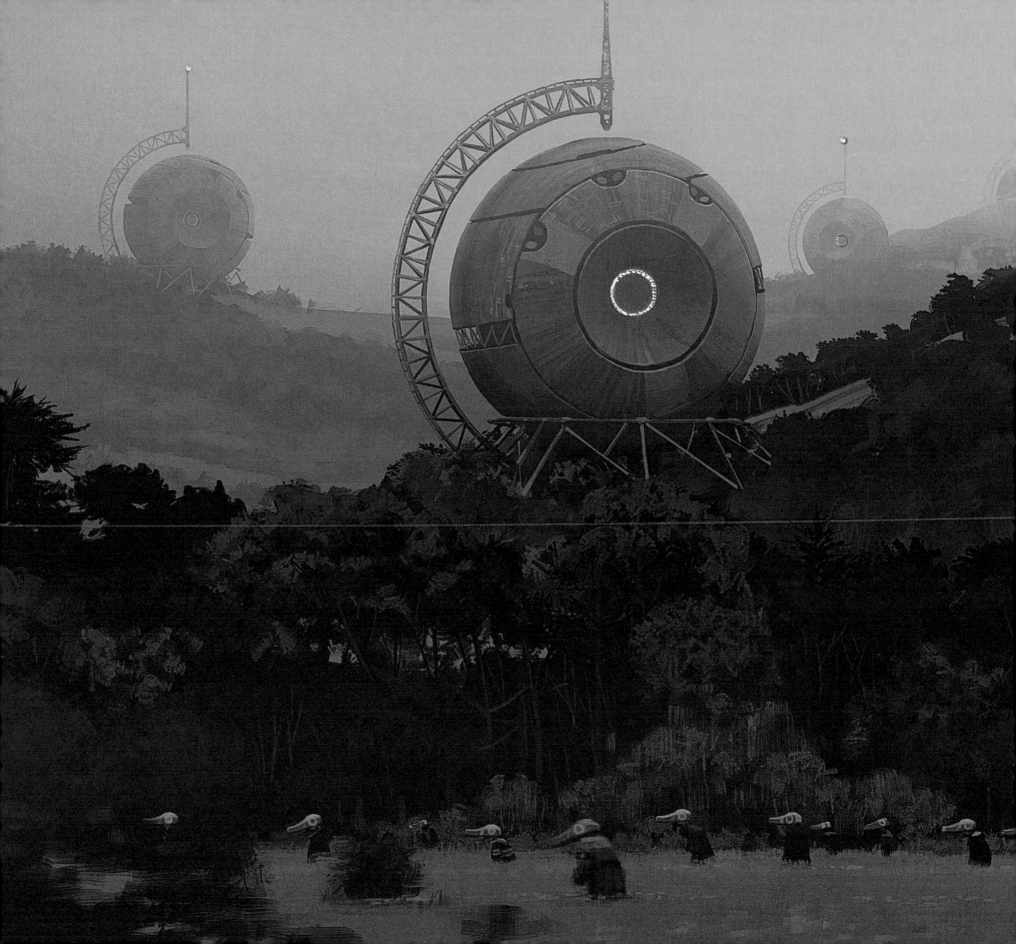

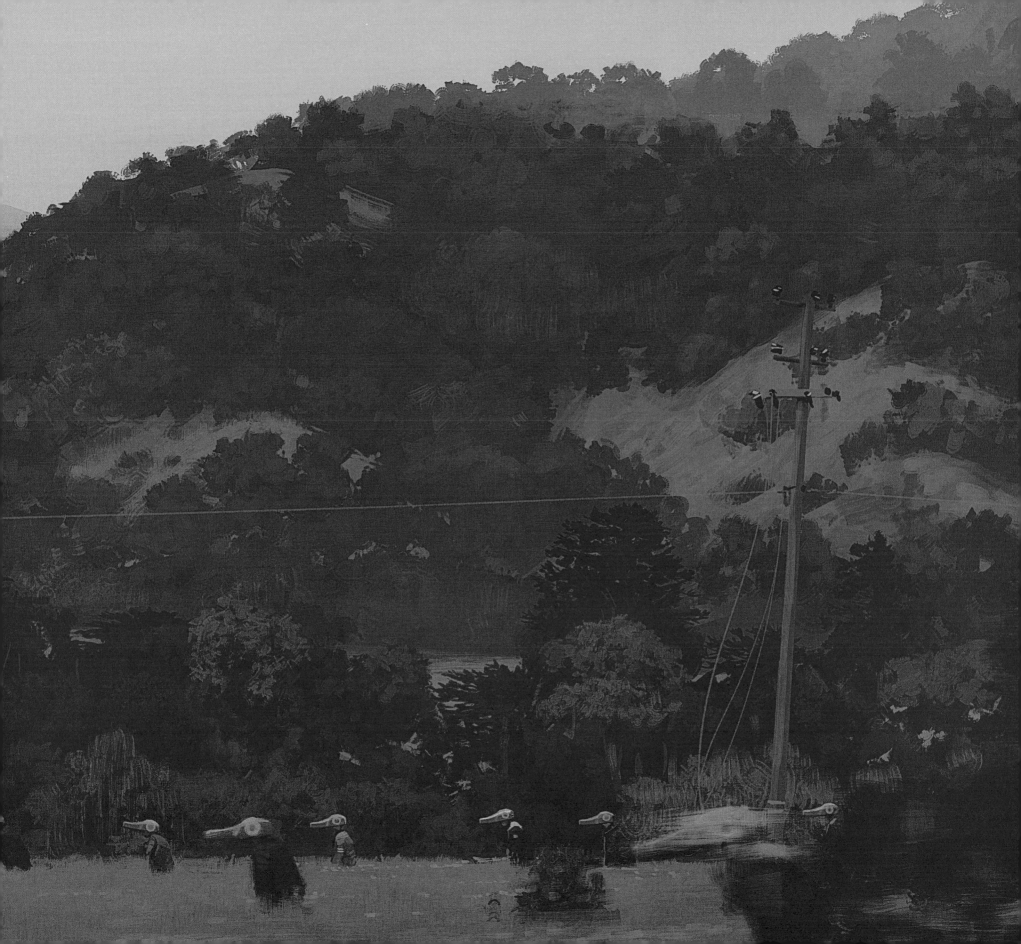

THE COAST

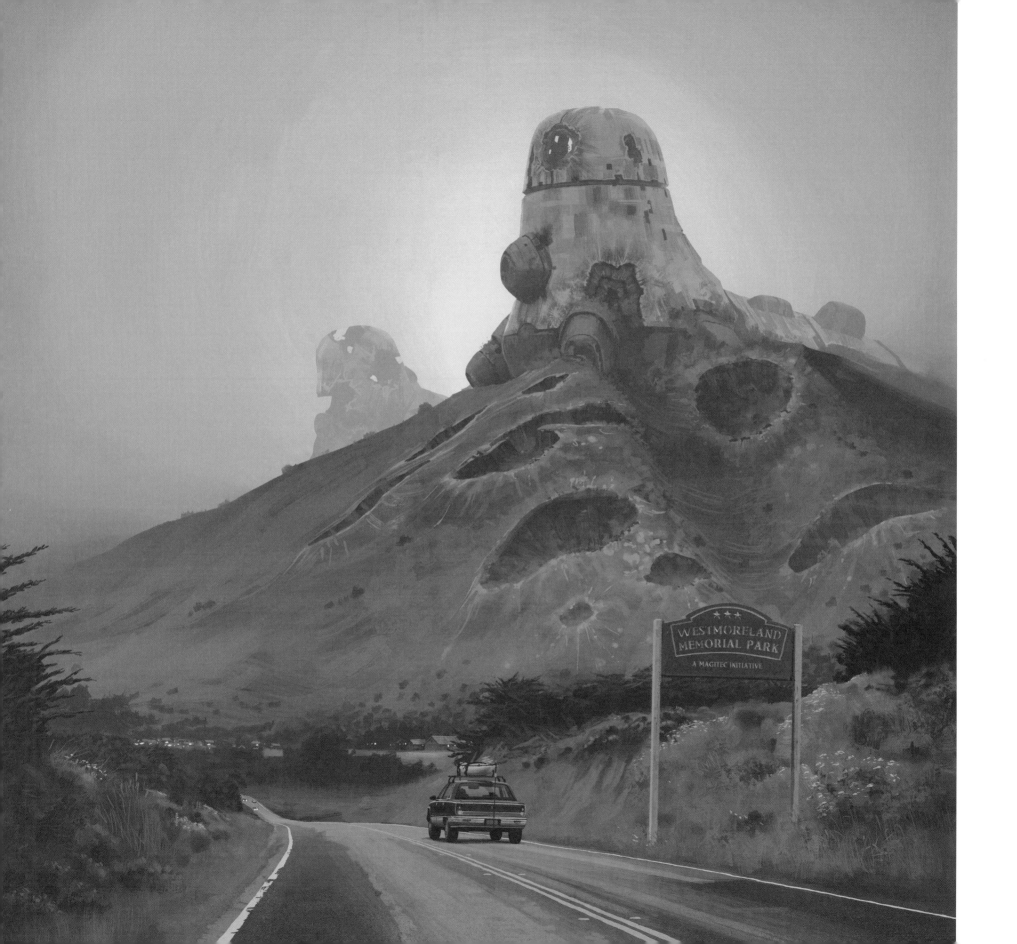

THE LANDSCAPE HAD GROWN more rugged and shrouded in haze. Cloud banks from the ocean came sweeping in over the hills to cover the road, and the windows were covered with a fine mist of water.

A few miles before Tomales we drove through something called Westmoreland Memorial Park, which seemed to be some kind of war memorial, where two enormous lode ships rose from the mists high up on a hill ravaged by bombs. As we came closer I saw vehicles parked in the craters, and there were small walkways and footbridges all over the area and up around the ships, and I remembered a discussion we'd had in class once about the bombed-out ships at Folwell's Memorial Park in Soest City. Half the class was certain that the ships were merely replicas, while the other half was just as certain the actual ships were in the park.

When we reached the coastal road, lack of sleep caught up with me and I stopped at a rest stop. I turned the engine off and took my map out. Below the rest stop, a boggy mud bed reached out toward what looked like a shallow lake, and on the other side of the lake a ridge rose up. I assumed the lake was the bay marked as Bodega Bay on the map, and that the ridge on the other side was part of Cape Victory. We probably had only half an hour's drive south before we reached Dunne's Landing, where we would turn right onto a smaller road that would take us all the way out along Cape Victory to Point Linden.

Skip was awake now, and he sat looking at something on the other side of the water. He pointed toward the ridge, and up there on a crest stood a single dead tree. Do you know this place? I asked. Skip nodded.

You've been here before, right?

He nodded eagerly and looked back and forth between me and the tree. He was almost jumping up and down in his seat.

It's okay, Skip. Take out your Walkman; you can listen to Kid Kosmo. It's not far now. I just have to rest for a while.

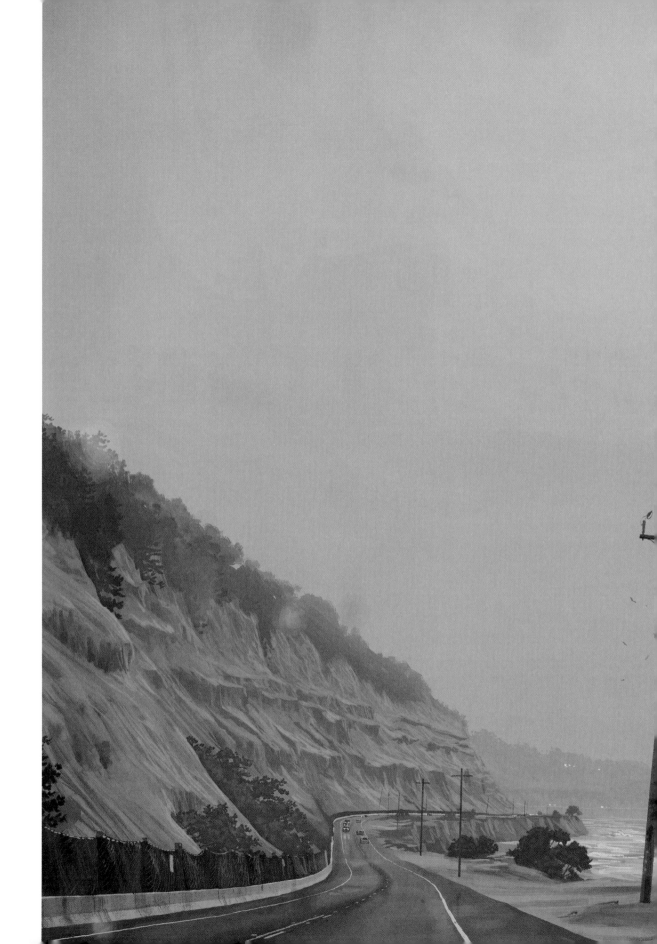

I DON'T KNOW how long I slept. Maybe an hour. Skip sat with his headphones on, still spellbound, of course. I tapped his shoulder. Hey, we can keep listening on the car stereo if you want to. Skip looked at me and heard nothing. I pointed at the car stereo. Skip took the tape out of the Walkman and pushed it into the stereo. I put the map back in my bag, adjusted my seat, and drove out onto the road again.

Three assault ships occupied the far end of the bay. Once upon a time, these kinds of ships had been the pride of the federal army, and they had been lined up on the runways where their captains had shaken the hands of presidents before thousands of spectators. Now, here they were, plucked out of the sky, hollowed out and chewed up by the sea, and finally back in service as cliffs for birds to roost on. Behold the Amphion, the pride of the air force: ten million tons of rust and bird shit.

It was the neuronics in the Amphion ships that had burned out my mother's mind, so I guess it was fitting, in a way.

Dunne's Landing was just ahead of us, not much more than a jumble of boarded-up shops and a crossroads. We turned right onto San Augustin Boulevard, a cracked country road full of potholes. It immediately led us out of the small town and farther out on the cape.

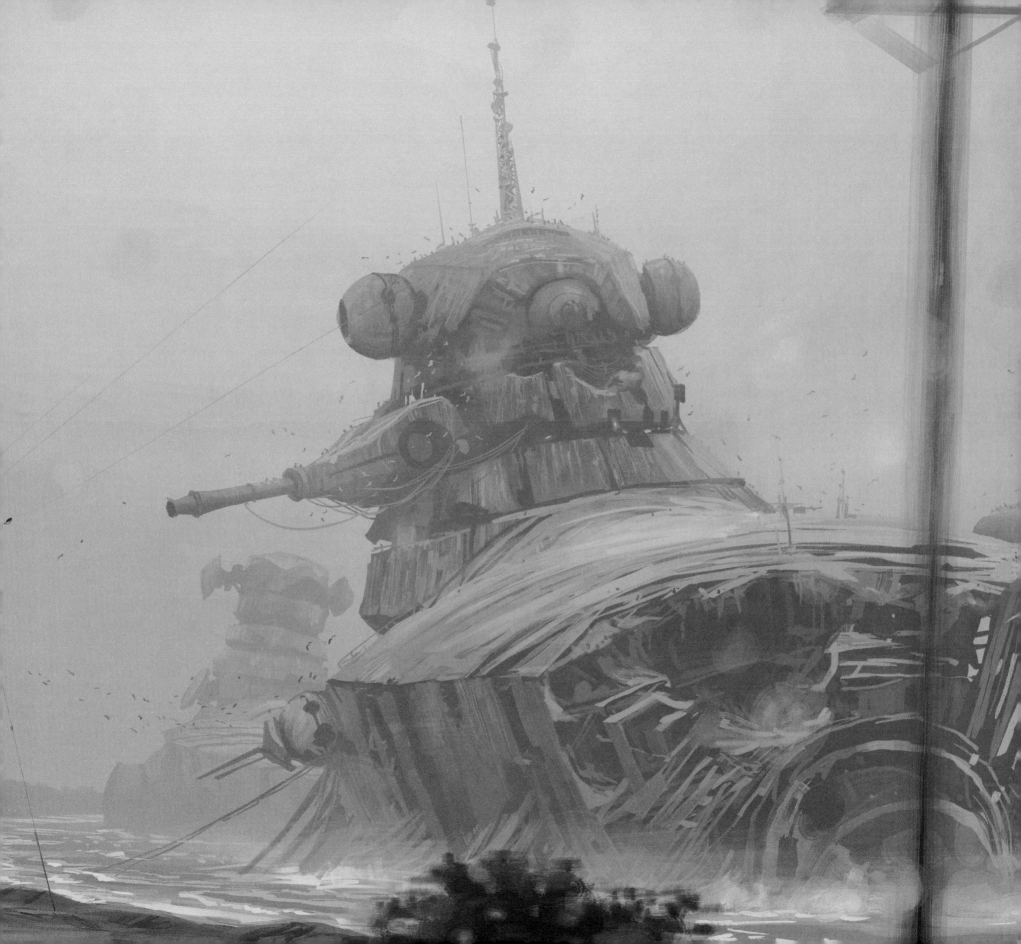

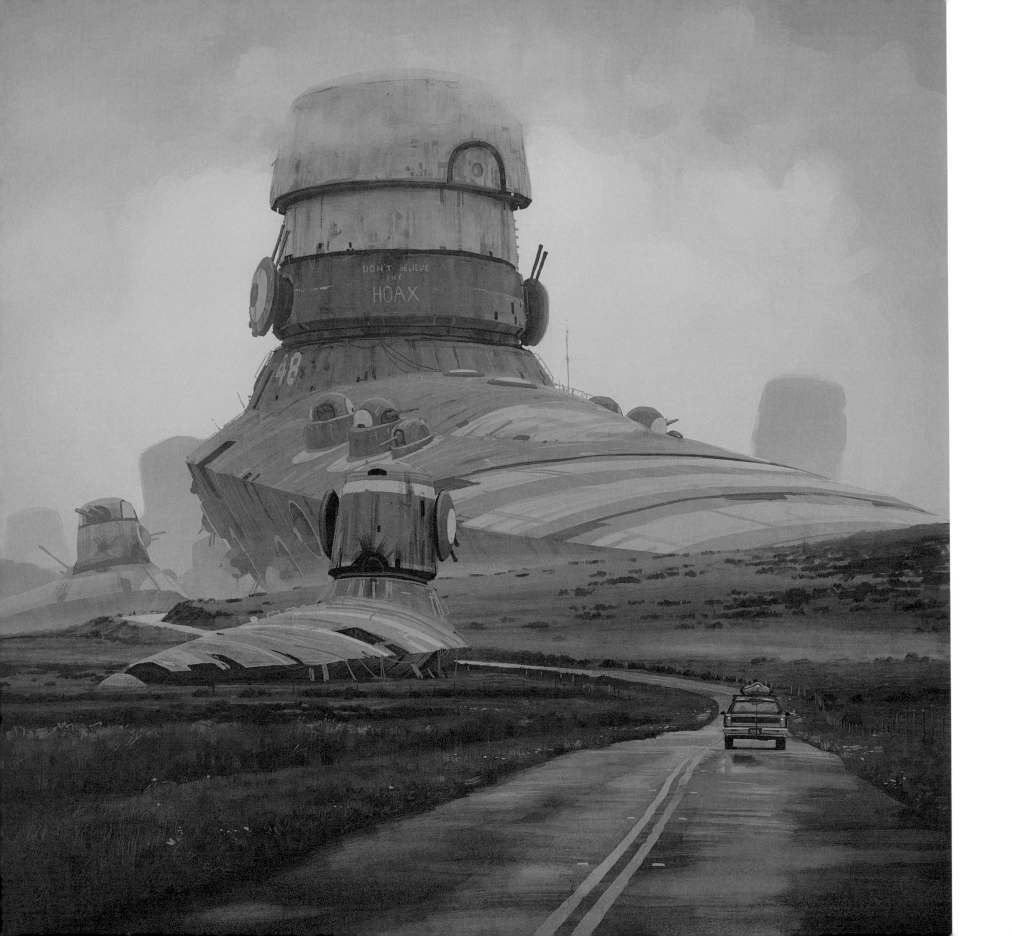

ALL OF CAPE VICTORY was an endless boneyard. On the map, a small area in the inner part of the bay was marked as San Augustin Salvage Yard, but there were wrecks everywhere. After each turn a new vista of never-ending rows of old suspension ships and combat drones opened up. Some were scarred by combat, while others seemed to have been left more or less intact—but everywhere across the ships there were traces of scrappers. The hulls were open and mutilated, parts where plating and equipment had been stripped. Some ships were almost completely gutted, with only the frame remaining on the grass, devoid of innards like a fish skeleton.

And I grew up like this. Jesus Christ, poor kid. Goddamn mother. Let's see. Could I remember the names of those ships? Amphions, of course; the big ships carrying smaller ships inside. What was the name of those smaller ships? Pentheus F something. The neuronics in the control chambers of the Pentheus ships were easy to access, especially for someone as small as me. The black cables with the yellow couplings were what you were looking for. Then there were the small assault ships—Autesions, they were called. According to my mother, my father had flown an Autesion ship at the Battle of Boise. The Autesion ships were gold to scrappers. Inside the control chambers there were panels with hatches marked with yellow stickers, and below the hatches there were rods you could pull out, and inside the rods there were a bunch of plastic filters you could remove by pushing a pen into a small hole on the side of the rod so it came apart in two pieces. If you were lucky, those filters were sticky with neurite.

WE CRESTED ANOTHER HILL, and on the other side there were cows grazing around the wrecks. It looked really peaceful, but there were dead cows farther down the road, badly decomposed, almost like mummies. Some of the carcasses seemed to be moving, but it was actually the dark backs of scavenger birds that had gathered to eat, and when we drove by they took flight, scattering on the wind like strange dandelion seeds. I followed the flock in the rearview mirror. It floated around like an amoeba in the air above the dead cows, broke apart, and then flowed back together.

I had lived in three different towns and attended four different schools by the time I started fifth grade. I had friends, now and then. It depended on how my mother was feeling and where we could park our RV. When the others went home to their families and their pep rallies and ice rinks and jamborees, I was busy helping my mother ingest the chemicals her body and country no longer supplied her with.

When I started at a new school, the school bus always had to change its route and drive through areas that none of the other children had ever seen. That was my gift to my new classmates. Kids weren't supposed to have a reason to get off the bus where we lived.

In the mist in the graveyards, abominable homemade drones moved. They waddled along with their bags and bundles of cables, and I looked at them and realized that this horrible place reminded me of my mother, and I was filled with something that might be called nostalgia and thought about how you have the memories you have. The scrappers looked up as we passed. I guess not many cars passed by here anymore.

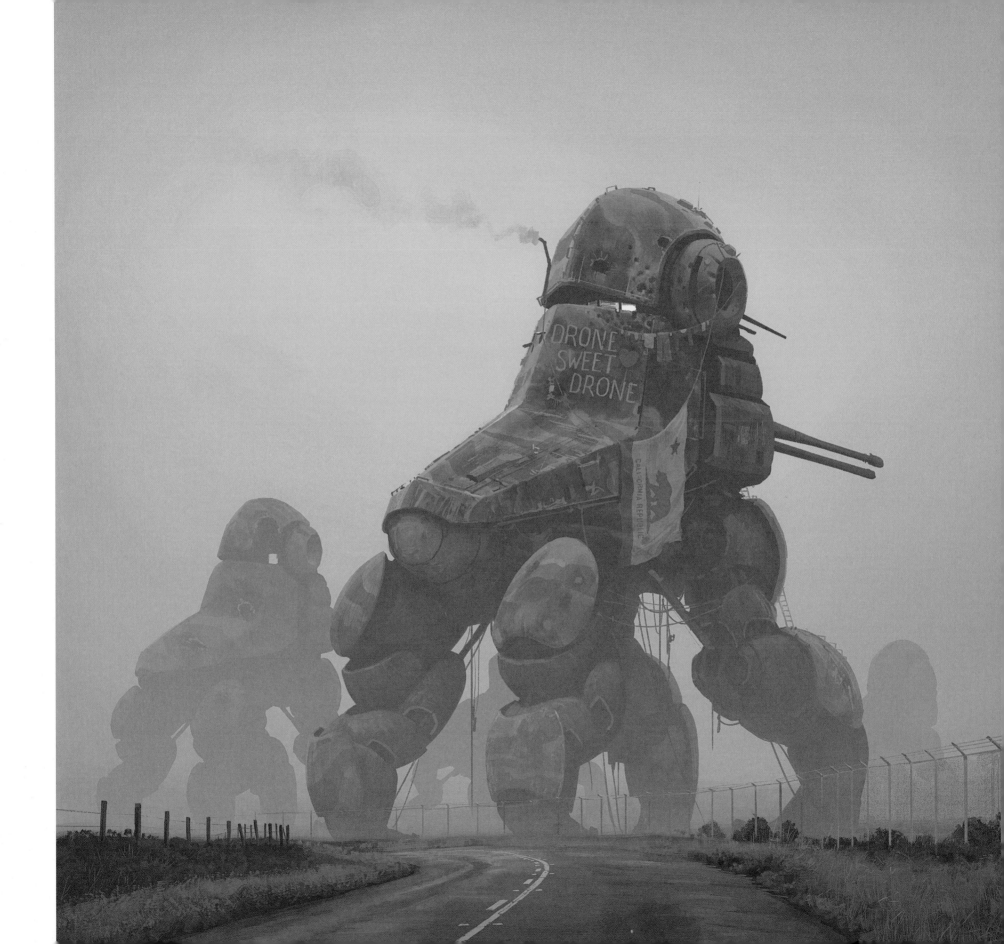

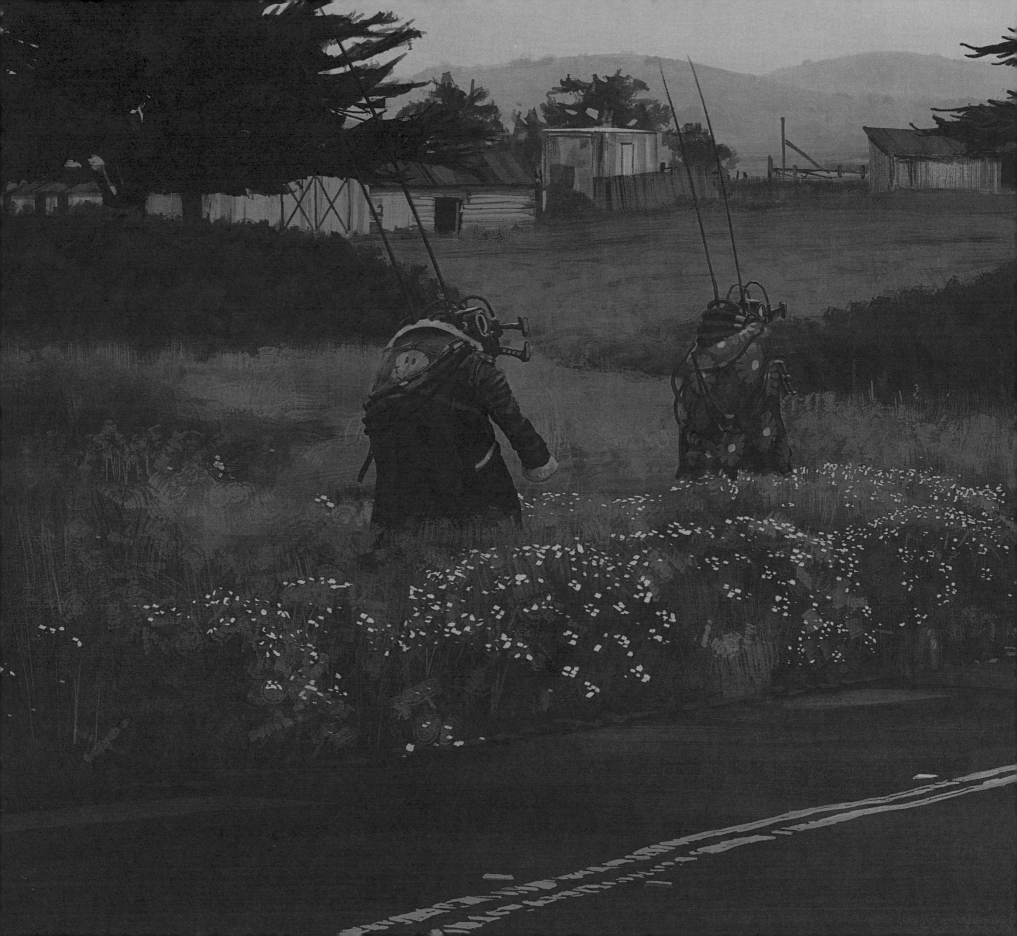

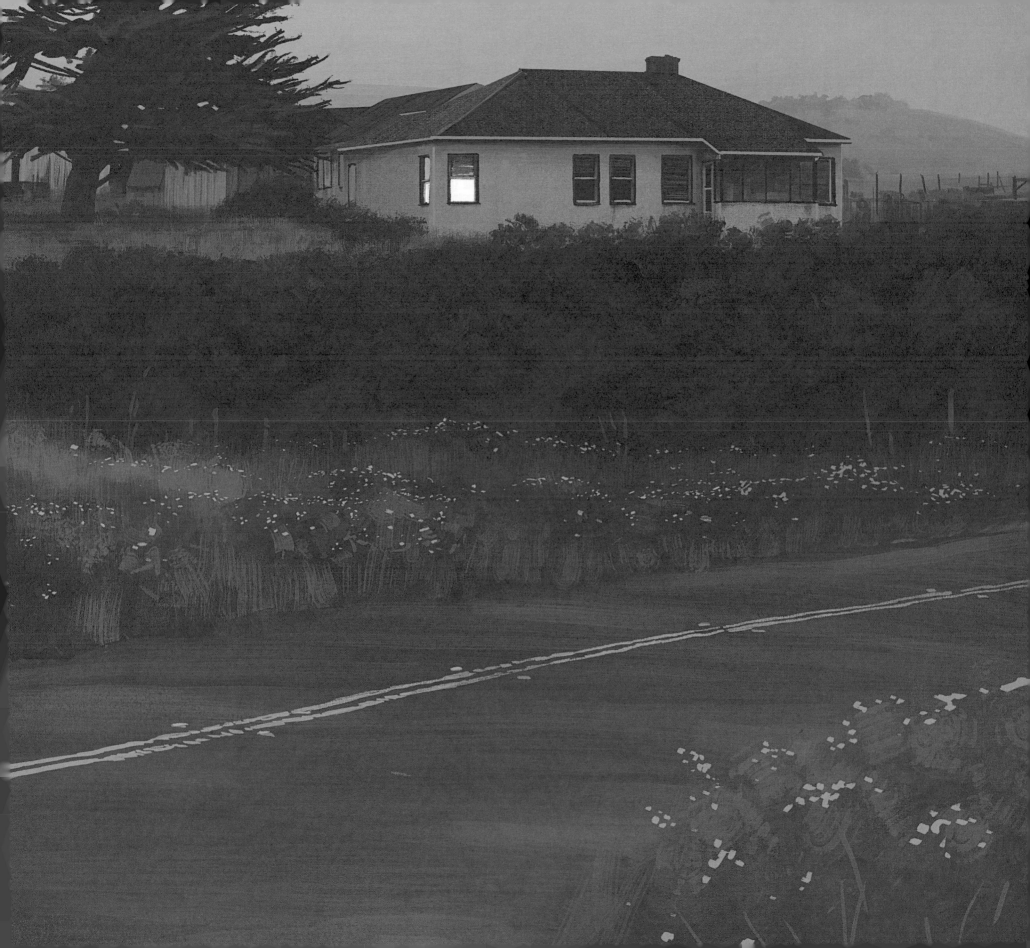

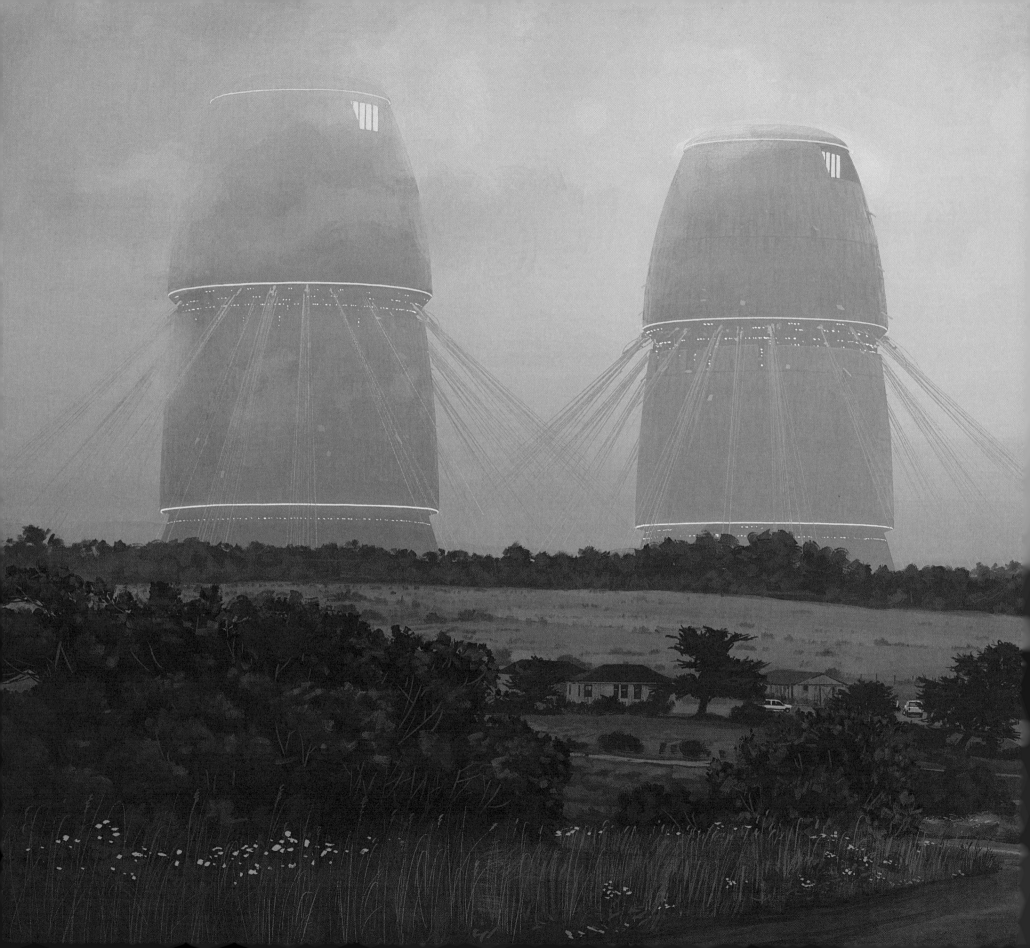

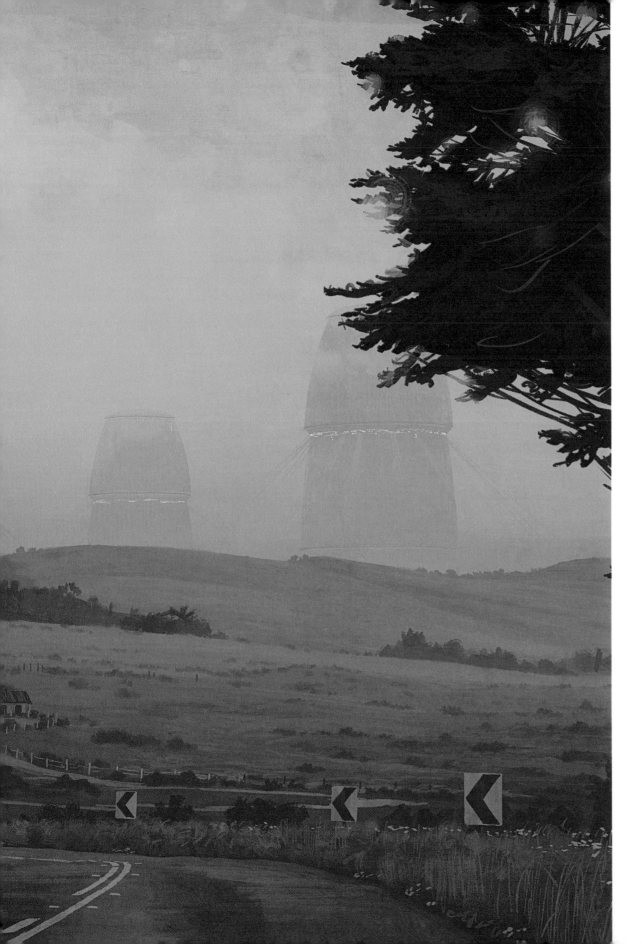

I USED TO TRY to avoid thinking about my mother, but now I was struck by how easy it was. It was as if I had passed some invisible borderline, and what used to be an open wound inside had finally hardened. There was still a pit there, sunken and covered in scar tissue like on people who've had their mangled faces reconstructed after an accident, but you could touch the scar without the pain searing through your body.

The time after that, in Kingston, was awful. I thought about my mother all the time. During the first period at my new school I started bawling, and everyone in the class looked at me and I put my head under the lid of the desk. It must have looked funny, I realized when I stopped to think about it. Confused silence smothered the classroom, and our teacher had to explain to the other kids that Michelle was going through a rough time in life right now, and then my grandfather had to come get me.

At some point, when I was about ten, I decided to lock up all the memories of my mother and not talk about her with anyone, and I managed to do that until one night in Soest six years later, when I suddenly told Amanda everything in an empty playground. We had been sitting in the net up on the jungle gym, and my head was in her lap. It was fall, and she was wearing knitted fingerless mittens and caressing my forehead. The gloves were gray, with snowflakes on them. She wore those gloves all winter, and then in the spring she moved.

ANOTHER THING about Amanda before I forget: her father showed up at our house much later, probably a year after Amanda moved away. Ernest Henry. Yes, that was his actual name. Father Ernest Henry. The Reverend. We never really talked, but he remembered me from Amanda's class. He asked if he could talk to one of the adults in the household, and I showed him into our living room.

This was after Birgitte's death, and Ted was sitting on the couch, wearing the neurocaster, completely naked. This time I hadn't even bothered to cover him up when I came home from school. The Reverend turned to me and said that maybe it was better if he talked to me instead.

We sat in the kitchen. The Reverend held his coffee cup and said he felt great concern about what was happening in Soest. He suspected that there was some sort of signal coming through on the neurographic network that made people sick and destroyed their will and turned them into slaves. The Reverend believed this signal was Satan and that Satan was luring people away from the path of God through the neurocasters, and in so doing was paving the way for the coming apocalypse. He had worried about the casters for a long time, and had tried to urge caution on his congregation: God gave us ears and eyes and mouths and bodies to rejoice in the world God created for us, and the promise of neuronics to move our minds to artificial bodies violated the will of God. The Reverend had started a movement that would help people fight off the addiction and, considering Ted out there in the living room, he thought it might be in my interest to join this movement.

Finally he asked me if I had ever been tempted to use a neurocaster.

I told him I couldn't use them, that the doctors said it was because of a congenital neurological condition that made one of my pupils larger than the other, and that also seemed to make it impossible for me to use neuronics. It was just black; nothing happened. The Reverend replied that I should be thankful for that. That God had protected me.

I focused my gaze on the small yellow packs of sweetener the Reverend tore open and emptied into his cup. He started stirring the coffee. When I asked him about Amanda, a smile of divine blessing spread across Father Ernest Henry's face, and he replied that Amanda's aunt and uncle had helped her find her way back to God and that it warmed his heart that she was still in my thoughts.

You were quite close, weren't you?

The monotonous noise of the Reverend's spoon meeting the porcelain cup over and over rose from the coffee and shot up against the ceiling and bounced off the walls where the silverfish contorted in pain and poured across the cereal and oats and instant waffle powder that collapsed inside their boxes and soon filled the entire kitchen, and I remembered the bruises the Reverend used to leave on his daughter's body and I looked away and said:

No. We didn't really know each other.

Something had appeared on the road in front of us: road work that had stalled—the workers were all lost in some new neuronic daydream.

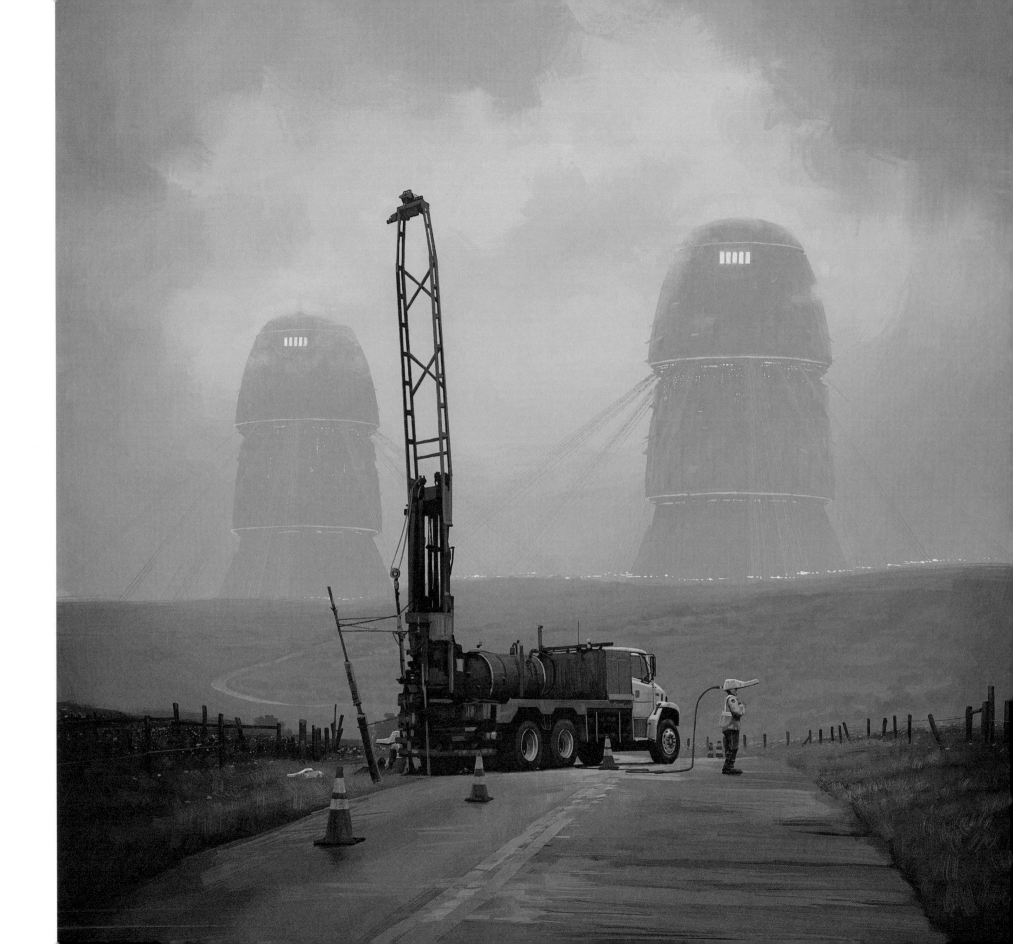

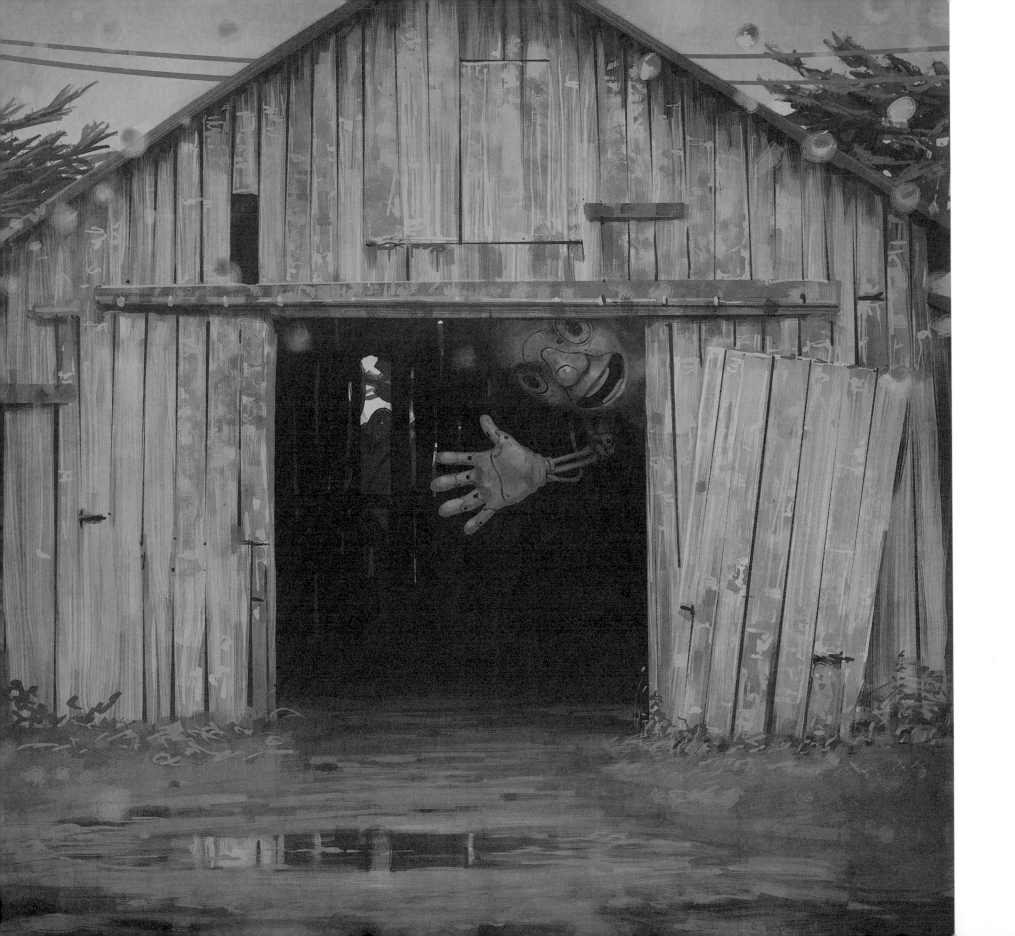

WOODEN BUILDINGS painted white, on both sides of the road. Shack, stable. White picket fence. A farm. The white wood was stained with moisture and looked like it had been attacked by algae, as if the buildings had been submerged in the sea until very recently. The road narrowed and passed one of those little bridges made from spaced-out metal bars that stop cattle from passing, and I had to slow down. In the paddocks stood boxes with dead calves inside. We passed a large barn on the right side, and in the darkness within I saw something. Movement. A smiling face. At first I thought it was just an old billboard that someone had put in there, but the face followed us with its eyes and raised its hand to wave. It was a drone there in the darkness. Skip turned his head and waved back cautiously, then looked at me. What was that thing doing in there? I didn't like it. I didn't like that it had seen us or the way it waved. Why did it wave?

There was something about this road. It felt like we were going toward a dead end. Technically we were; there were no other roads to or from Point Linden. Cape Victory was one big dead end. I tried to shake off my discomfort and kept my eyes on the barn in the rearview mirror. No. Nothing. The farm looked completely abandoned. From this side I could see that the main house had been on fire; the whole side facing us now was black, and parts of the roof were gone.

RIGHT OUTSIDE the town, two police cars were parked across the road. A roadblock.

I sat paralyzed and squeezed the wheel hard. After I slammed on the brakes, the car keys swung back and forth in the ignition, ticking like the hands of an old clock. I couldn't take my eyes off the police cars, and I waited for a crackling voice from a loudspeaker to start yelling at us at any second. I sat like that for several minutes until I finally opened the door and put one foot down on the asphalt. Skip threw himself at me and grabbed my arm. It's all right, Skip.

If we're nice, then they'll be nice.

I pried Skip's hard mechanical fingers from my sleeve and stepped out of the car. I was convinced it was all over and that I would never see Skip again. I would rot away in a cell in some forgotten police station after all the officers in Pacifica had abandoned their posts for one reason or another.

But it didn't happen. When I came up to the roadblock the cars were empty, and something was lying on the asphalt: a gun, and something that looked like spilled nickels. Empty shell casings.

Once I was back in the car I sat for a long while with my hand clenched around the car keys and caught my breath. I was shaking. Then I took a few deep breaths and looked at Skip.

Permission to activate the warp drive.

But my voice was quivering. Skip looked at me. Yeah, maybe that wasn't my best Sir Astor impression. He raised his hand to salute me.

Thank you, captain, I said, and turned the key.

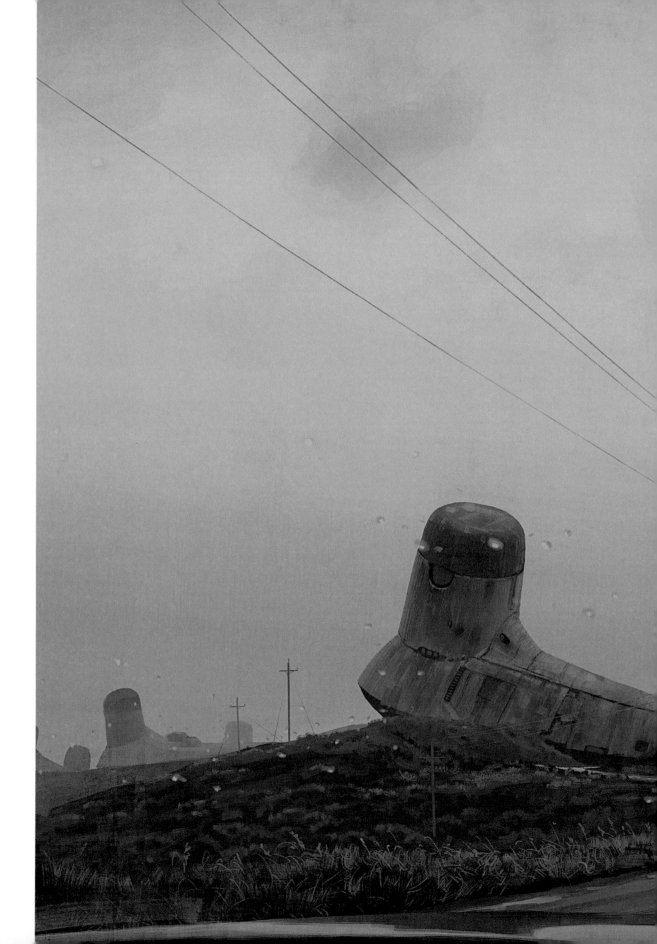

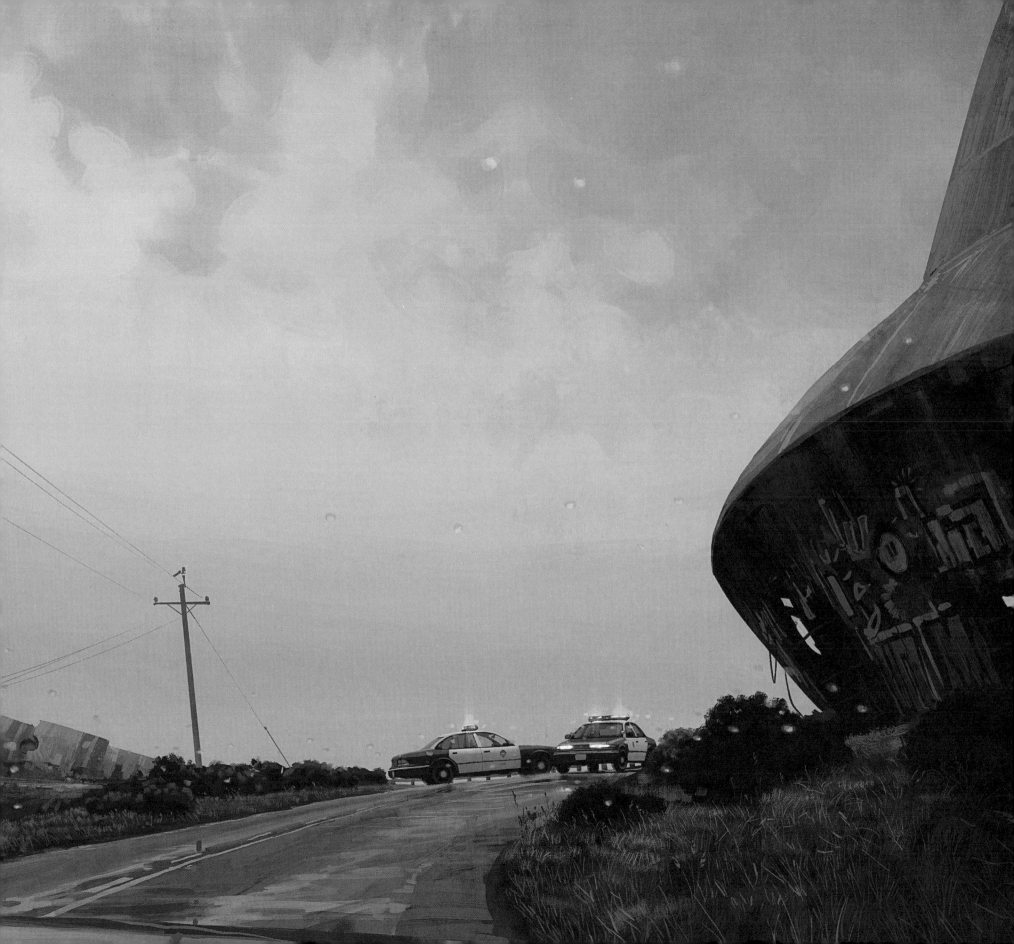

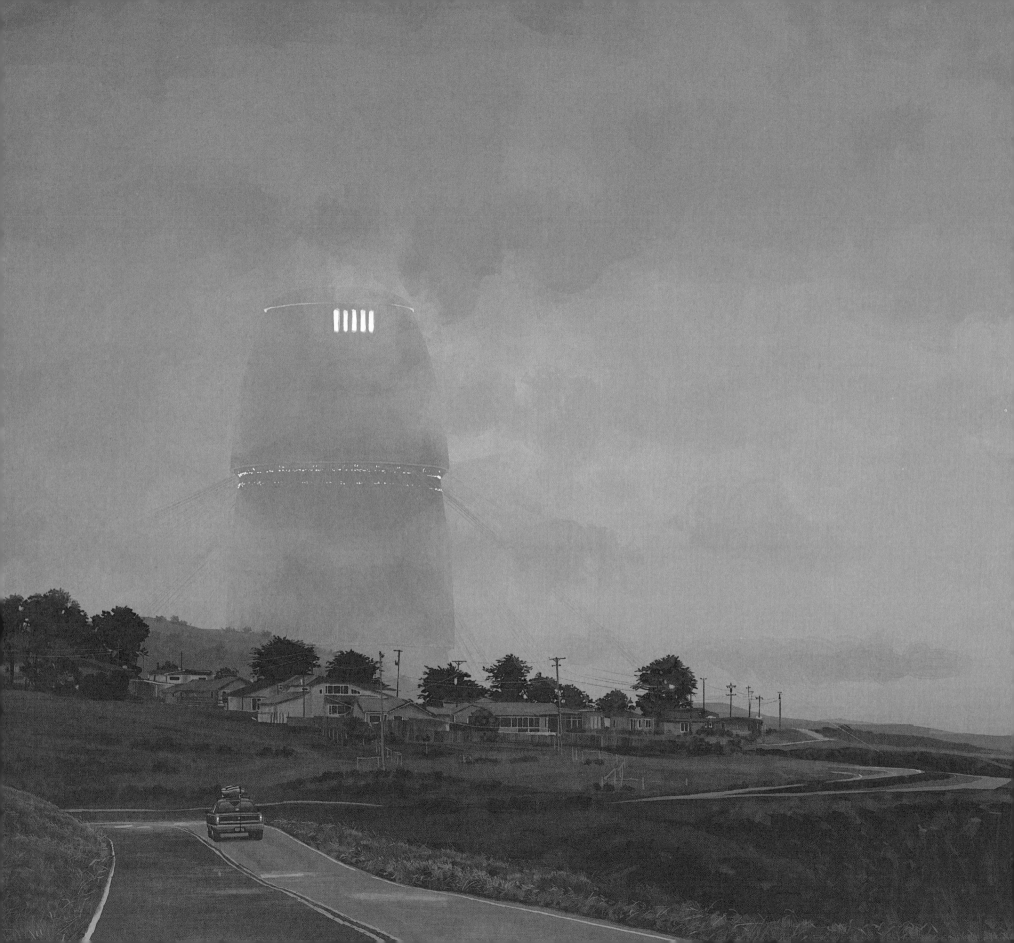

Welcome to

EST. 1915

POINT LINDEN

"The best kept secret
of Pacifica."

MARIN COUNTY

HOME OF TREY DE LUCA
1991 PAC COACH OF THE YEAR

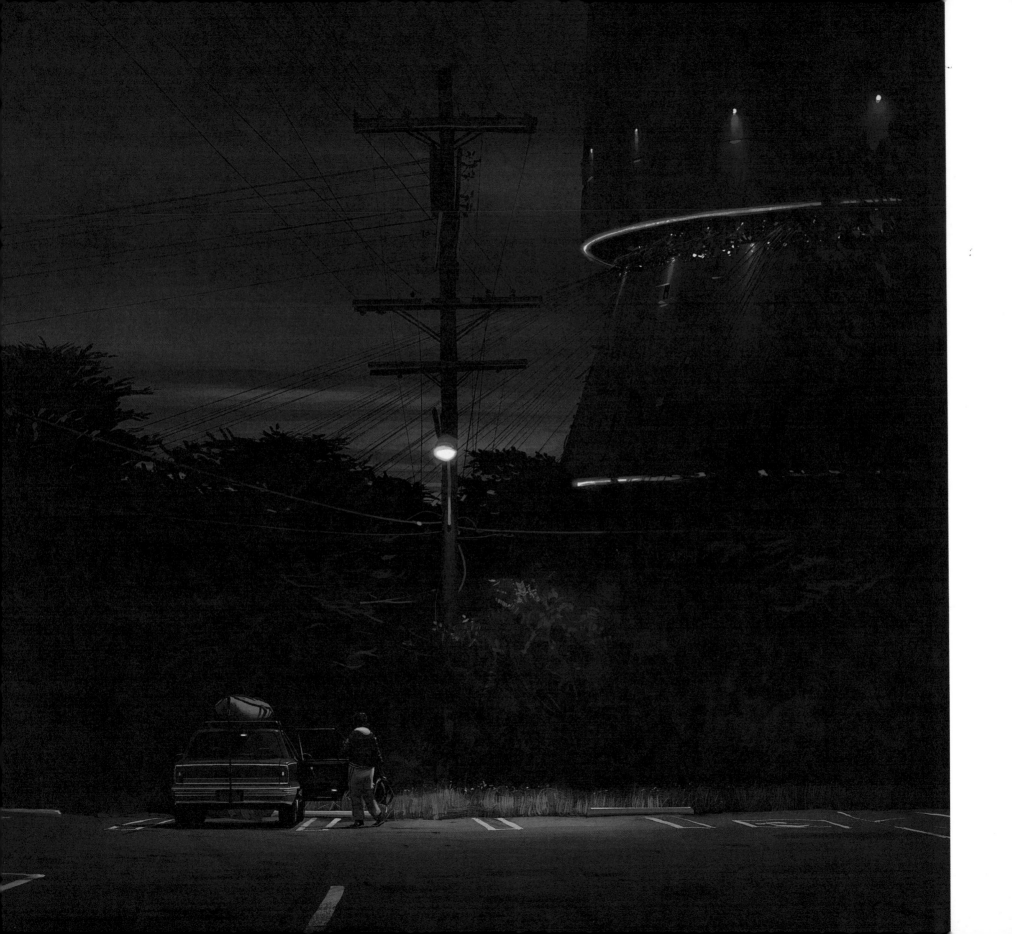

IT WAS LATE when we drove into town. I was exhausted and in desperate need of sleep. Skip was already asleep. I parked in the dark beneath a feral cypress tree, turned off the engine, and got out of the car. No cars, no voices. Just crickets and distant thunder. Beyond the hills to the east I could see the red lights from the neurograph towers. I couldn't see whether anyone had noticed our arrival. This would have to do. I lay down on the backseat, squeezed my hands between my thighs, and tried to curl up in a little ball.

Michelle. You have to wake up. It was all a dream. A game. Jim and Barbara have made me realize that now. We were just playing. And that's okay. It was all pretend.

Amanda was standing by the side of the bed, and I took her hand and pressed her fingers against my lips. She pulled her hand away. I slid down to the floor and buried my face against her pant leg. What have they done to you?

I WOKE UP. The car was freezing cold and damp, and the windows in the back were fogged over. Skip was sitting straight up, immobile in the front seat, looking out the window. I slowly became aware of a pulsing noise, like a distant washing machine. There was something out there, something gleaming red through the foggy window. I rubbed my sleeve against the glass and looked out.

A crowd of people stood on the other side of the parking lot, gathered around something huge. Neurocasters glittered everywhere. What they had gathered around appeared to be an enormous rebuilt drone, and the noise seemed to emanate from it. The head and the raised arm looked like they had come from one of those big action drones they used to have in the Neurodrome arenas, and bundles of cables poured out of its open head like the arms of an octopus, spilling down to the ground, where they slithered across the asphalt up and over a minivan and into the driver's seat. I could just make out something there—the pale torso of a naked woman. She was pressed against the glass, her eyes closed, her face twisted with passion.

Skip turned his head and looked at me. I held my finger to my lips and edged over to the driver's seat, then turned around and picked up the shotgun. I cradled it in my arms and kept it aimed at the floor. And so we waited.

The cables worked inside the minivan for maybe ten minutes. Then they pulled out of the van and made their way back up into the giant round head, where a crown of bony fingers closed behind them and folded together like two interlocked fists.

The mechanical pulsing noise faded away. The drone thing turned around in two giant strides and waddled away into the mist. Slowly the crowd scattered and withdrew into the shadows, the neurocaster lights blinking and disappearing like fireflies into the underbrush. We sat completely still, barely breathing.

When the parking lot was empty again I put the gun in the backseat. When I turned around to start the car I saw the door of the minivan open, and the woman I had seen inside stepped out. She was wearing a dress now and straightened it out before walking away and disappearing into the mist.

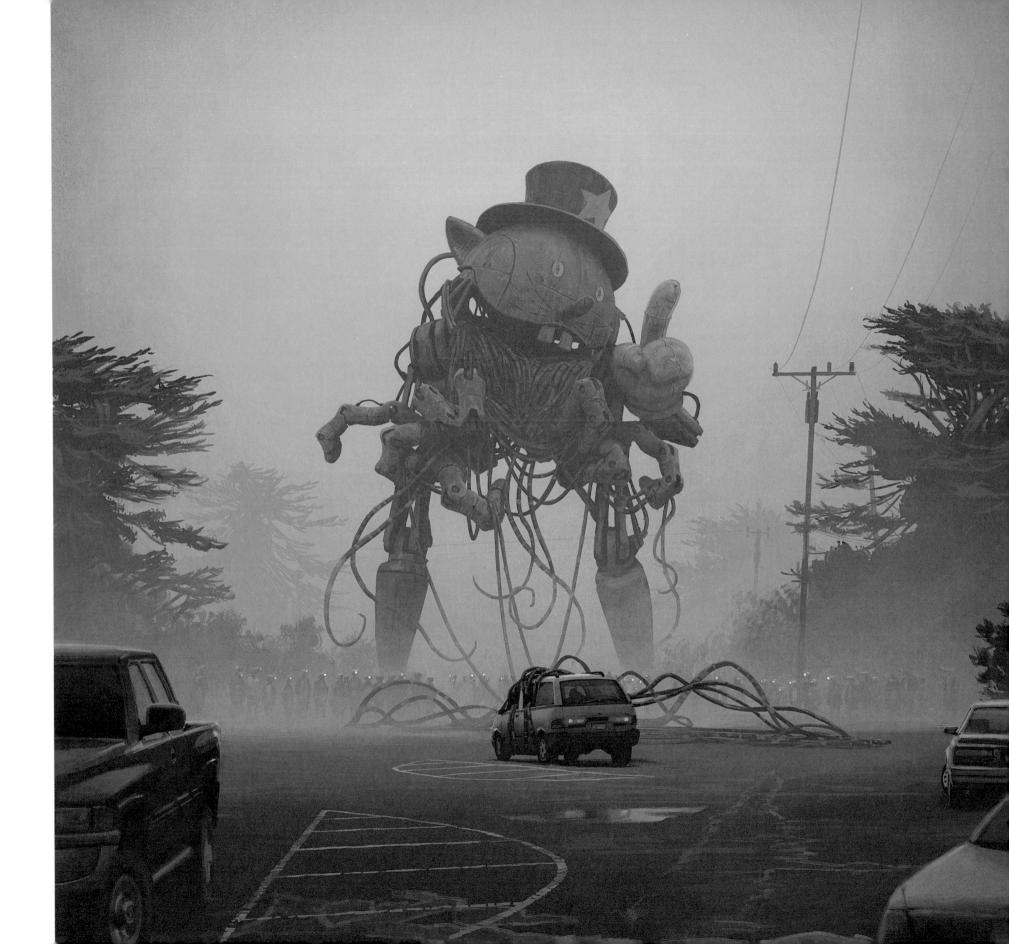

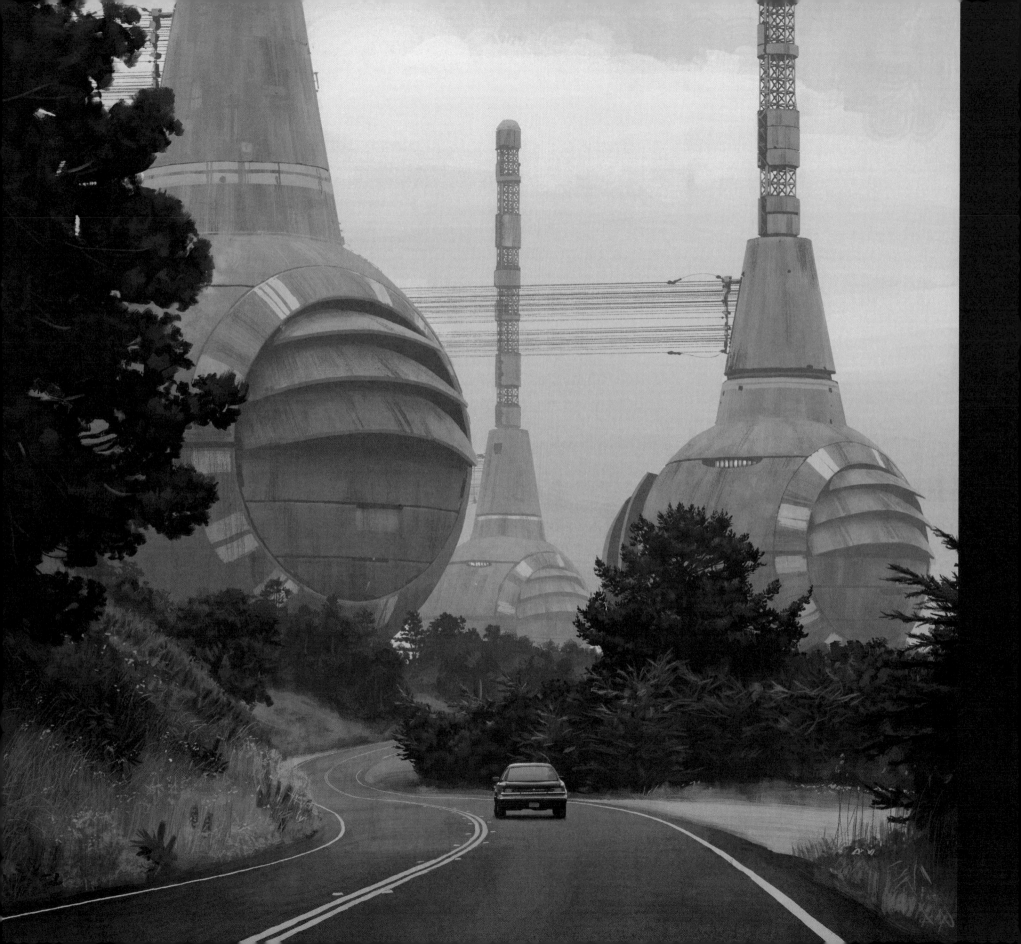

I still dream about it. It was the last winter of the war.

We were supposed to repair the equipment at the airbase on Charlton Island in Hudson Bay. Apparently they had lost contact with the base, and since it was winter it was simply assumed they had some issues with the weather. I don't know how to describe it. It was as if they had all been transformed into termites or something. I mean, the things they had built; there was nothing human about it, if you understand what I mean. No human intellect could have come up with it and made it move like that. And the smell. It was worst in the cafeteria. All the tables and chairs were stacked against the walls, and in the middle of the room there were a number of Dumpsters where they had put them. The children. The stillborn. Like I said, I still dream about it.

Something moved out there in the snow, far out on the white expanse. It heaved itself across the snow crust in a motion that was impossible to fathom. We burned it. We burned everything.

Not a single one of the one hundred fifty people stationed at the base survived more than a few hours after we removed their neurocasters. So when the Convergence talk about their Inter Cerebral Divinity and how it tried to take physical form during the war, I'm not going to say they're completely wrong. What I saw at Charlton Island was not what I would describe as divine, but it definitely wasn't human. The Convergence believe that this superintellect actually managed to create at least one successful pregnancy during the war, and that this child carried within itself a perfect nonhuman genome that it is the duty of the Convergence to breed and spread.

Maybe it's madness after all. But it doesn't matter. What you believe about all of this doesn't matter. They only thing you need to care about is that the Convergence has a ton of money and that the boy is valuable to them. This might be our last chance, so if any of this bothers you, remind yourself that the ground has started moving beneath us. Remind yourself that the streets might be impassable soon, and any chance that has ever been within our reach will be gone.

NOW, LISTEN. Something unbelievable has happened in the secret paradise of Cape Victory. Monsters do exist—the things moving in the mists out on the cape cannot be called anything other than monsters. I mean, you could see that they were basically built from scratch. Put together by humans. You could clearly see parts of drones: a leg, an arm, a laughing face. But they had something else—a complexity that I've never seen before. Thousands of cables and wires and plastic, steel, and oil created an impenetrable organic mass, and these things weren't just randomly put together but had clearly been built with purpose, and underneath the unfathomable surface some heaving movement could be seen, almost like breathing.

I was scared. But I also felt something else when that thing stepped out of the mist in front of our car. I can't think of a better word than awe. I was impressed. Like when you suddenly become aware that you've walked into the wrong part of the woods and come face-to-face with a gigantic wild animal. Beyond the grotesque, there was also something else—something majestic. And in its wake, the citizens of Point Linden, hundreds of people linked together, their neurocasters connected to the oily god in the mist, floated across the ground in front of the car, and they looked almost happy. Calm and peaceful, they moved past the car and formed a single group again behind us, and soon disappeared into the mist again.

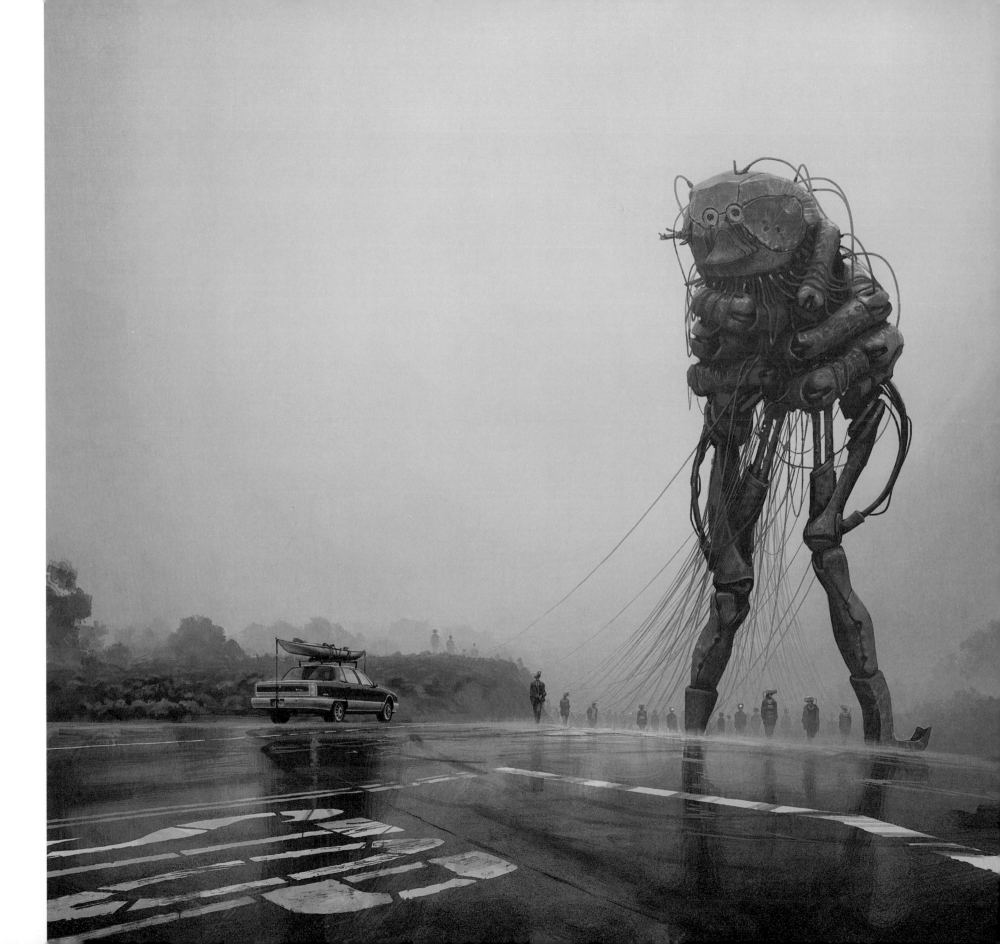

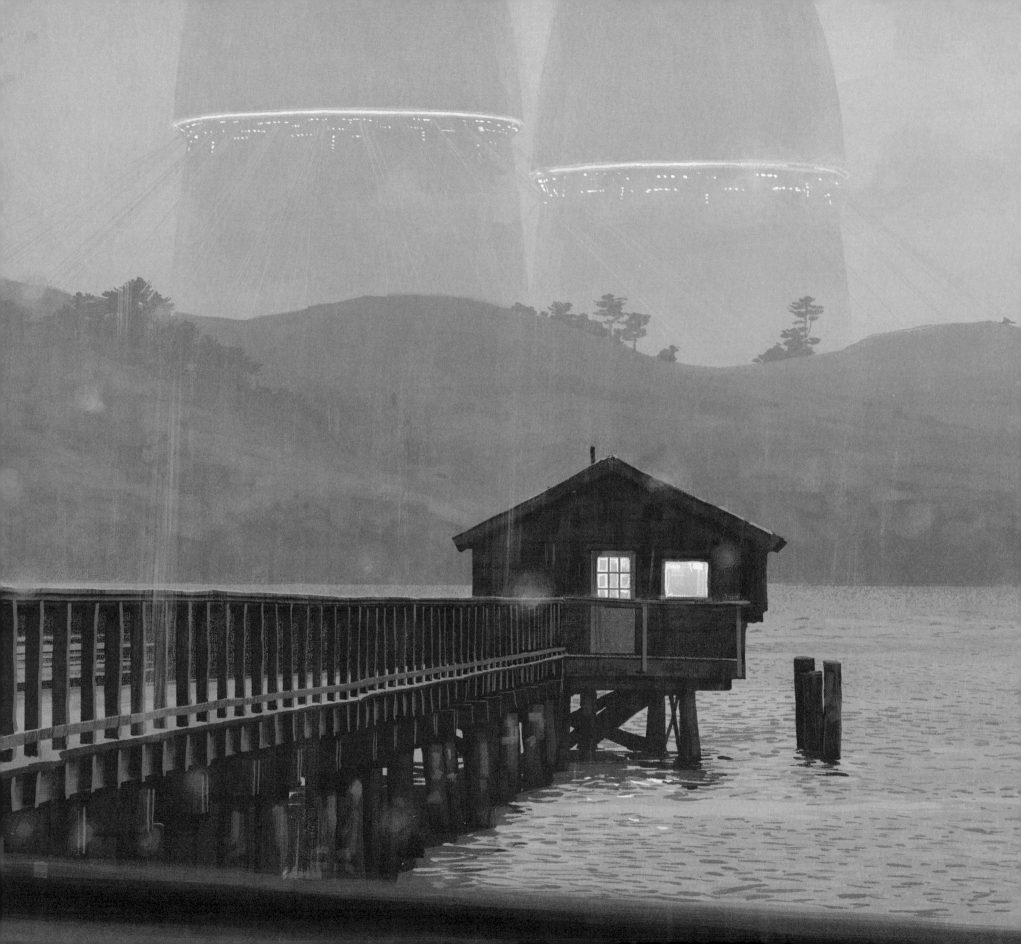

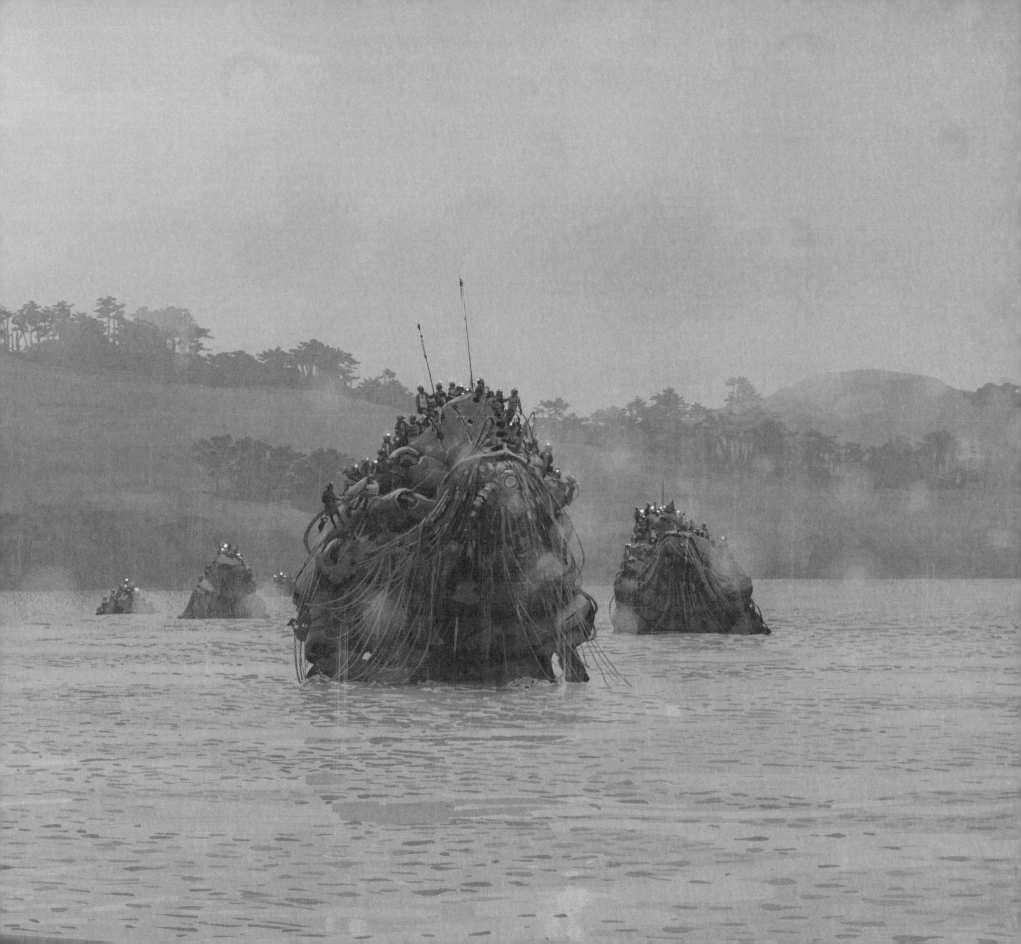

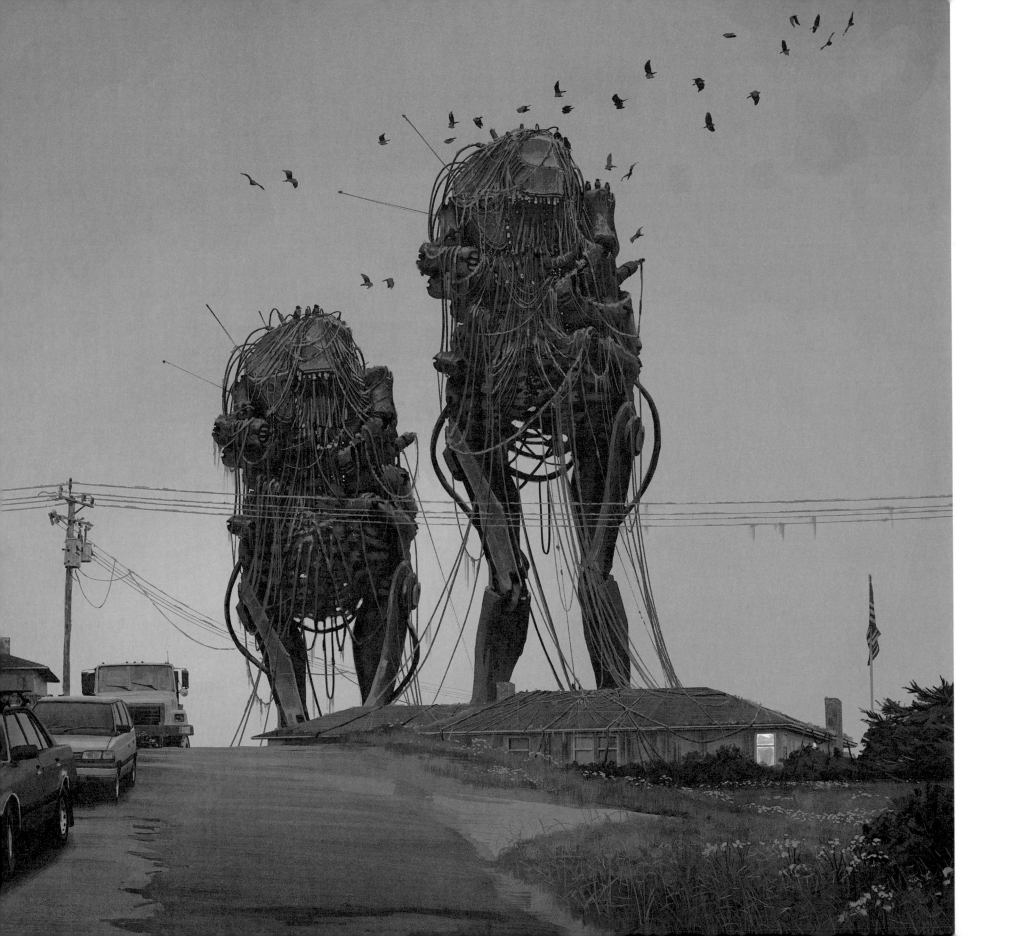

APART FROM THAT, the streets of Point Linden were completely abandoned. I tried to decipher the microscopic map in the Realtor's folder as we slowly rolled down the street between the suburban yards. Alder Road, Jefferson Road, Chestnut Street, Oakwood Avenue, Hamilton Lane—typical names for typical streets that stretched between typical houses that had once been populated by typical families.

Most of the lawns were unkempt, overgrown. How long had this been going on? In some yards, even more incomprehensible shapes rose straight out of the grass: restless, twisted giant fetuses, eager to be born.

I have to say: they were fantastic. Something inside me wanted to stop the car and get out, to walk up to them and touch them and closely examine every single one of these strange growths. In another reality I would have loved this. I would have calmly walked these streets, fascinated—certainly with a degree of disgust, but rapturous, pleasant disgust. In the real world, everything was backward now. We were the fascinating growth, the insane—the only sick souls in a healthy world. There was no safe everyday life behind us, no normal zone to return to, and the only way out was forward.

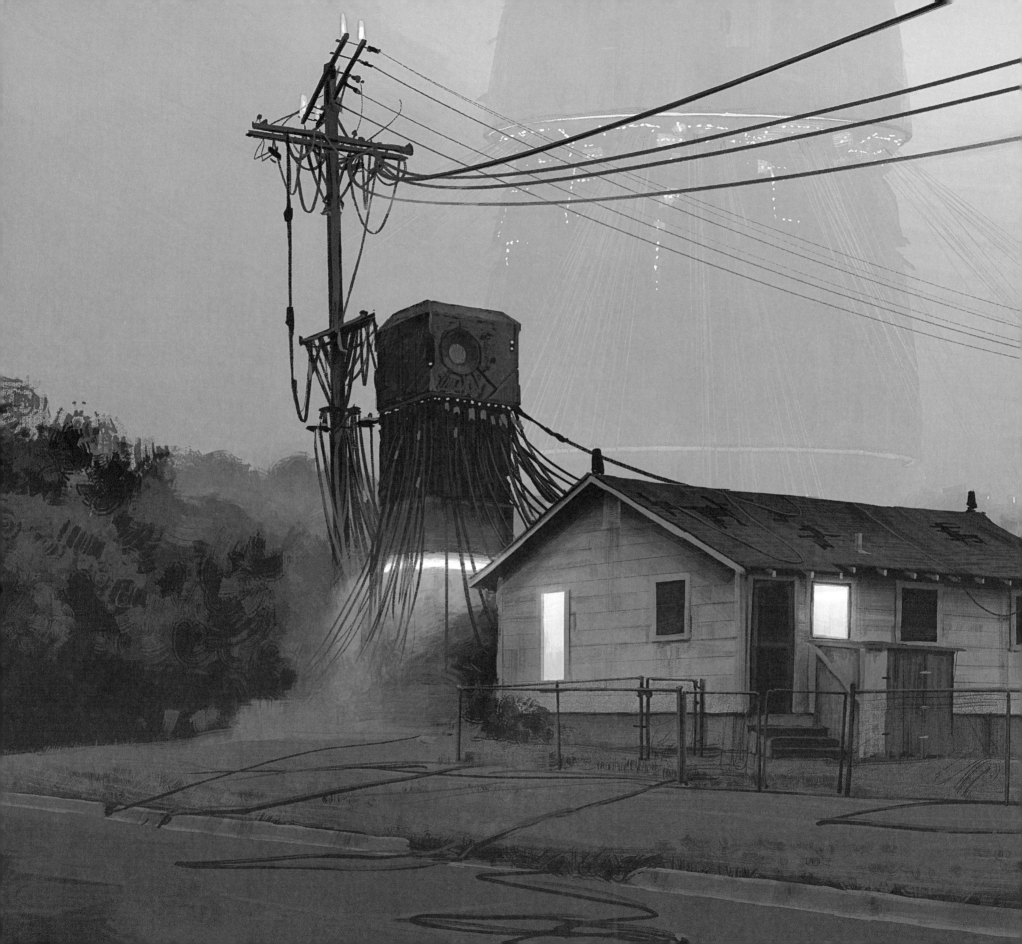

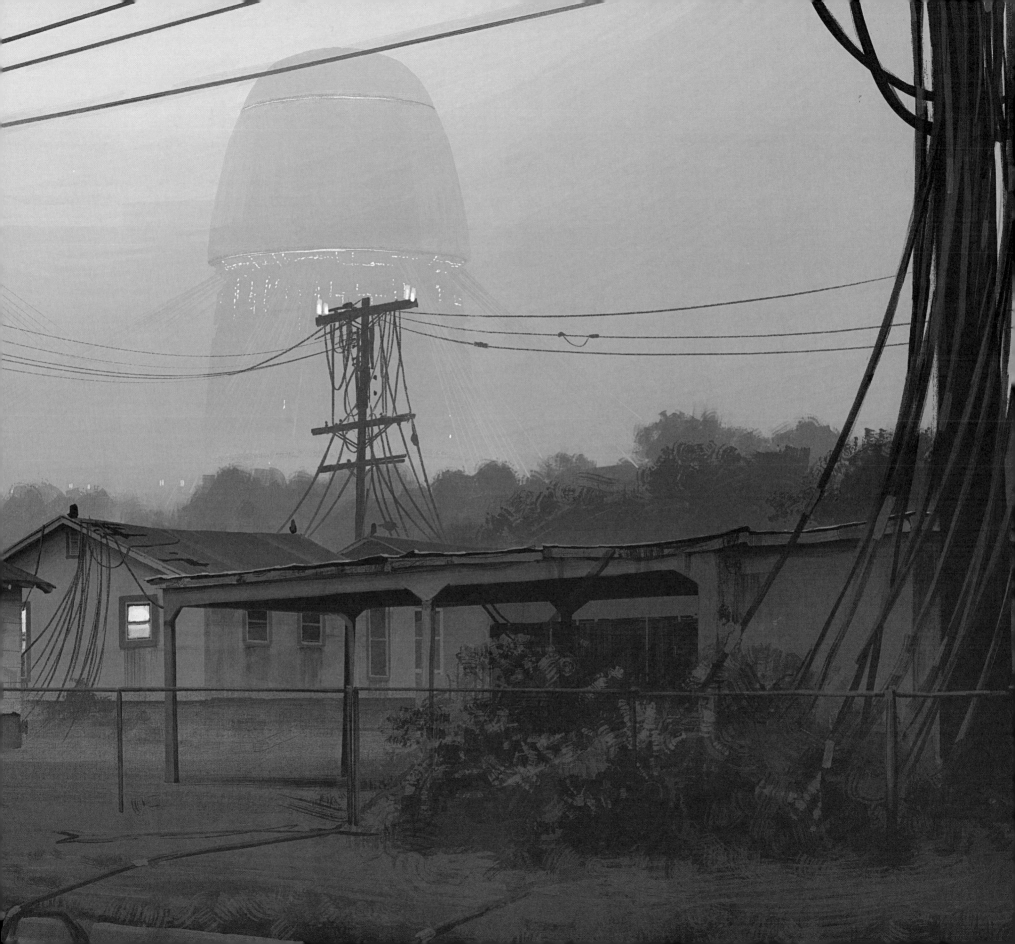

What we're doing isn't civilized, I know that. But I know it must have happened to you too. Like me, you must have woken up one day and suddenly realized the inevitable: we no longer live in civilized times.

You're almost upon them, Walter. It is almost over.

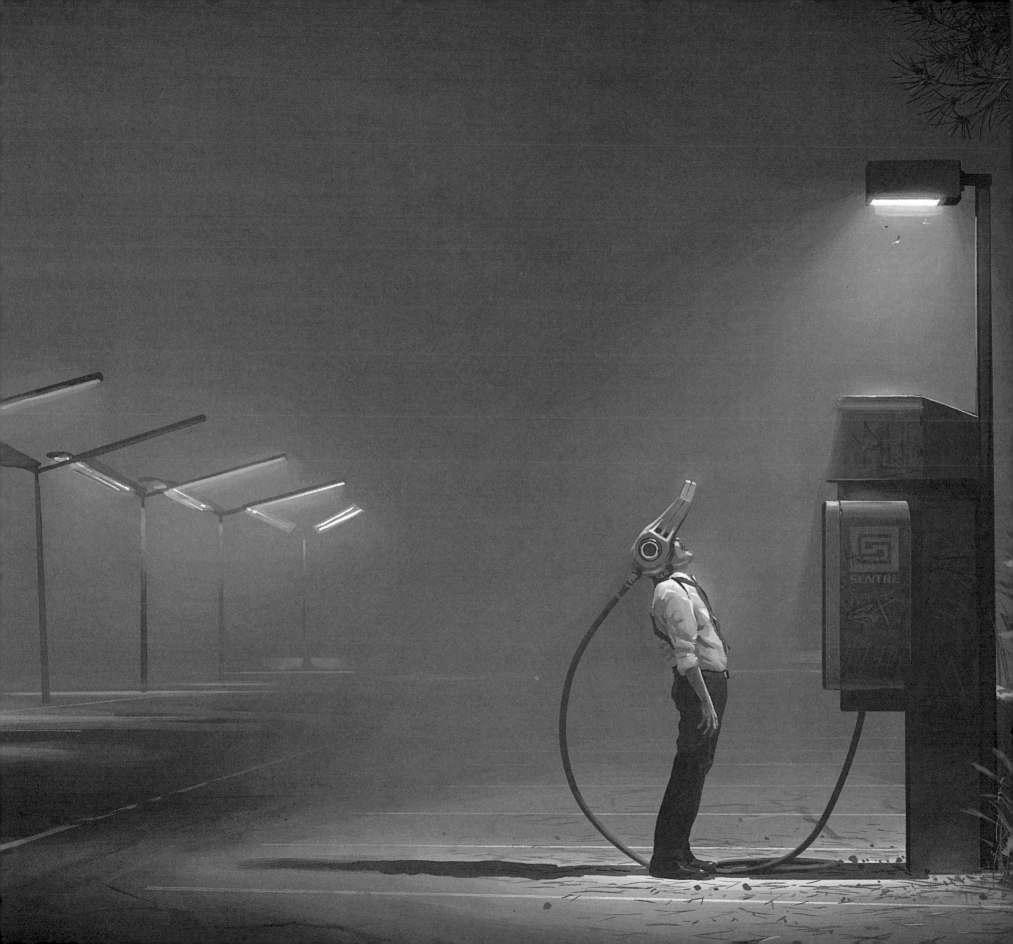

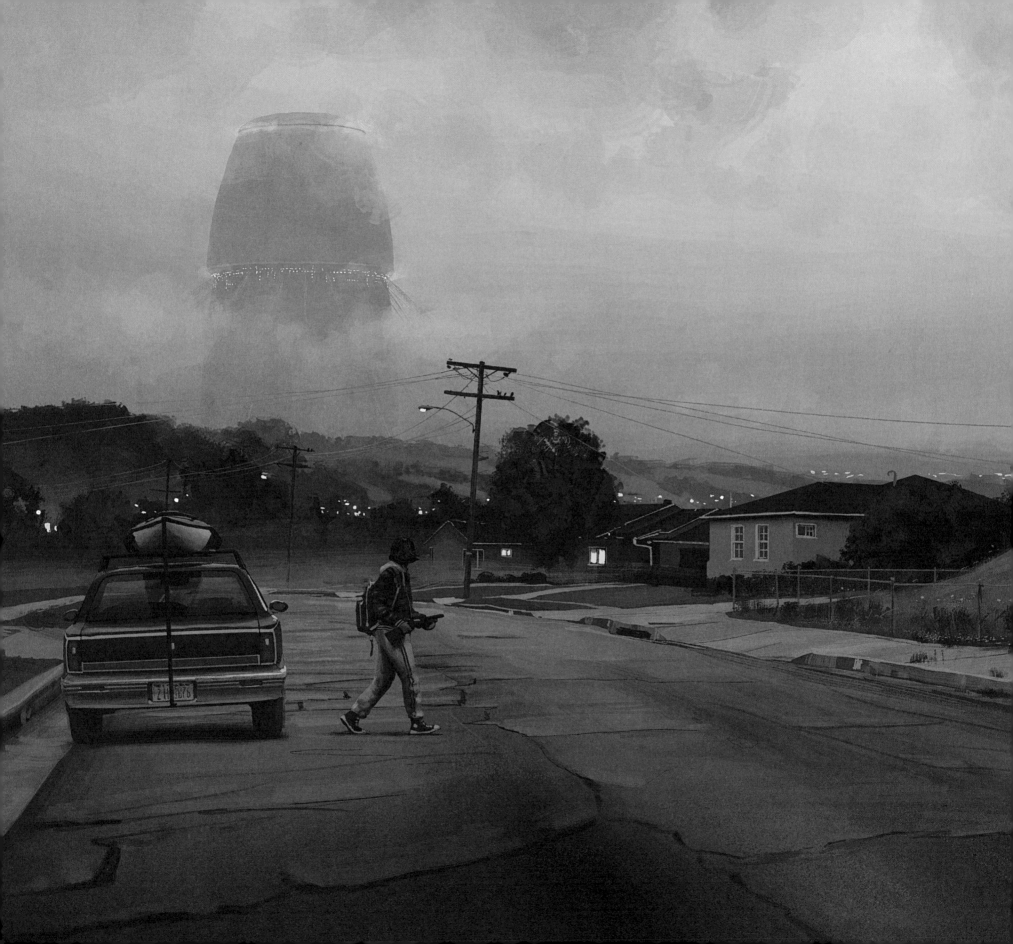

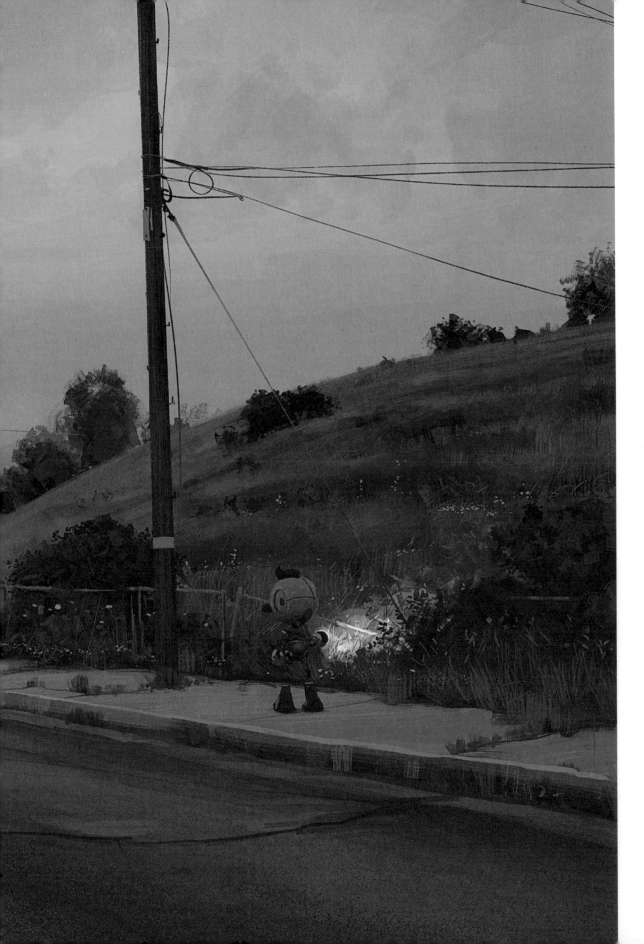

WE ARRIVED at 2139 Mill Road late at night on May 11, 1997, six months after Skip picked me up in Soest, and now it's about time I tell you about my brother.

Christopher was born when I was four, on October 12, 1982. My mother always said that Christopher didn't have a father, so I guess he's my half brother. I remember a doctor, a man with blue gloves and a military uniform. He was holding a little baby in his arms, wrapped in a blanket. He said, This is your brother, Michelle. Something was wrong with him, they knew that right away; something about his brain, and before he was three he had gone through more than thirty surgeries. When I was about seven my mother was fired from the air force and the assistants went away, and it was my grandfather who had to teach me how to change Christopher's diapers and dress him and what he should eat and how I should feed him. It was my grandfather who started calling him Skip.

Another memory: I was nine, and we lived in our mother's RV in a boneyard somewhere in northern Libertaria. My mother was in the RV with her pocket knife, emptying cables of neurite. Skip was five. We played among the wrecked ships, and I found a Kid Kosmo toy, a small action figure. Skip loved Kid Kosmo, he had seen every single episode, and when we played, Skip was always Kid Kosmo and I was his sidekick, Sir Astor the space cat. At night when our mother was away with one of the men who gave her money, I would hold Skip and make up stories about Kid Kosmo and Sir Astor, and I would lie there and whisper about their courageous journeys out in the galaxy until Skip fell asleep. I had given him that toy, and he carried it with him everywhere. About a year later, maybe more, I found my mother unconscious on the floor of the RV. I walked three miles along the highway holding Skip's hand until we found help. She died a year later, at the hospital in Hobbes. Social services took Skip away, and I ended up at my grandfather's in Kingston.

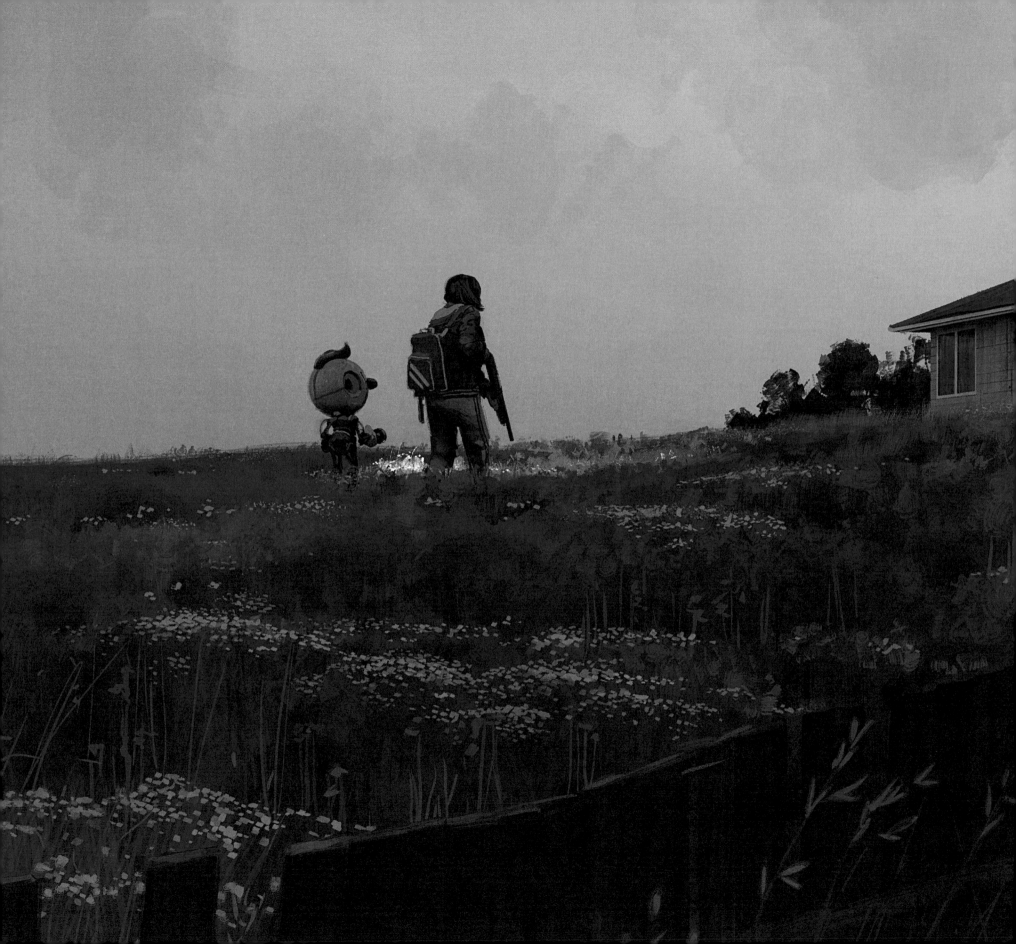

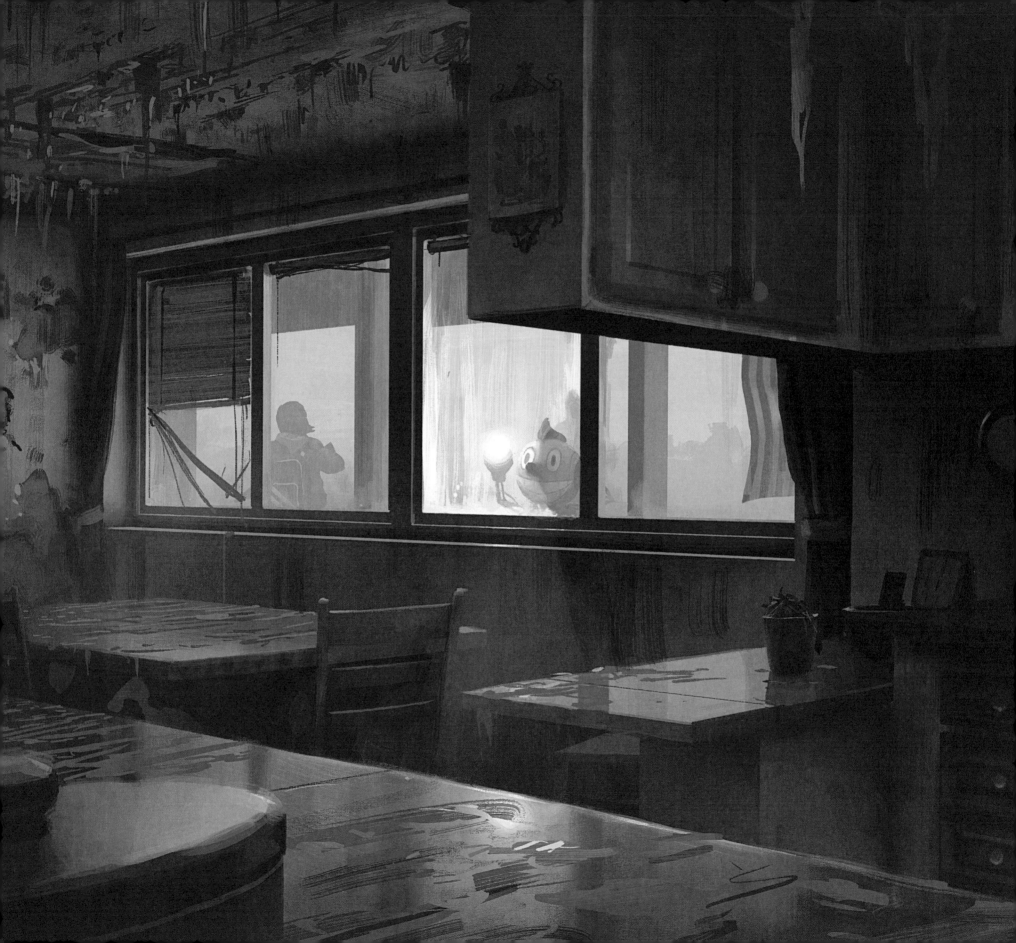

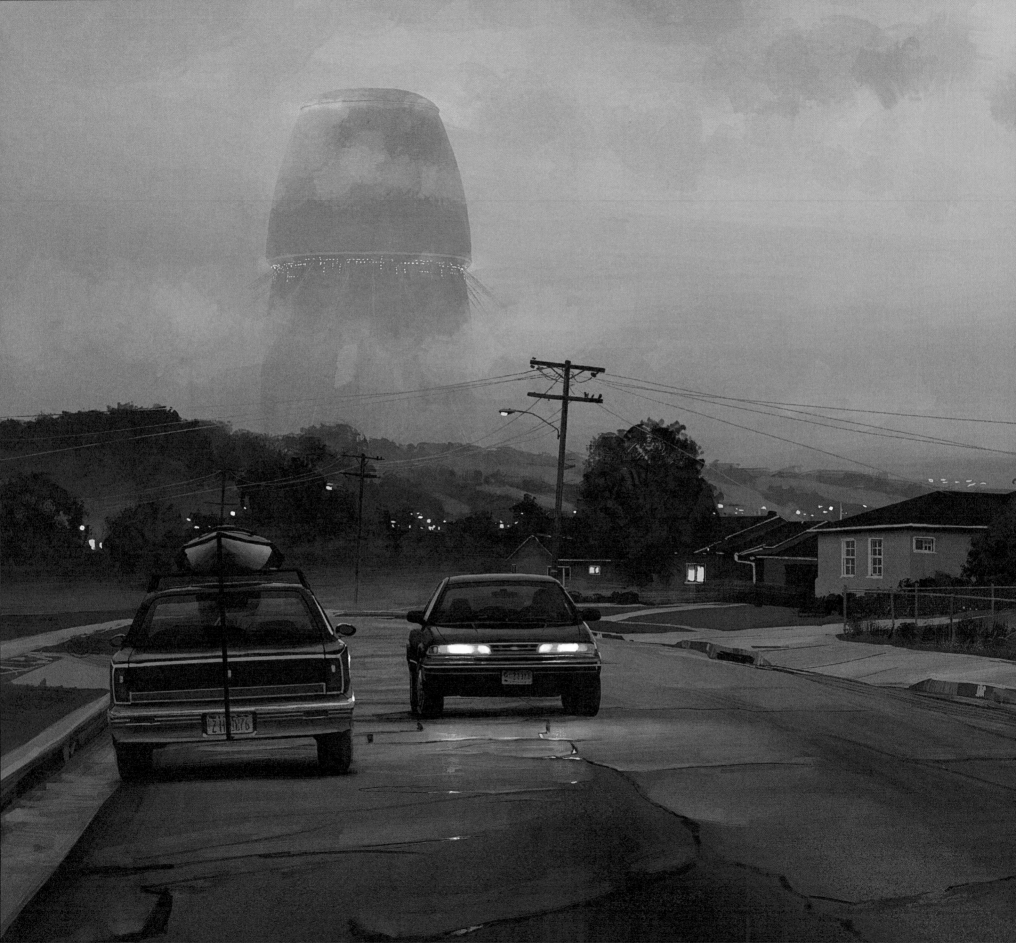

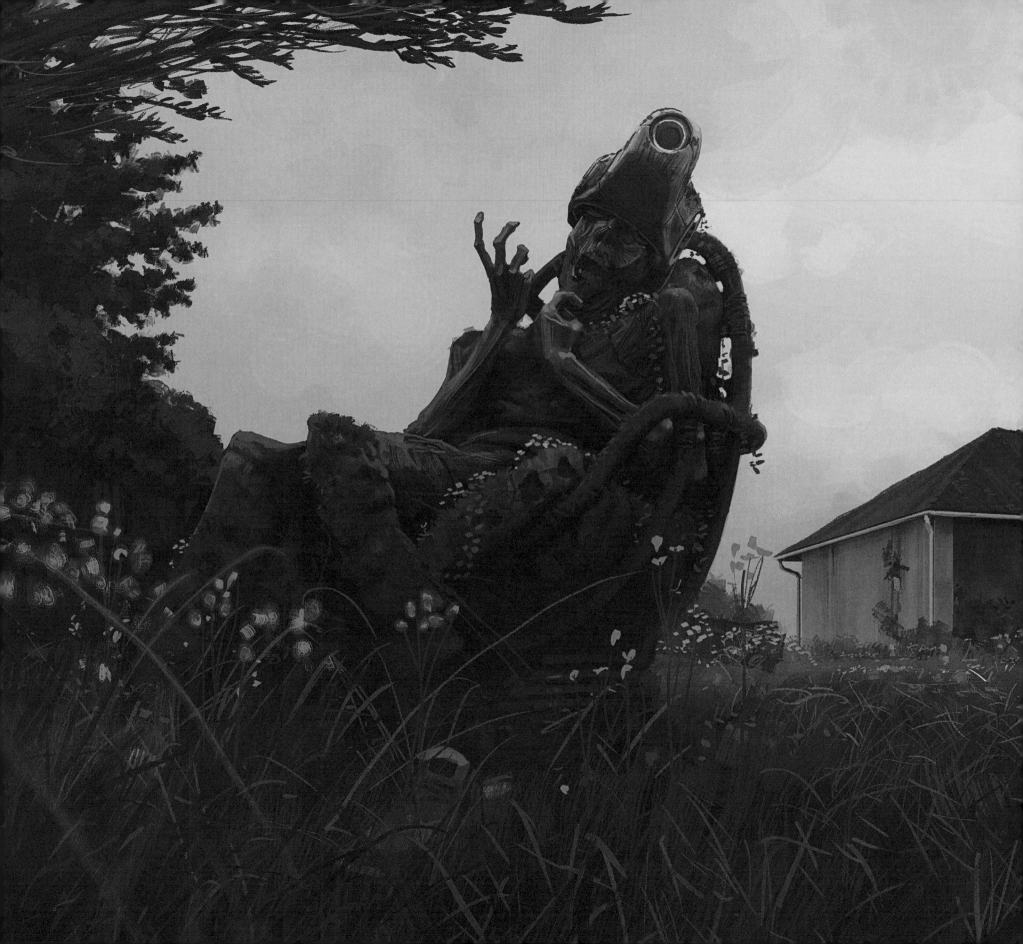

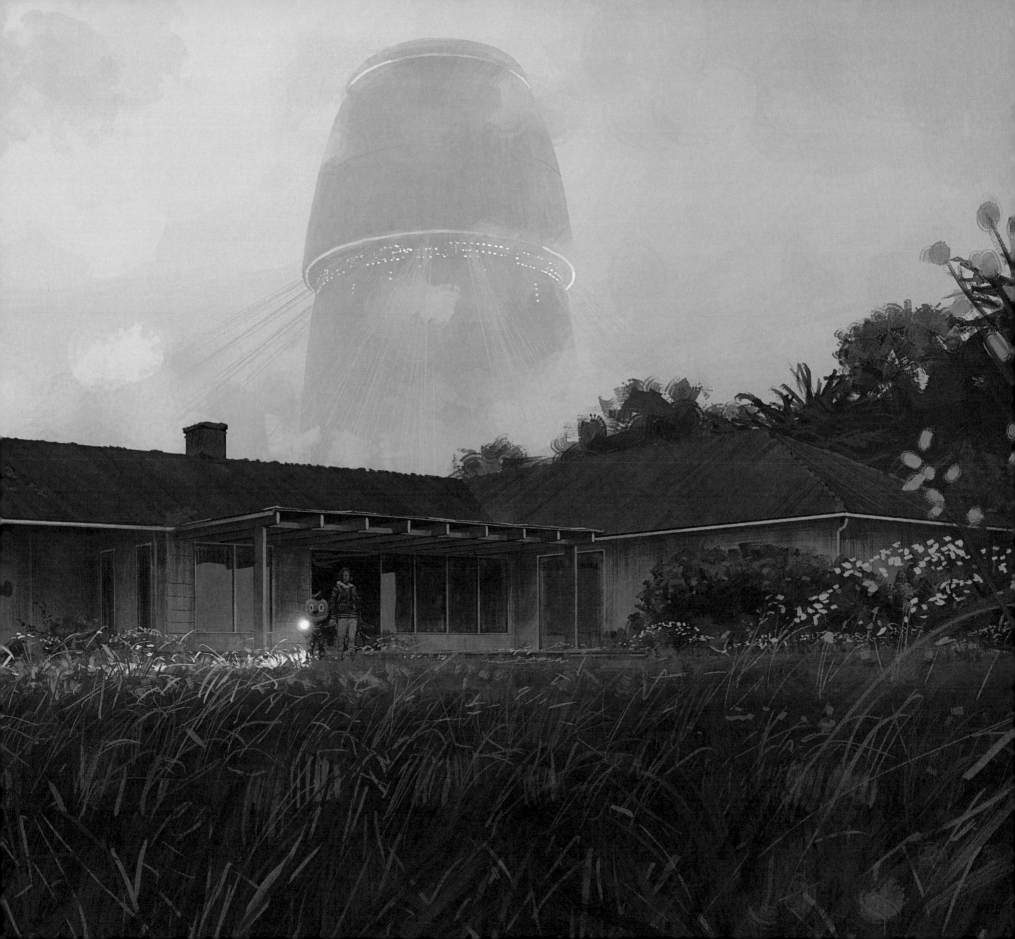

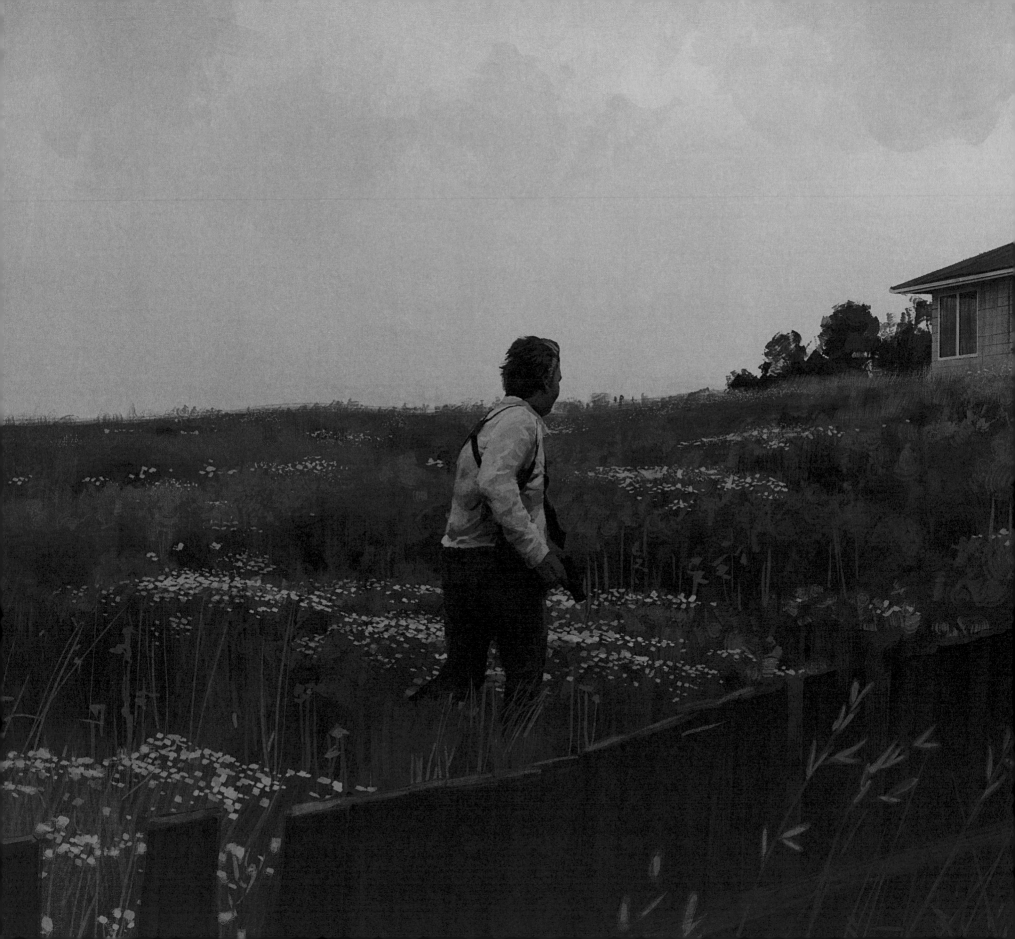

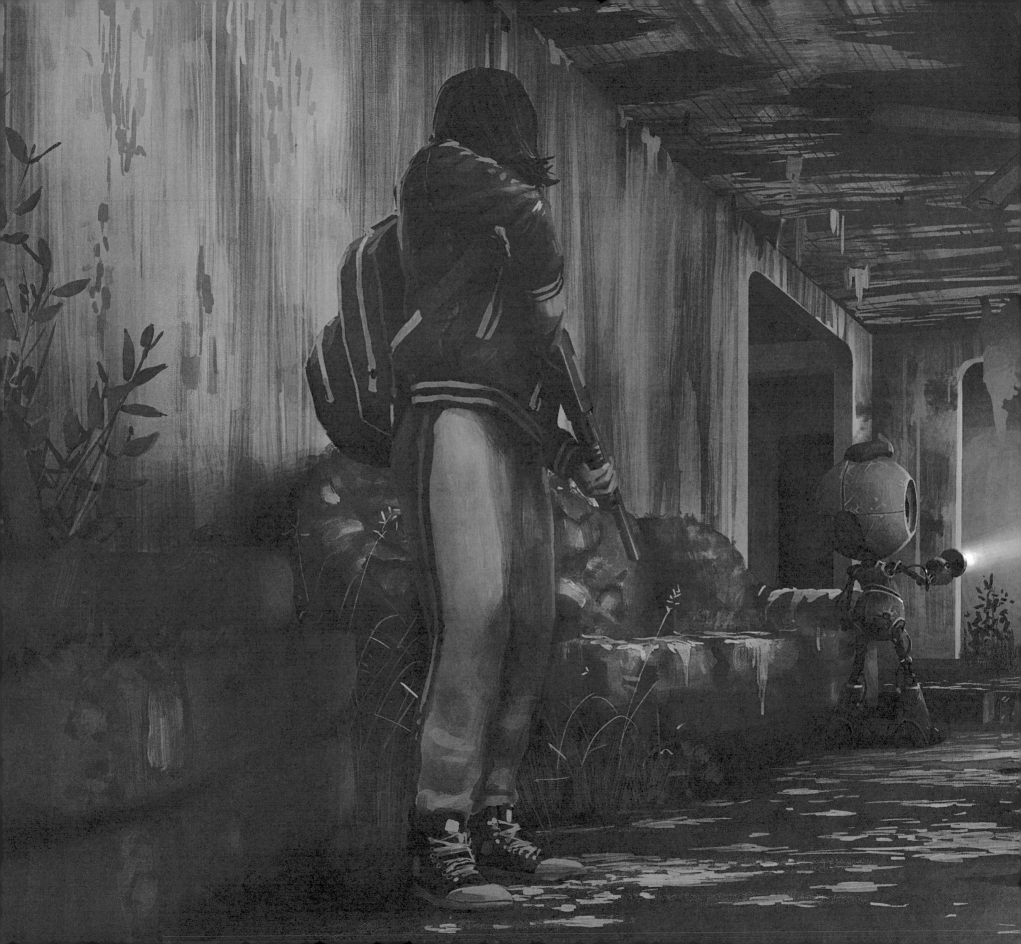

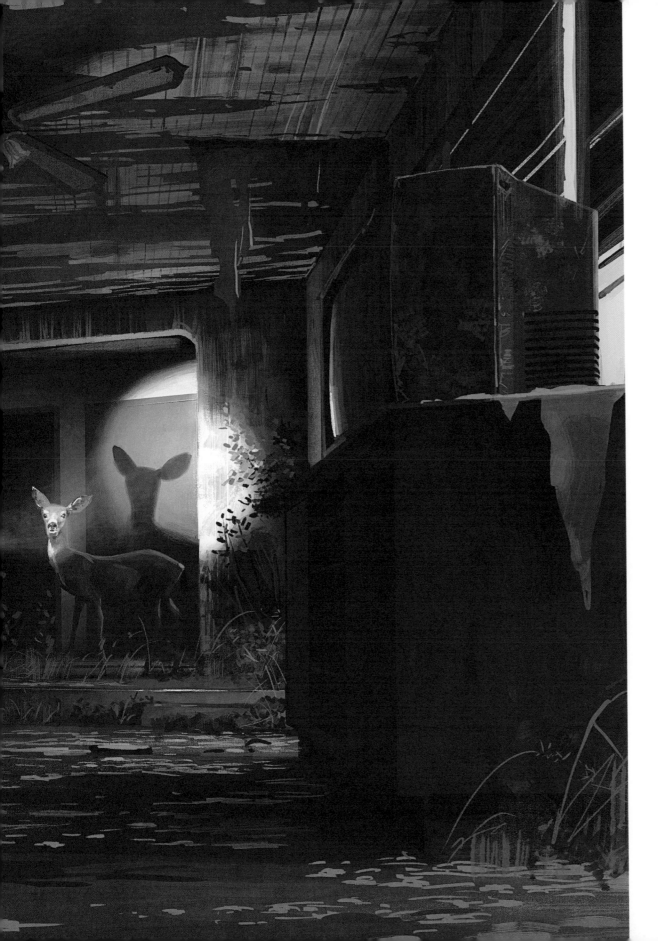

WHEN SKIP CAME to get me in Soest, the city was falling apart. I had just seen Miss Styles in the house across the road get dragged out and shot in the street by a group of armed men. Ted had been down on the riverbank for a week. Amanda was long gone, and my black heart lay broken and discarded somewhere on Soest's desolate streets.

I hadn't eaten in days. Not that there wasn't any food—the pantry was full of canned food and old pasta—but I think I had decided to die. I can't really remember, but I do believe that's what I'd planned to do.

I don't know how Skip found the Kid Kosmo drone, or me for that matter, but when that yellow robot stood there on the driveway with the toy cradled in its arms—the same toy I had given my brother nine years earlier—I understood immediately. Skip, is that you? I said, and the yellow robot nodded.

That's a kickass Kid Kosmo you've found.

Then I sat down on the driveway and wept. Like I said, Ted had been down on the riverbank for a week. He was sprawled beneath a beach umbrella, and when we left Soest in his old Corolla the vultures had already eaten most of his body, but below the horn of the neurocaster his mouth was still moving like he was dreaming.

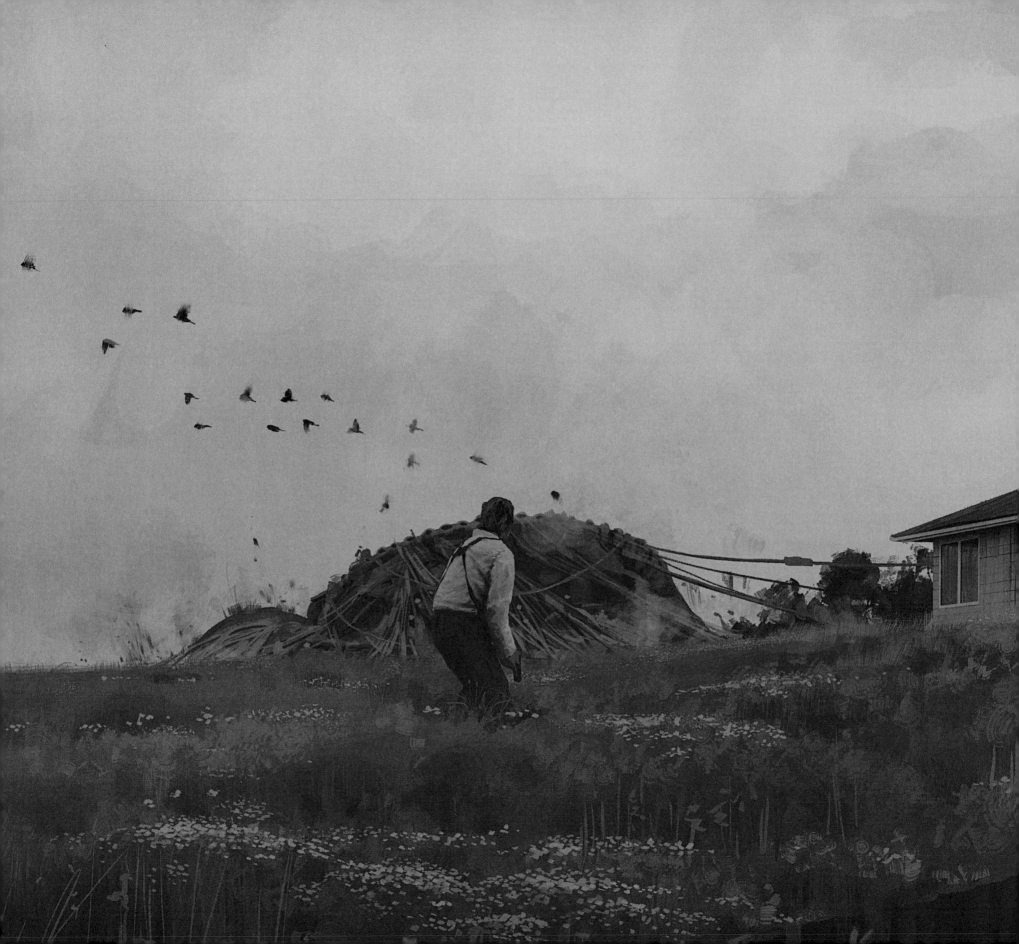

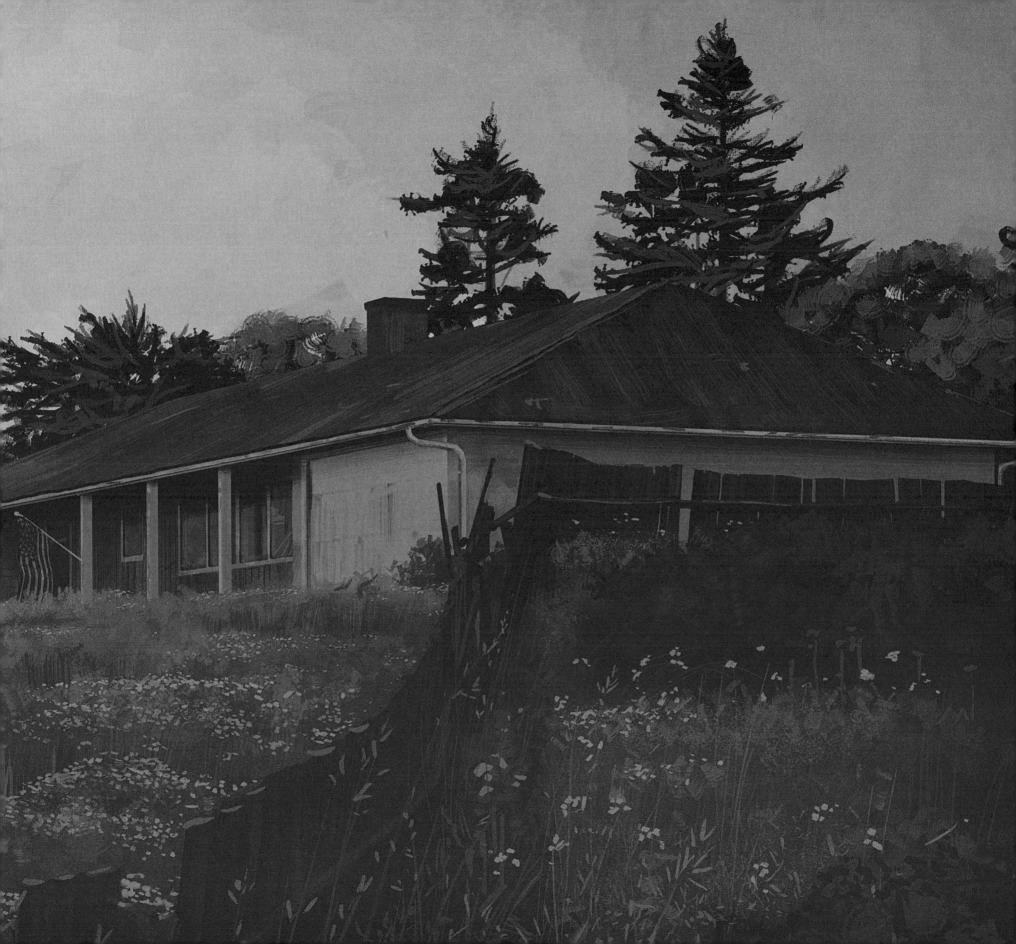

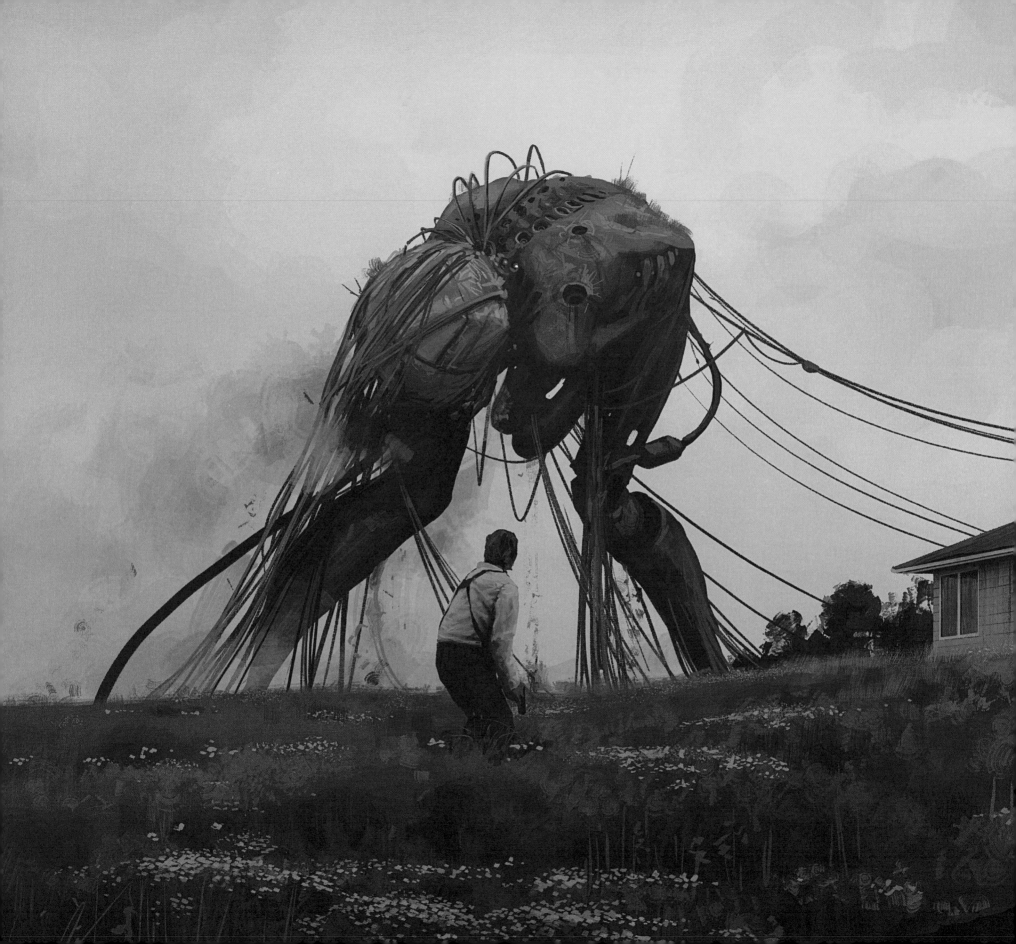

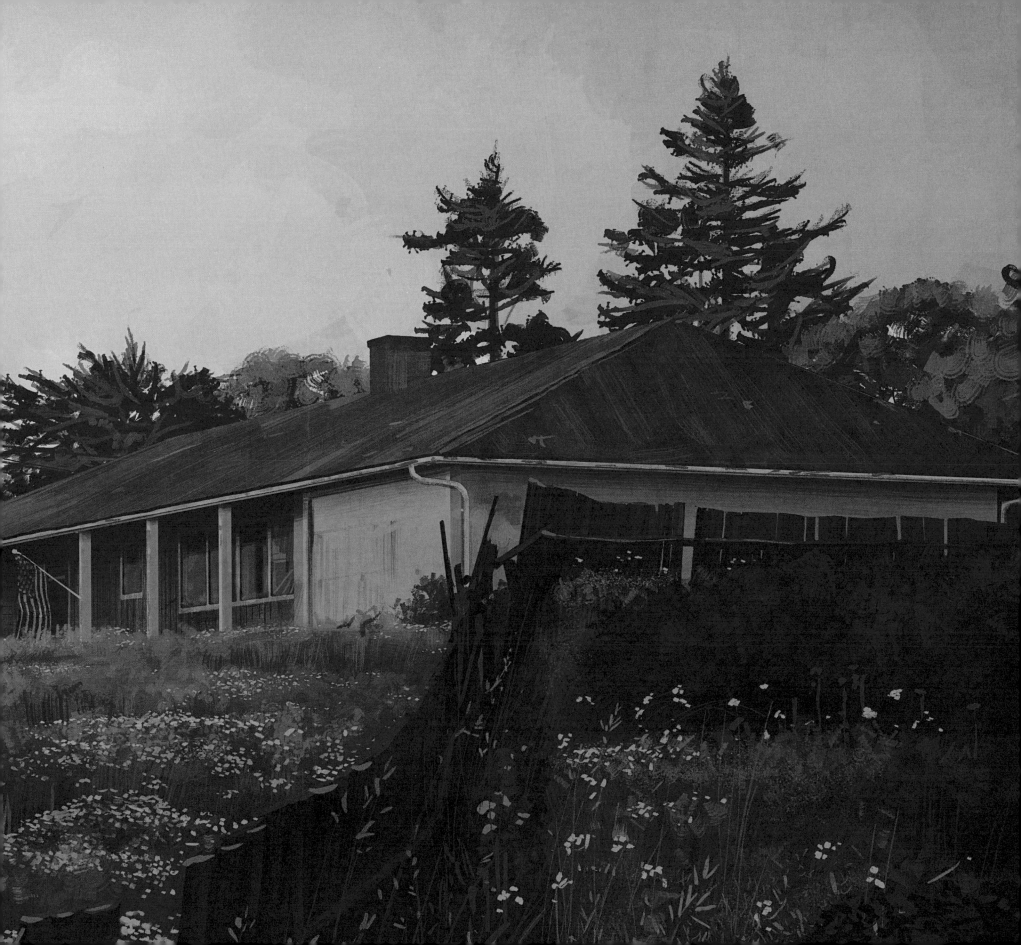

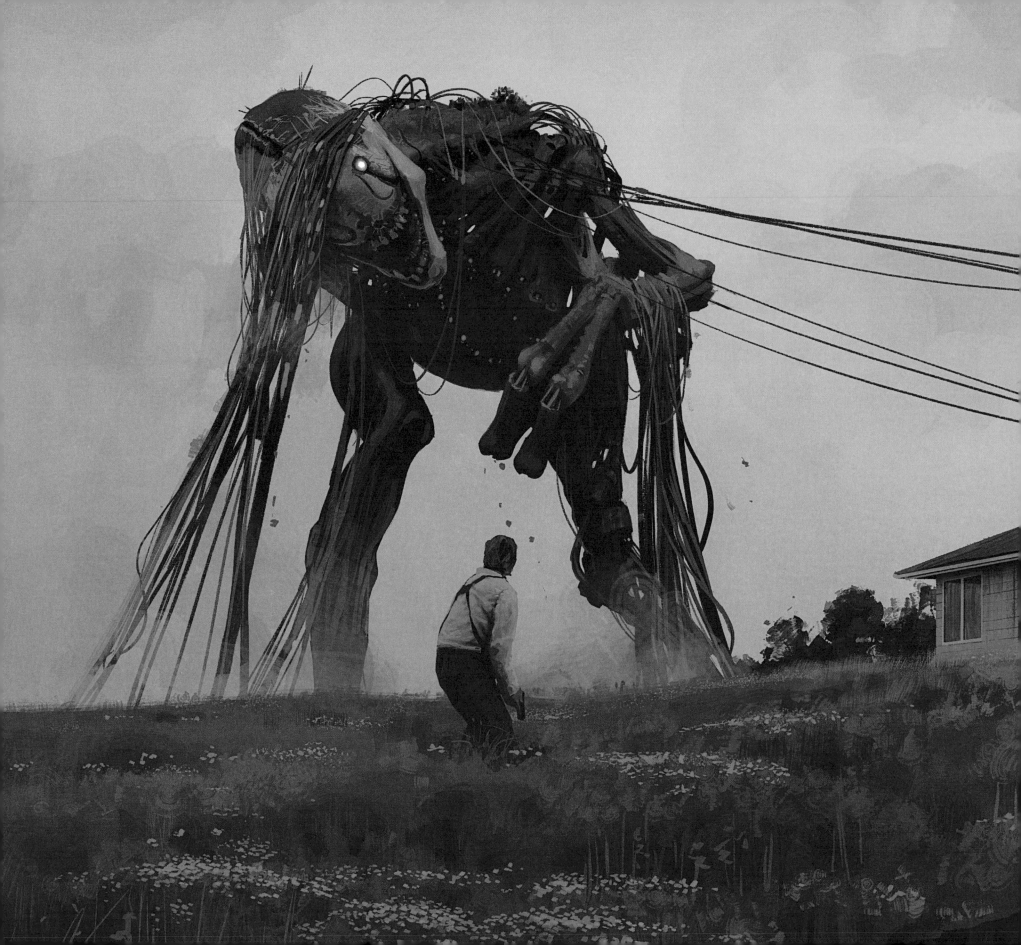

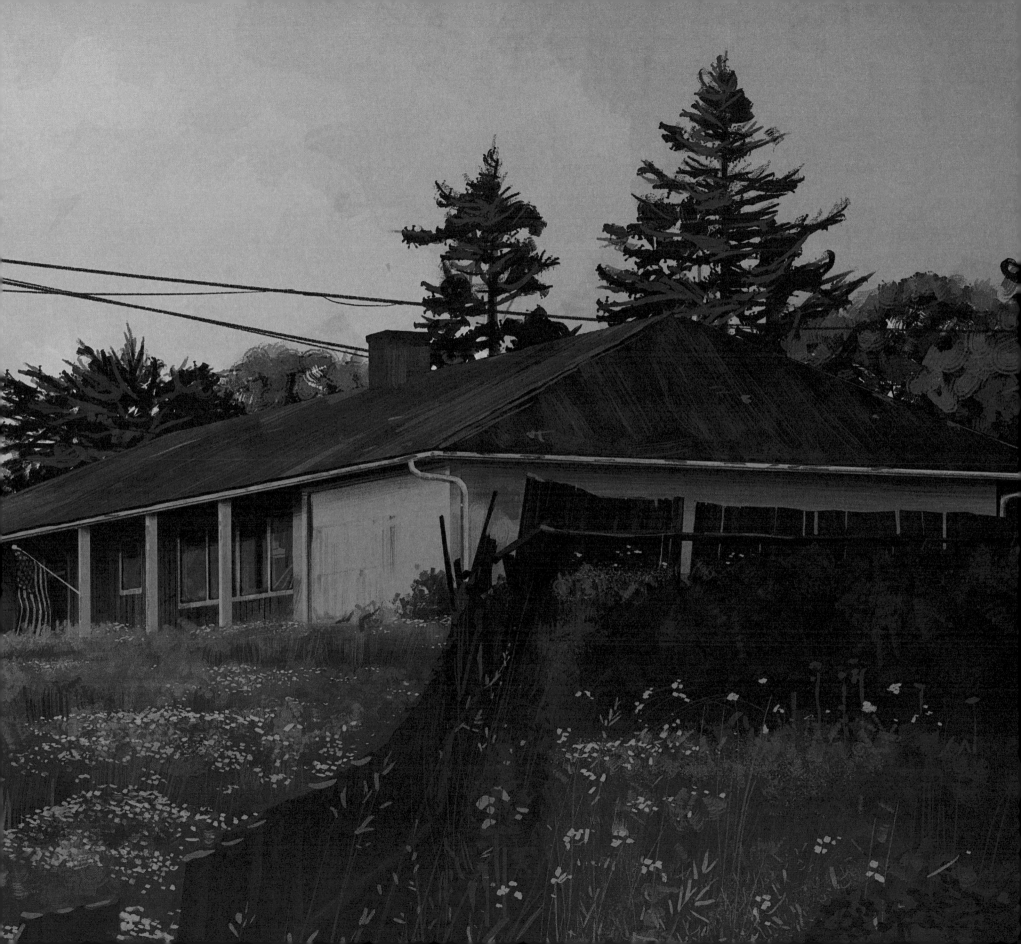

SOMETHING SHOOK THE HOUSE with a series of deep, hollow concussions. The floor vibrated under my feet, and without thinking I threw myself down and embraced the emaciated boy in the bed. Something massive was moving around out there, and flakes of paint and plaster rained down over us. I closed my eyes and waited for the roof to cave in. One final, massive shock wave crashed through the house, and something made of glass shattered against the floor somewhere; then the house was quiet. I lay there with the boy in my arms, and the only sound was the soft whir from the fans in his neurocaster.

Finally I raised my head and looked at the boy. I turned his head gently, and there, behind his ear and just below the edge of the caster, I found it: the long, shining scar from the surgery. I sat there for a while and just held his hand.

Skip was six years old when I saw him leave Kingston in the backseat of the social-services car, and he was fourteen when I lifted him out of the bed at 2139 Mill Road in Point Linden. I don't have the slightest idea about what he'd been through in between. His body weighed almost nothing; it felt like the neurocaster was the heaviest part. I guess he should have been dead, but there was no way to tell how long he had been lying there. I carried him to the bathroom and washed off the worst of the filth with a towel, and then I sat for a long time with my hand against his cheek and felt his pulse against my fingers.

Something rattled, and I groped for the gun before I realized he was still controlling the yellow robot and that it was walking around out there in the kitchen. It walked into the bathroom to stand in front of us. It carried cans of fruit in its arms.

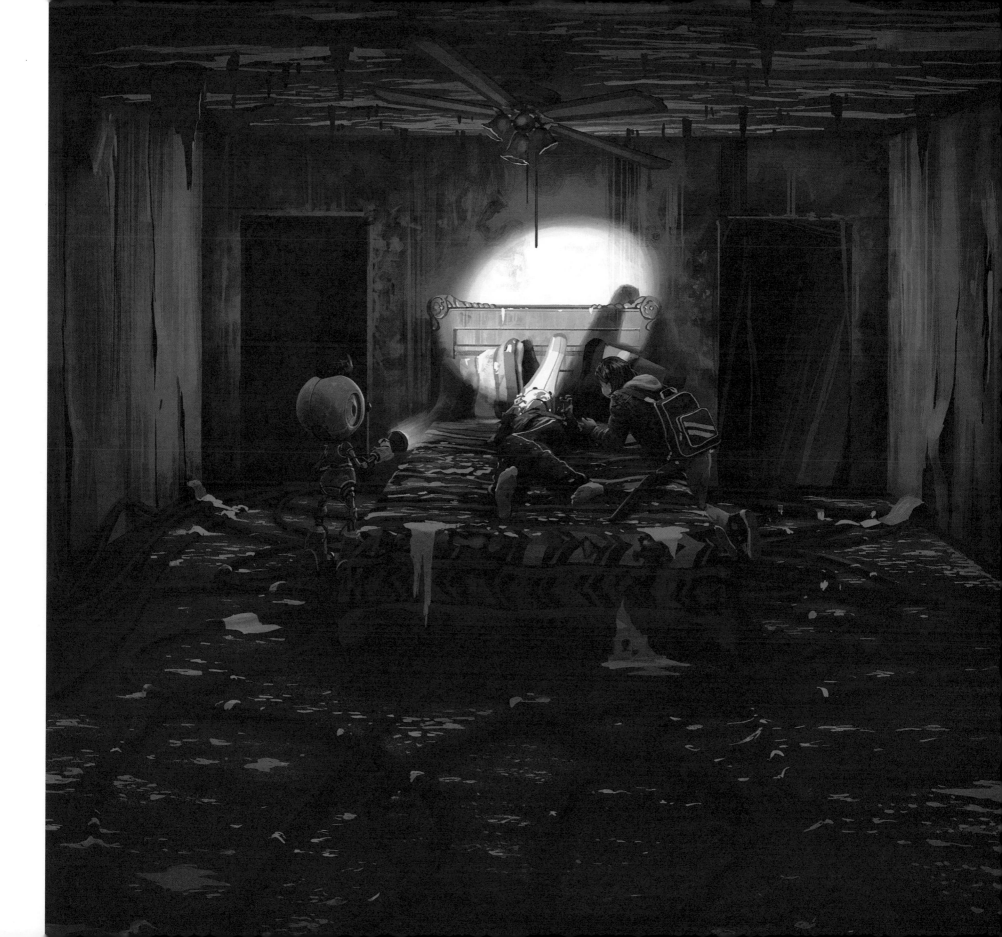

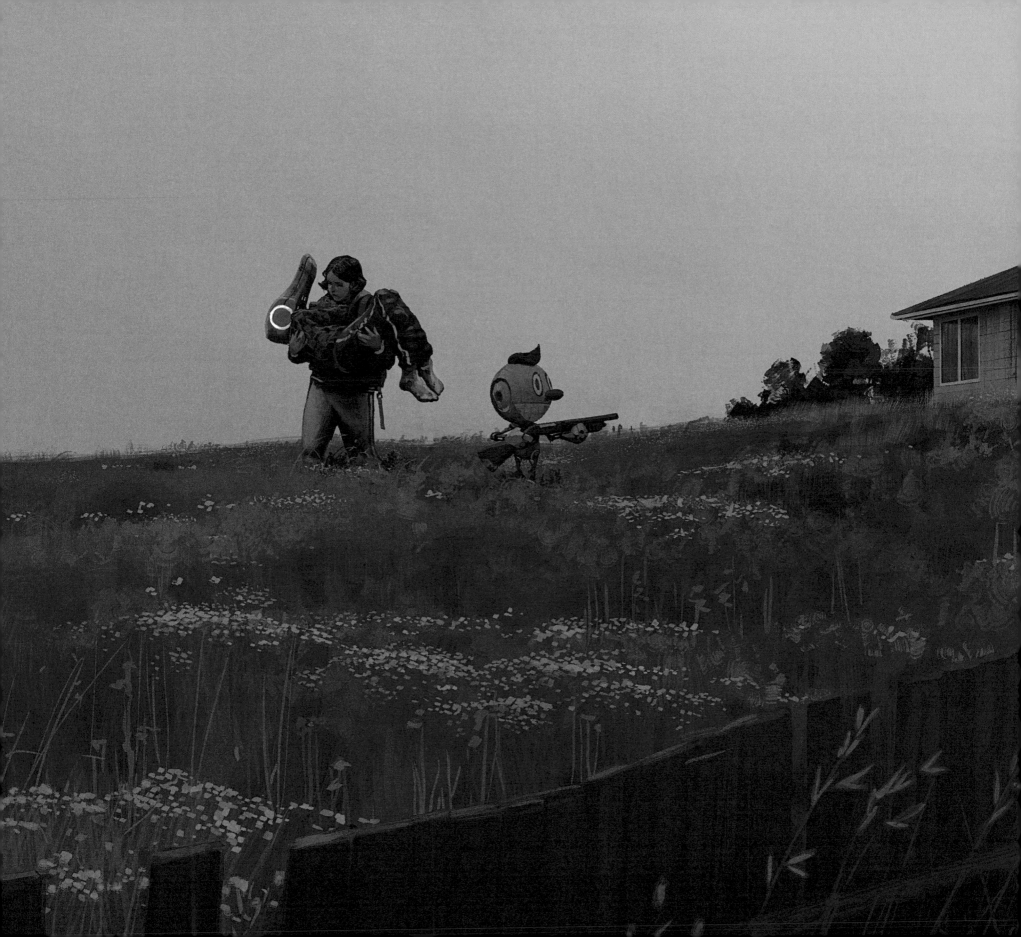

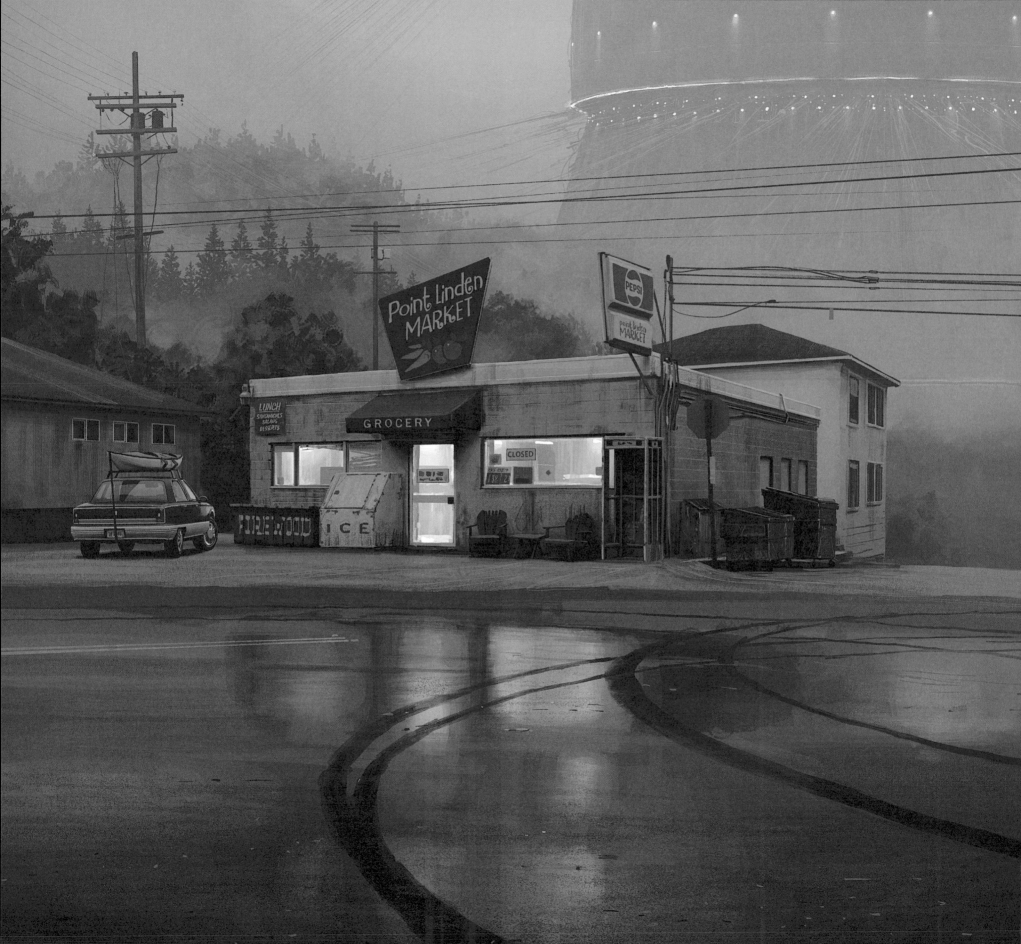

WE'RE IN AN ABANDONED convenience store in Point Linden. I've fed Skip some canned food, and he managed to drink some mineral water. I got him new clothes and new sneakers from the sporting goods store across the street.

I still haven't removed his neurocaster. He's eating and keeps his food down, but I haven't found the courage to do it. Not yet. I can't stop thinking about Birgitte and how she collapsed on the couch as soon as Ted removed her caster. Sooner or later I'll have to do it. The kayak can hold only two people, and the robot will break down and then I don't know what I'll do. No. Soon we have to go down to the beach, and then it has to be done. It will have to be tomorrow morning. I'll do it then.

PACIFIC

OCEAN

PACIFIC

OCEAN

Point Line

Naval A

PACIFIC

OCEAN

PACIFIC

OCEAN

THE SEA

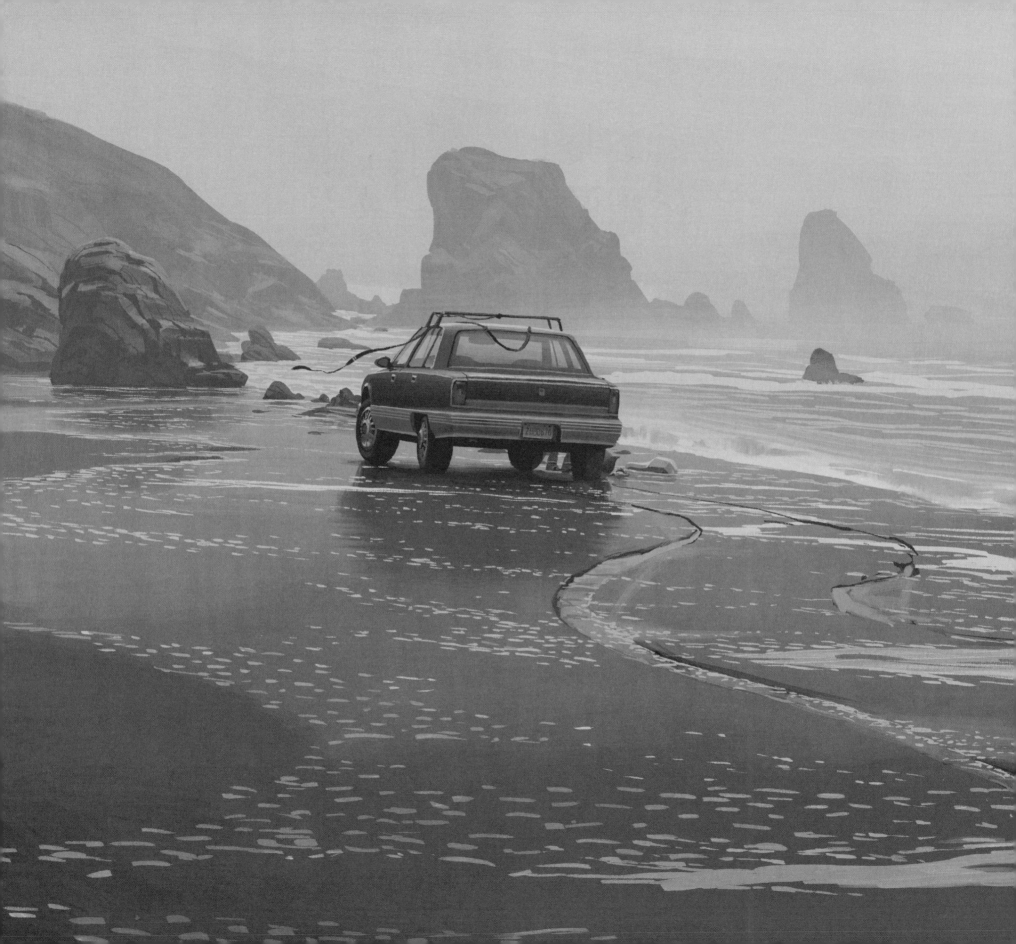

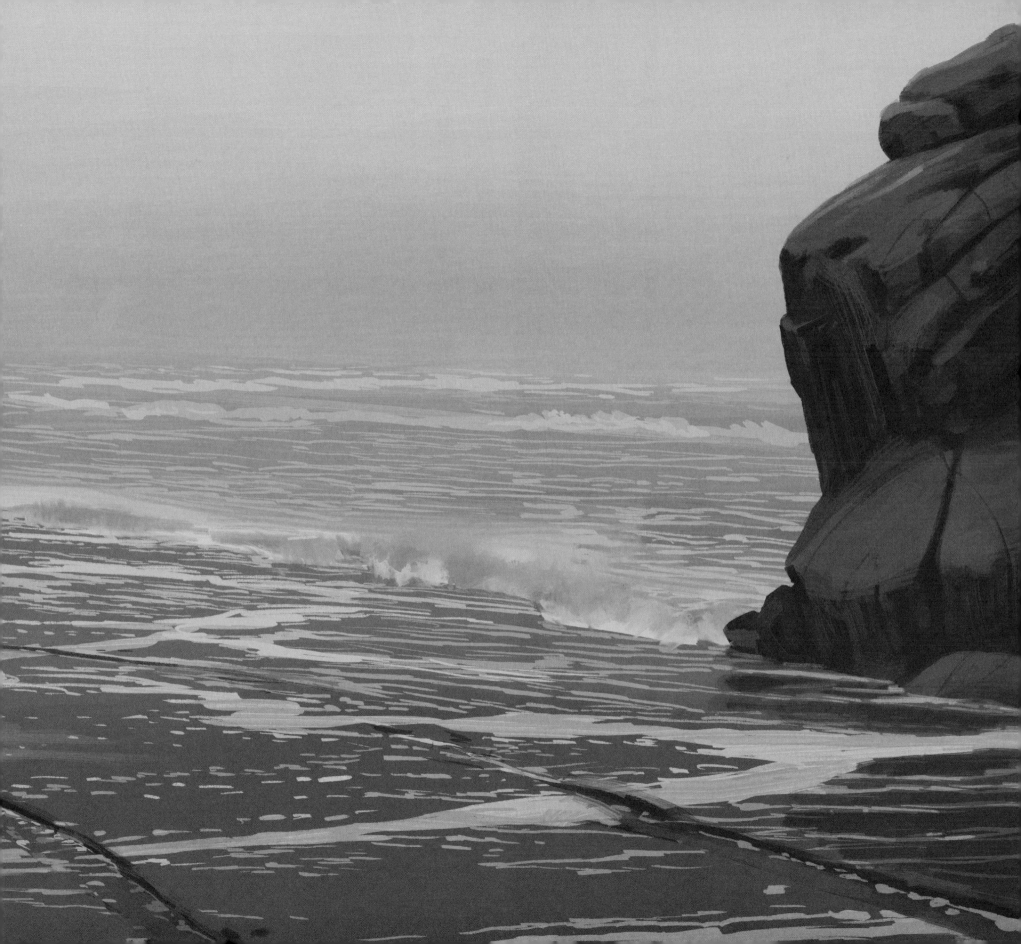

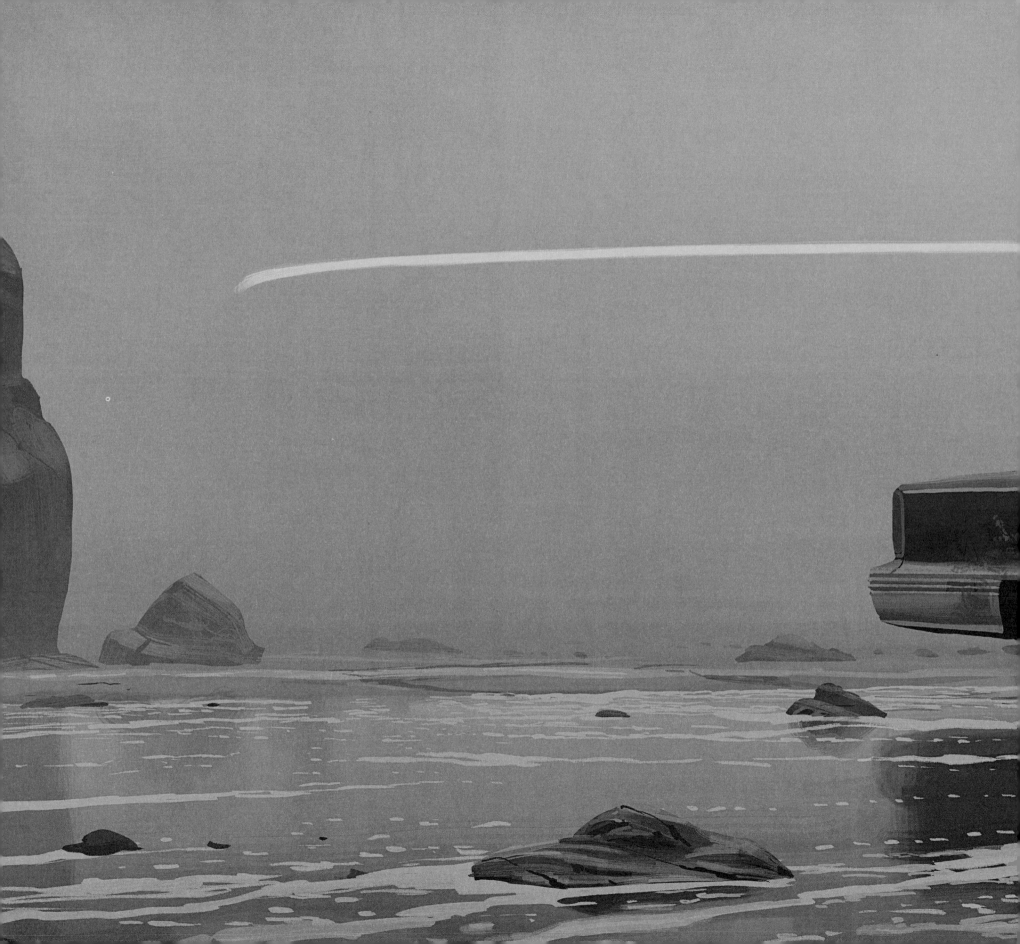

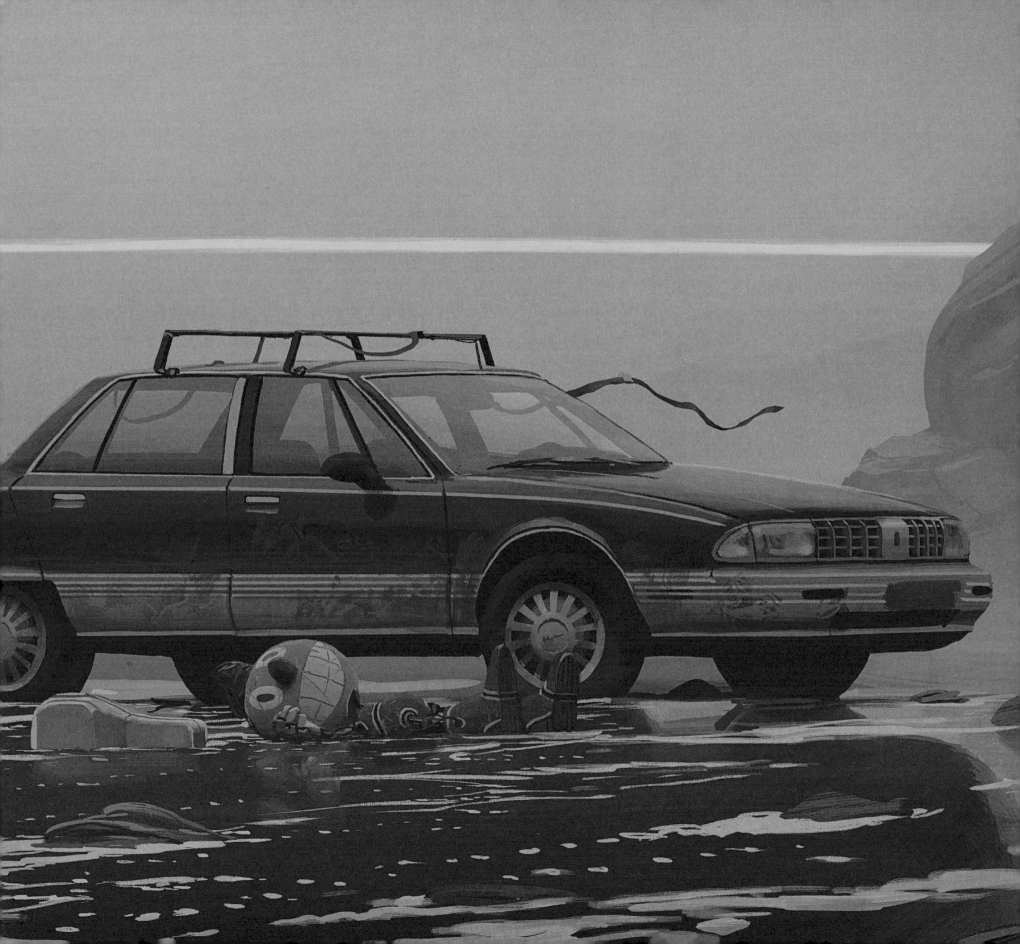

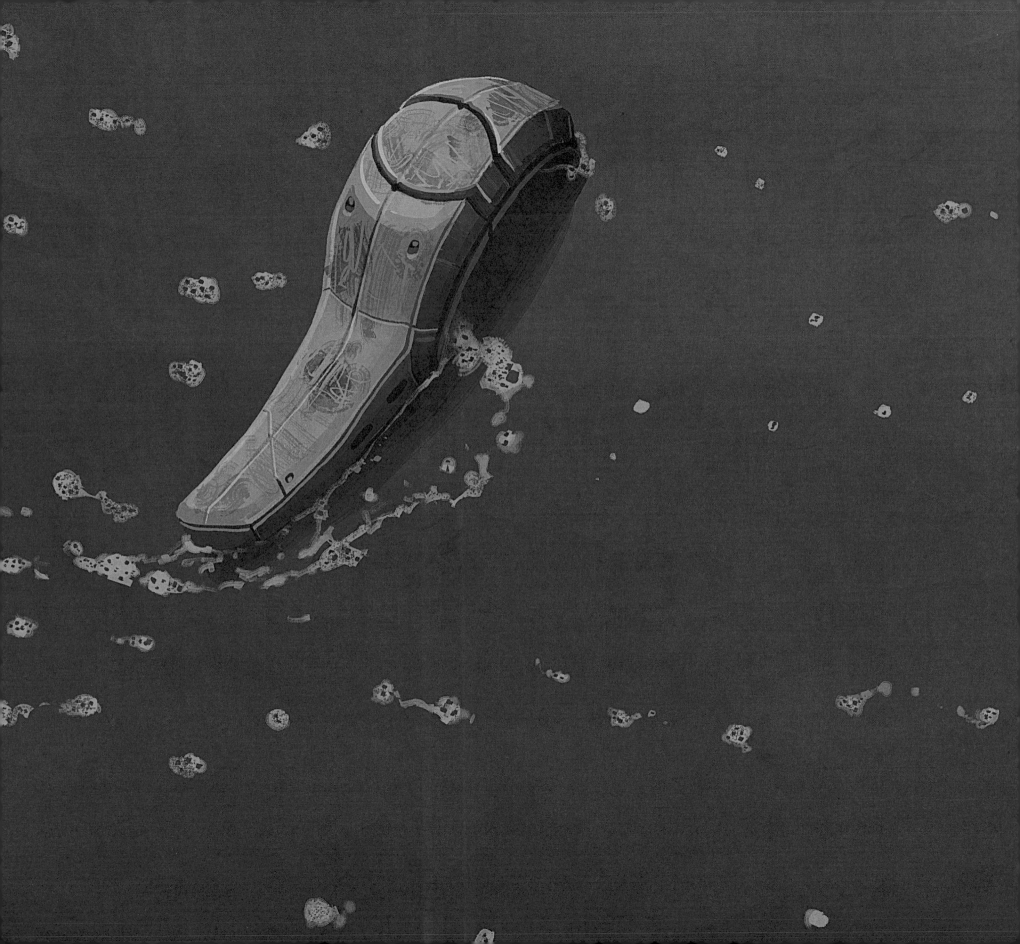

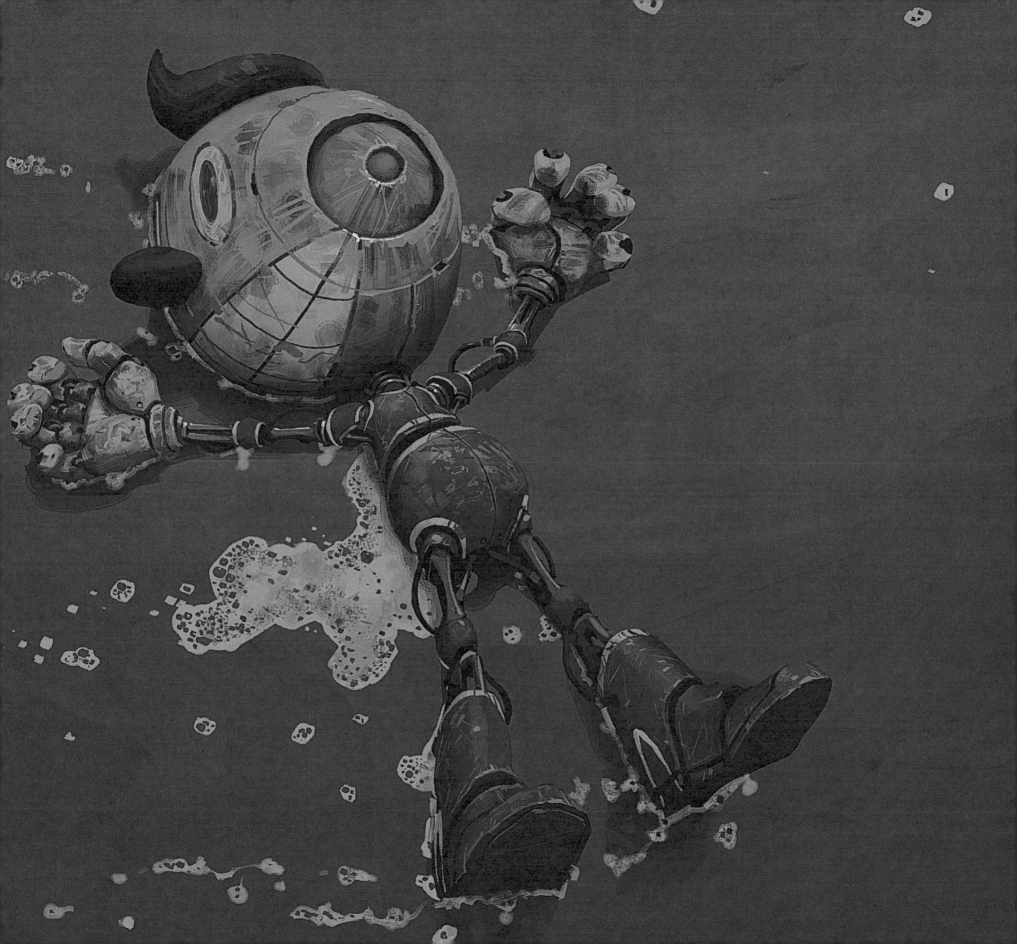

ALSO BY SIMON STÅLENHAG

Tales from the Loop

Things from the Flood

SKYBOUND
BOOKS
——————
ATRIA

An Imprint of Simon & Schuster, Inc.
1230 Avenue of the Americas
New York, NY 10020

This book is a work of fiction. Any references to historical events, real people, or real places are used fictitiously. Other names, characters, places, and events are products of the author's imagination, and any resemblance to actual events or places or persons, living or dead, is entirely coincidental.

Copyright © 2017 by Simon Stålenhag and Free League Publishing

Published by arrangement with Salomonsson Agency

Originally published in Sweden in 2017 by Fria Ligan AB

All rights reserved, including the right to reproduce this book or portions thereof in any form whatsoever. For information, address Atria Books Subsidiary Rights Department, 1230 Avenue of the Americas, New York, NY 10020.

First Skybound Books / Atria Books hardcover edition September 2018

SKYBOUND BOOKS / **ATRIA** B O O K S and colophon are trademarks of Simon & Schuster, Inc.

For information about special discounts for bulk purchases, please contact Simon & Schuster Special Sales at 1-866-506-1949 or business@simonandschuster.com.

The Simon & Schuster Speakers Bureau can bring authors to your live event. For more information or to book an event, contact the Simon & Schuster Speakers Bureau at 1-866-248-3049 or visit our website at www.simonspeakers.com.

Manufactured in China

10 9 8 7 6 5 4 3 2 1

Library of Congress Cataloging-in-Publication Data is available.

ISBN 978-1-5011-8141-2
ISBN 978-1-5011-8143-6 (ebook)